A Life Made with Artists

Doris Littrell

and the

Oklahoma Indian Art Scene

Julie Pearson Little Thunder

THE ROADRUNNER PRESS

The RoadRunner Press
Oklahoma City, Oklahoma
www.TheRoadRunnerPress.com

FIRST EDITION PRINTED JUNE 2016

Printed in the USA
by Maple Press, York, Pennsylvania

Publisher's Cataloging-In-Publication Data
(Prepared by The Donohue Group, Inc.)

Names: Little Thunder, Julie Pearson.

Title: A life made with artists : Doris Littrell and the Oklahoma Indian art scene / Julie Pearson Little Thunder.

Description: First edition. | Oklahoma City, Oklahoma : RoadRunner Press, [2016] | Includes bibliographical references.

Identifiers: LCCN 2016941111 | ISBN 978-1-937054-21-2 (hardcover) | ISBN 978-1-937054-48-9 (ebook)

Subjects: LCSH: Littrell, Doris. | Art dealers--Oklahoma--Biography. | Indian artists--Oklahoma. | Indian art--Oklahoma. | Art museums--Oklahoma. | LCGFT: Biographies.

Classification: LCC N8660.L58 L588 2016 (print) | LCC N8660.L58 (ebook) | DDC 709.2--dc23

10 9 8 7 6 5 4 3 2 1

for artists and art lovers everywhere

A Life Made
with Artists

Contents

Foreword

A Life Made with Artists tells the life story of a truly remarkable and tenacious woman, Doris Littrell. Yet, it is far more than that. It chronicles the cultural awakening of contemporary Native American art in Oklahoma.

Growing up in western Oklahoma, Doris Littrell became fascinated by Native American history and culture. She loved the rich ancestral stories of native people. She had enormous respect for their values and their creativity.

Without advanced formal education, she made herself into a true scholar, deeply immersed in the life and heritage of Native people. She realized that Native arts provided a valuable prism through which to view contemporary America. Through many forms and styles, it maintained a connection to the basic moorings of life, including a reverence for creation, respect for others, the deep love of family and friends, and the importance of symbols and ceremony that give structure and perspective to human experience.

Doris had the courage to open a Native American art gallery at a time when some even questioned the value of Native American art or its legitimate place in the "art world." She reached out to scores

of contemporary Native American artists encouraging them to paint, sculpt, and create for her gallery. She used every available means to create a market for their work and to establish market values for it.

Slowly but surely, Doris Littrell's enthusiasm for Native American art became infectious in Oklahoma. The works of Native artists were not only purchased and collected by individuals, they began to be treated more seriously by distinguished museums and institutions.

It is hard to believe that one person could make such a difference. Without Doris Littrell there would not be thousands of works in collectors' hands today. Without her, scores of Native artists would never have produced so many lasting images.

Doris pushed artists when they needed someone to motivate them. With a twinkle in her eye and a sharp pencil, she inspired collectors to fairly compensate Native artists for their work.

Through it all, this tenacious woman moved with kindness and care for others. No one ever sought her help in any way without receiving it.

Doris Littrell's story is the story of a central figure in the field of Native American art, but it is also a story of a great person whose love of art and concern for others left a lasting mark.

—David Boren

Chapter 1
Legacy of Fire

I MAGINE THAT A CATACLYSMIC FIRE has swept through an entire continent of which your community was only a small part. Countless people died, those who remained are traumatized, but eventually, new growth takes over. The medicine wheel of nature continues its patterns, but psychologically, your entire community is changed. As a child, you are barely aware that this fire ever occurred. You have no idea of the extent of its destruction. Sometimes the old people talk about it among themselves, but when you try to listen in, they stop talking and shoo you off.

Everyone goes about trying to make the best of their lives—no matter what hardships they've endured; they laugh and joke and enjoy what they have. They pour love upon you and the other children because they have always been child-oriented, but also because the historical odds against your mere existence were so great.

Your grandparents still wear small signs of their Indian identity, partly borrowed from the larger society, but always adapted to express what they value and find meaningful. In northeastern Oklahoma, it might be black hats for men with a wild turkey, egret, or scissortail feather in their hatband; for women, handmade dresses and bandannas

worn around the neck or head. In central and western Oklahoma, it is braids, earrings, and armbands for men, braids and handmade cloth dresses for women. Such expressions of identity were not encouraged for your parents and they are not encouraged for you.

Your community, having survived genocide and multiple dislocations, is now supposed to disappear through absorption. Whether you attend boarding school, mission school, or public school, you must be careful not to stand out in hairstyle or dress. Despite the fact that your physical appearance marks you as Native American, you must not draw attention to your Indianness. You must not use the language you hear at home in public. Nor must you ever let the wider society know that your community still engages in dance and ceremony, if and when it does. The practice of your Native religion is strictly forbidden. To be discovered is to risk jail time while being publicly denounced as a "savage." This inability to be yourself and express your relationship to your community has harmed you, and those you love, in ways that can't begin to be measured. Yet one undeniable casualty has been the waning of a particular kind of creativity.

This creativity once expressed itself in an unceasing drive among your people to endow the objects they made—no matter how big or how small, no matter how important or how ordinary—with beauty and significance. Through their choice of materials and by means of design, shape, and pattern, they turned the objects of everyday life into pleasing and profound reminders of your community's place in the web of life.

These objects are not referred to as "art." There is no equivalent in Native languages for what Euro-American society came to view, after the Industrial Revolution, as a specialized, rarefied activity. Nor is the Western distinction between "fine art" and "craft" present in Native cultures. Instead, Native languages have nuanced ways to describe the making of things, the people who make them, and the spirit powers that support that process.

The fires tried to erase this. Yet while not everyone in your community has stopped this kind of creation, many have put it aside in the struggle for survival. According to the larger society, the one that now dictates your priorities and sees the beautification of everyday objects

as frivolous, such objects are dangerous reminders of the past and must be let go. They literally represent a potentially subversive, alternative value system.

This was the situation that Oklahoma's Native peoples encountered at the threshold of the twentieth century, when for reasons to be explored later, American Indian "art" became acceptable to the larger society. Some of the earliest signs of change happened where they were least expected: inside Indian boarding and mission schools. These schools had not abandoned their assimilation goals, but they began to encourage what in many cases was a kind of watered-down Native cultural production that could be marketed to non-Indians. That was certainly the case with the beading business launched by the Missionaries of the Reformed Church in Colony, Oklahoma, under the name Mohonk Lodge in 1901.

As the Native art historian Mary Joe Watson writes, the Lodge purchased materials for Cheyenne/Arapaho women to bead a wide array of objects from scissor cases to purses to book covers. The beaded items were then advertised in a catalogue produced by the Lodge and mailed to customers across the country. The beaders received half the profits from their labor, and the Church, the other half. Eventually, the Lodge became an independent business with a non-Native owner who went so far as to measure, graph, and note the colors of the women's personal, family, and clan designs so they could be reproduced by the business ad infinitum.

Although the women were under pressure to agree to this commercialization of their beadwork, it is doubtful they shared with the owner the true meaning behind their designs. This embodied knowledge is what accounts for Native art's longevity, as well as its power to resist and subvert centuries of colonization. As Martha Berry explains, the Cherokee kept alive the steps and patterns of their ceremonial dances, popularly referred to as stomp dances, through their beadwork patterns. They did so with the approval of the missionaries, who thought they were reproducing pretty designs, and nothing more.

In 1917, on the old Kiowa/Comanche reservation, Susan Charlotte Peters went to work for the office of Indian Affairs as field matron. Her job was to teach white homemaking values to the Native women

3

in the area, but in doing so, she came across several girls and boys who displayed unusual artistic talent. A Choctaw nun at Saint Patrick's mission school had initially exposed the children to art, but it was Peters who organized the students into an actual art club. She arranged for a professional artist in Chickasha, Willie Baze Lane, to teach them painting, and brought in a new student, Monroe Tsatoke. She also called on Oscar Jacobson, a professor at the University of Oklahoma in nearby Norman, to offer studio space at the school to the most serious ones.

Spencer Asah, James Auchiah, Jack Hokeah, Stephen Mopope, and Monroe Tsatoke—they would become known as the Kiowa Five—all eventually moved to the OU campus in 1926, joined by Lois Smoky, a year later. Jacobson began promoting their work, first sending it to the Denver Art Museum for exhibit. He then submitted watercolor paintings by the group to the 1928 First International Art Exposition in Prague, Czechoslovakia. The reception to their work was so favorable the OU professor tapped his artist wife, Jeanne d'Ucel, to reproduce a portfolio of their images as pochoir prints. The result was *Kiowa Art*, a collection of stencil-cut, hand-colored reproductions that responded to a global public's interest in Native art.

In 1932, the Kiowa artists showed in the Vienna Biennial, Austria, where their display is said to have attracted more visitors than any other. That same year, Acee Blue Eagle (Pawnee/Creek) won the High Award for tribal painting at the Second International Exposition held in Los Angeles, next to the Olympic games. Oklahoma's Native artists had become a force to reckon with in the international art world.

In 1934, with the passage of the Indian Reorganization Act, or the Wheeler-Howard Act, suppression of Native art began to officially ease. For the first time, the U.S. government acknowledged, on paper at least, that all expressions of Native cultures and Native religions were to be respected. This included Native art, which has always been part and parcel of Native ceremonies, songs, dances, and other lifeways. The consequences of this shift played out during the lifetime of a grassroots Oklahoma businesswoman who would come to be often compared to Susan Peters and Oscar Jacobson.

Doris Littrell combined Susan Peters's ability to nurture individual talents with Jacobson's educational penchant and flair for promotion.

Growing up in a small ranching and farming community in south-central Oklahoma, neither she nor those close to her could foresee that one day she would forge a life made with Native artists, joining a wave of individuals, organizations, and institutions seeking to create a favorable environment in which this old-and-now-new-again art could flourish.

Chapter 2
Native Influences

DORIS LITTRELL WAS BORN April 30, 1928, on a dairy farm on the outskirts of Apache, Oklahoma. Her parents, Clarence and Isa Mason, already had one eight-year-old daughter by then, and a son, William, would follow four years later. When Isa went into labor with her second child, the family sent for the town physician, but he failed to arrive in time. Instead, Isa's mother, Rosa Cook, delivered the baby.

The fact that Rosa was first to hold her always meant a lot to Doris, for throughout their lives, the two shared a special bond. Doris remembered spending many a weekend at her grandmother's house—times when she felt happy, secure, and free to exercise her inquiring mind.

Most of the trees on her parents' farm had been cut to make fields for crops, but trees covered her grandmother's land, especially near the house. Grandmother and granddaughter could often be found together, drawing water from the well, reading side by side, or taking long walks in the nearby woods.

Doris recalls Rosa as a woman who placed great value on education and considered her life fulfilled when her youngest daughter, Ruby, obtained her teaching degree.

Rosa's father, Isaac Washington Read, a Civil War veteran born in Tennessee, and his wife, Mary Messer Read, eventually moved west to Arkansas, and that is where Rosa was born. The Reads were barely eking out a living when news came that Indian Territory would open to settlement with a land run on April 18, 1889. The 1889 run was the first of several in Indian Territory, and according to Oklahoma Historical Society records, one of the more orderly. United States soldiers led the swarm of people across the Cherokee Outlet to the two million acres in the "Oklahoma district" designated for homesteading. Ironically, this chunk of Indian land had been "opened" to non-Indian settlers through an amendment to the Indian Appropriations bill that year.

The Reads packed their possessions and joined the throngs of people clustered by the railroad towns of Arkansas City and Caldwell on the Kansas border. Among their fellow campers were the Suggs, who owned a freighting business for hire, transporting goods and equipment by mule, workhorse, or wagon. Doris's maternal uncle, Evert, later wrote about the meeting between the then-teenaged Rosa Read and the smooth-shaven, broad-shouldered Louis Suggs, noting that sometime before the run started, "he proposed and she accepted." The young couple and their families staked their homestead claims in what is now Pryor, Oklahoma.

The couple had not been married long, however, than Louis contracted tuberculosis. Hoping that a drier climate would cure him, Rosa and Louis sold everything they owned but two teams of horses and moved to Pueblo, Colorado. Shortly after their arrival, Louis died, and Rosa returned to Indian Territory with their three young daughters. She used the money her husband had left her to buy a farm outside the town of Stillwater.

It could have been a lonely existence but the young widow was soon befriended by the Cooks, a neighborly family that hailed from Iowa. The two families had almost daily contact with each other: Rosa helped Mrs. Cook when she was sick and William Cook helped Rosa with her livestock. When Mrs. Cook died in 1898, William Cook and Rosa married, perhaps as much for practical reasons as romantic ones. Their blended family would grow by four children they had together: Isa (Doris's mother) Ruth, Ruby, and Evert.

These were changing times. In 1901, the Kiowa and Comanche reservation, along with the Caddo/Wichita/Delaware reservation, was divided into allotments, and the rest of the county was declared available for homesteading by non-Indians. Family history doesn't record why Cook decided to leave the Stillwater area, but depart he did, filing a homestead claim for a ranch in an area that would become Caddo County, six miles north of Fort Cobb. He chose a spot in the Slick Hills, so-named for its lush grass that drew abundant game. Cook, however, saw the potential for grazing cattle instead, and became not only one of the area's first ranchers but also one of its leading citizens. Even today, a Rotary club plaque commemorates his role in several businesses from those times.

Caddo County is a picturesque area of fertile bottomlands, deep canyons, and rocky outcrops, all once storied sites for the tribes who lived or passed through there. One of the most revered is Mount Scott, which towers over Comanche County and is also clearly visible around Apache, where Doris grew up.

The Kiowa and Comanche are the largest tribes in the area, and as their migration stories acknowledge, some of its more recent historical arrivals. According to the Kiowa, the first buffalo emerged onto the earth from Mount Scott. By the 1880s, when white hunters had slaughtered them almost to extinction, the buffalo retreated to this place for safety. Mount Scott opened up, admitting them to its paradise of plenty, and closed like a stone door to a vault behind them.

The Caddos, for whom Caddo County is named, are now a small tribe in numbers, but their mound-building ancestors were so populous that their villages extended from present-day Arkansas through Oklahoma and Texas. The Wichitas, whose relatives Hernando de Soto encountered, also have long roots in the area. The Apache and the Fort Sill Apache were among the Native peoples brought to southwest Oklahoma as a result of forcible relocation. All received individual land holdings after the General Allotment Act of 1887; all are served to this day by the Southern Plains Regional Office of the Bureau of Indian Affairs in Anadarko.

Arriving in Caddo County when she did, Rosa witnessed at close range the first-generation impacts that allotment had on the Southern

Plains Indians. The breakup of collectively held tribal lands was nothing more than a land grab, for as soon as tribal members had their respective one-hundred and sixty acres, all the rest of the surplus land was made available to non-Indians. The official justification, however, was different. As President Theodore Roosevelt explained, allotment was "a mighty pulverizing machine" planned to "break up the tribal mass." Native Americans were to cast off their collective ties and tribal identities, learn Western individualism, assimilate with those who had torn them from their homes, and henceforward support themselves with Anglo-style farming.

The Caddos and Wichitas had a tradition of farming, but the Southern Plains tribes—the Comanches, Kiowas, Southern Cheyennes, and Arapahos—did not. (In the Cheyennes' case, vestiges of an agricultural past could be found buried in their stories but nowhere else.)

Southern Plains peoples were not prepared to take up farming for a living. They did not have the expertise or experience. When they did, they encountered an economic system that was rigged against them. Local banks would not extend credit to Native families for farm machinery, seed, and livestock as they routinely did for white farmers. Moreover, white attitudes toward land and land use stood squarely at odds with Native communal values.

While some Native families did go on to farm successfully, the majority leased their land back to their non-Indian neighbors with encouragement from the Bureau of Indian Affairs. Indian families would then continue to hunt and raise subsistence gardens, with many of them also working seasonally for area farmers.

There were plenty of exceptions, of course, including Kiowa artist Robert Redbird's paternal grandfather who married a woman of German descent. He acquired farming equipment and other resources through his father-in-law, and according to the painter, became "a fantastic farmer."

The Bureau of Indian Affairs negotiated lease prices between Native individuals and their lessees and oversaw the distribution of lease payments. These payments were much lower than they would have been on the competitive market, fractions of pennies on the dollar. Still, they provided Indians with a small amount of cash income, a

practice that continues today. In fact, the Imaches, a Fort Sill Apache family, leased between eighty and a hundred-and-sixty acres to Doris's own father.

The ability to access additional acreage above and beyond the land they had occupied at Native people's expense should have made for feelings of gratitude on the part of whites toward Indians. But in a well-known twist of debtor psychology, some whites resented Native Americans precisely because they didn't farm their land. They saw this, and other cultural differences, as evidence of what they believed to be Indians' backwardness, and they freely expressed such sentiments in public. This was not true of all whites, of course, but especially in central and western Oklahoma, too often feelings of hostility and prejudice toward American Indians lurked just beneath the veneer of small town friendliness offered up by settler descendants.

This was not true, however, for Rosa. According to Doris, Rosa's attitude toward Native people was always cordial and a departure from the local norm, and, after William Cook's death, she was freer to build on that. She cultivated a close friendship with her Indian neighbors, hiring them to help keep away rustlers and often paying them with cows to butcher. (Live cows were given out as government rations back then due to the challenges of refrigeration.)

Starvation had been a key weapon of the government during its wars against North America's tribal nations, and malnourishment, or undernourishment, was common among Oklahoma Indians from the reservation period up through the 1960s. While government commodity programs, started in the 1930s, were also directed to relieve food poverty among Native families, the shift from a nutritious diet of buffalo, wild game, and gathered foods to a sugar- and carbohydrate-based diet wreaked havoc on Native people's health.

The lack of nutrition was one loss for Native peoples, but the lack of access to meat also brought a sense of emotional and psychological deprivation. Buffalo have always played, and continue to play, a central role in Southern Plains people's ceremonies, and in pre-reservation days, the buffalo provided much of their material culture, from lodging to clothing to implements. Traditionally, men were the hunters, while women were in charge of skinning, butchering, and curing the meat.

Both took great pride in their skills, and as my husband, artist Merlin Little Thunder, noted, any one of them "could have taught at meat science school."

As late as the 1960s, he remembers his family's lessee pulling up to his grandmother's house, inviting her to "come butcher" a cow that had just been run over on a nearby road. These calls often happened at night, but no matter the hour, Merlin's grandmother would immediately send word to other relatives and friends. Each woman would bring her own knives, a washtub, and plenty of dish towels to the site. Working together, they could dismantle a nine-hundred-pound cow in a couple of hours. The women knew exactly how thin to slice the beef to prevent spoilage, which portions to wrap in cowhide until they were cooked, and which portions could be safely transported uncovered. Every part of the cow was saved and used.

Butchering was a joyful time; women would laugh and joke amongst themselves as they worked, relishing the thought of how happy their families would be when they brought home meat. Yet no matter how hungry their immediate households were, they always set aside portions to share with others, especially those in need. Allotment had not successfully undone the communal bonds of clan, band, or society among the Southern Plains peoples: quite the opposite. They knew their survival depended upon working together and sharing what they had with each other. It was this Native ethos of sharing that Rosa especially admired and strove to imitate in her own interactions with her Indian neighbors. She absorbed the Indian notion that the more dire your circumstances, the more important it is to be generous. "You've got to believe in the Bounty," she would often tell her children. It was a maxim that Doris would adopt in her own life as well.

Doris believes her grandmother embraced her Native neighbors for another reason, too: because of her own mixed-blood Cherokee heritage. It was a heritage Rosa never discussed with her stepchildren, but according to Doris, she did eventually reveal it to her own children.

Doris's uncle, Evert, grasped hold of this information eagerly. Although Rosa had come to Indian Territory during a land run and never resided in Cherokee Nation, he began applying for Cherokee citizenship. "He would write or call the Cherokee Nation on a regular basis,"

Doris said, with a chuckle. "I think the office workers there must have gotten pretty tired of him."

As a young man, her Uncle Evert had been friends with the Kiowa Five artist Spencer Asah and Chiricahua Apache sculptor-to-be Allan Houser. Evert married late in life, and along with ranching, he worked several years as director of nearby Camp George Thomas for the Boy Scouts of America. He took Doris to some of the first early powwows in the area, because as she explained, "I was the only one of the nieces or nephews who would go with him." She was only five or six at the time, but she has always credited her lifelong love of bold patterns and "strong but dignified color" to the beadwork, appliqué, and feather-work she saw the Native dancers wear.

Besides her exposure to the powwow drums, Doris benefited from an accidental proximity to peyote meetings. The Codypony family, which lived next-door, hosted Native American church meetings several times a month. Although she had no idea of the prayers being offered and could not make out the songs, Doris felt a sense of well-being at overhearing the rhythms of the fast-paced water drum. As an adult, she made a point of learning more about the Native American Church and treasured paintings on the subject.

Doris's sensibility was shaped by the land itself and the teeming beauty that surrounded the family farm. She had no interest in drawing or painting. Her creativity expressed itself through her imagination. "My brother and sister and I were all given chores based upon what we were good at. I was good at daydreaming, so I was chosen to walk the cows to pasture because cows don't like to be hurried," she explained.

Spring and summer, she reveled in the riot of colors around her: pink prairie briar, yellow sunflowers, pale blue morning glories, purple vetch. When the landscape changed to the rough bare dirt in a plowed field, she would imagine how the field would look if covered with pink blooms, pink trees, and pink bushes. Young as she was, she recognized these thought experiments as a kind of aesthetic exercise that expressed her special feeling for color and texture.

Doris often voiced her love of the outdoors to her mother, but she learned early on not to speak of it to her father. Throughout the Great Depression, Clarence Mason managed a good living from the land, but

his sensibility, values, and temperament were antithetical to his daughter's. Once while working in the field, she asked her father why he had to chop down a certain tree. "You want to eat, don't you?" he snapped. She felt herself wither at his tone. "Something in his voice was so cold, I never asked him another question again."

The family home burned twice during her childhood, the first time when she was still a toddler. Everyone got out safely, but in the chaos, Doris became convinced her mother was trapped inside. She was trying to go back in, when her paternal grandfather grabbed her and set her down a distance away from the burning abode, warning her to stay put and not move. Doris still remembers the firmness of his voice against the background of leaping flames.

Once she started school, Doris became an avid student, often reading aloud to herself as a way to help memorize her lessons. She was also strong-willed and prone to tantrums. Once she showed her mother a report card with a comment from the teacher saying that she was "sweet and mild-tempered." Doris's older sister, Wanda, looked in disbelief at their mother and said: "Good thing she doesn't live here."

Doris always suspected she carried a "teaching gene" because she certainly loved playing school. She often conscripted her brother, Bill, and his best friend into being her students. She'd make them sing songs and practice their grammar and penmanship; she corrected Bill's grammar so much—inside and outside her imaginary classroom—that one day he finally exploded, "Will you quit tellin' me how to talk!"

At age six or seven, Doris begged her mother to help her start a flower garden, but Isa already had a full plate what with caring for the farm, the orchard, and her children. Doris didn't dare mention her idea to her father, who in any case would have thought it frivolous. She had all but given up on the idea, when not long afterwards Richard and Amy Imach, who leased land to Clarence, stopped by the farm to see him. Somehow during their visit with her father, the Fort Sill Apache couple learned of Doris's gardening ambitions and began bringing her zinnias, marigolds, and other bedding plants whenever they could. The plants rarely survived her assiduous attention, but tending to them thrilled Doris and made her feel special. Occasionally, the Imaches brought along their daughter, Mildred, to the Mason farm. Mildred

was tall and pretty, and Doris developed a "little girl crush on her."

Mildred Cleghorn, as she would later be known, would go on to graduate from Oklahoma Agricultural and Mechanical School, now Oklahoma State University, in Stillwater, Oklahoma. She became a teacher, was named the first chairperson of the newly recognized Fort Sill Apaches in 1976, and revived the art of Apache doll making. What most impressed Doris most during that time, however, was Mildred's style: the Imaches' daughter never wore trousers, only skirts and dresses.

The affection Doris felt for Mildred was apparently reciprocated. After Mildred moved home to her family's allotment, she would often stand on her porch in the afternoon and wave at her younger neighbor as Doris got off the school bus. "She'd invite me inside her house and offer me something to eat, and we'd chat," Doris said. "I was always impressed with her house because our house was so much smaller."

Among other subjects, they may have talked about the "expression lessons" Doris was taking in Broxton, a small school just outside of Apache. Isa paid for these lessons, a combination of speech and dramatic interpretation, with her own money. The culmination of the class was a public performance for the students' families and friends. "I'd give readings, usually humorous readings," Doris said. "The audience would laugh, and I'd think that was pretty fun."

After the class was over, Isa continued to pick readings for her daughter and search out opportunities for her to perform at women's teas and other community events. Doris has always credited her ability to speak and engage an audience to those dramatic readings.

At age nine or ten, the age when little girls form strong attachments to their girlfriends, Doris chose for her best friend a half-Comanche girl from town named Betty Williams. Their friendship brought Doris into contact with the ugliness of racism at close range. "When Betty and I walked down the street in Apache, we had to pass a pool hall. The guys standing outside would holler at us and call her 'Squaw.' I'd go up and offer to fight them, and she'd say, 'Just don't pay any attention.' We were in the fifth grade."

Doris never understood the anti-Indian sentiment that permeated Apache and other small towns in the area. "That's why I was so close

to my mother and my grandmother, and her side of the family," she says, "because that other side of my family was more like the people in Apache."

"[Apache] was 80 percent Indian, but that 20 percent that wasn't, was very strong against them. You could have someone, like Doc Tate (Nevaquaya), who's very famous, the only Indian person who ever played at Carnegie Hall, and they didn't know any of that. They didn't know that he was a great painter among them." —Doris Littrell

Chapter 3
Proving Her Mettle

DORIS LITTRELL HAS MANY happy childhood memories of her mother and her siblings, but her relationship with her father largely consisted of staying out of his way. This was especially true when he binge drank and his behavior became frightening and erratic from the booze. At age thirteen, she has said, "a tragedy befell her" at the hands of her father, and she left home, never to live there again. She sought refuge with her Aunt Myrtle (her mother's half sister on the Suggs side) who ran the switchboard office in Apache. Myrtle and her family were already living with her in-laws so she could not take her niece in. Instead, she offered Doris a job and a place to stay at the switchboard office. Doris would work the night shift, be paid a small salary, live in the back, and be able to continue attending school during the day.

The office was housed in a modest brick building downtown. In the front lobby was the telephone booth; in the back, the switchboard and a bed. When someone arrived to place a phone call, they would hand Doris the number through a small window and step into the phone booth where she connected them to their party. Not everyone had a home telephone in 1939, and switchboard operators were often

the first point of contact for emergencies. Any other thirteen-year-old might have felt overwhelmed by such responsibility, but not Doris. She liked her job all the more for its serious nature.

Doris can recall only one true emergency during her tenure: someone called from the town of Elgin to report a tornado on the ground and headed straight for Apache. Doris pushed the button in the office to sound the warning siren for the town. Fortunately, the tornado lifted back up into the clouds just before it reached Apache. Other than that, there were only a few medical instances, when Doris had to place a call to the town doctor on someone's behalf. Most nights, she was able to finish her homework at her leisure and sleep undisturbed.

Her living arrangements might sound lonely, but Doris never regretted leaving home, although she missed her mother and siblings badly. She did her best to stay in touch with them. Every morning, she would meet her brother, Bill, at his school locker; he would have a letter for her from their mother, and Doris would give him one to take back. A few times, she tried walking the three-and-a-half miles home to visit Isa, but it took so long they'd barely have time to talk before she had to hurry back to work.

During this period, Betty and her family became her emotional lifeline. She began spending all her weekends and days off at their house. The girls would sleep together in the upstairs bedroom. "Sometimes we'd get to talking late, and her dad would get tired of it," Doris said, with a laugh. "He'd grab a broomstick from the floor and thump the ceiling with the end of the handle, saying 'Girls, it's time to hush!'"

Betty's father, Clay Williams, was a white preacher with the local Baptist church, but her full-blood Comanche mother, Bessie, ruled the home. The couple had met at Cache Creek Mission Hospital where Bessie was a nurse. Once they married, she quit the hospital to stay home, her only nod to conventional 1940s domestic ideals. At home, Bessie rarely cooked or sewed, although she was good at both. She never cleaned their white two-story house either: Clay and his daughters did that. Instead, she spent all her time and energy on outdoor projects designed to make money for the family. She gathered bushels of pecans and spread them in her attic to cure. She incubated starter chickens to sell to farmers. "We'd hear them peeping, and Betty and I would beg

to go play with them," Doris said. "She'd let us for a few minutes, but then she'd shoo us out."

While not without their own problems, Clay and Bessie were good to Doris. More informal than her own parents, the Williamses insisted Doris call them by their first names, and she took away an alternative vision of what family life could be. Sunday mornings, Bessie would turn on the radio, and the girls would jitterbug across the spotless kitchen floor while making homemade ice cream. It was always only a matter of time before Clay would stick his head in and say with mock exasperation, "Here I run a church that doesn't believe in dancing, and even on Sundays, my girls just dance away."

Betty and Doris had always shared a passion for horses, and prior to Doris leaving home, they often met at Cache Creek to go riding together. After Doris took up her switchboard job, she and Betty would sometimes ride Betty's horse back to the Mason farm, so Doris could borrow her brother's for afternoon rides. On such outings, Doris often collected leaves for her high school botany class. "On horseback, I could reach the taller, prettier leaves that were high up. The teacher was so impressed, but to me it was nothing. You rode your horse and you did stuff with it."

One summer, the two girls announced to their families that they were going to climb Mount Scott. Betty's father threw his support behind their plan, driving them to the base of the mountain and staying at their camp the first night to show them how to cook outdoors. The next morning after he left, the girls packed their camping gear and started their ascent. They walked for hours up the dirt road that wound around the side of the mountain. By the time they reached the top, they were exhilarated and exhausted. In *The Man Made of Words*, N. Scott Momaday describes standing on top of Mount Scott and seeing "the earth below, bending out into the whole circle of the sky." Doris and Betty might not have realized it at the time, but by spending the night there, they had made a kind of spiritual journey in their own, little girl way.

What the two of them never imagined was that going down would be harder than going up. "We were so tired that we went straight down through the trees," recalled Doris. "I had on new Oxfords, and I wore

out my shoes." When they finally made it back to their base after their crow-flies descent, Clay was there, waiting for them.

Even as a young girl, Doris enjoyed the company of older women, and that was true when it came to her best friend's mom as well. She spent hours with her neighbor thumbing through Bessie's nursing books and asking her questions about medical matters. Neither Betty nor her sister ever seemed very interested in their mother's former career, which always puzzled Doris.

Doris also couldn't help but wonder why Bessie seemed to prefer taking Doris along when she went to Lawton to shop, instead of one of her own daughters. Bessie never explained the choice, but Doris suspected it might have been an effort to shield her daughters from the kind of behavior that Doris witnessed with Betty in Apache. Mixed-blood children had a difficult time back then in Oklahoma and elsewhere, encountering prejudice from Indians and whites alike. After Clay died, Bessie reportedly told a friend if she had it to do over, she wouldn't marry a white man because it was too hard on the children.

After Betty finished school, she became a teacher and moved out of state. To Doris's disappointment, she eventually lost track of her old friend. But she stayed in touch with Bessie for the rest of her life, often visiting her in Anadarko. When her own mother, Isa, passed away in Lawton, it was Bessie whom Doris asked to babysit her five-year-old daughter, Kim, while she made funeral arrangements. She remembers when she returned from the funeral home Kim's cheeks were "plump as a chipmunk's" from all the food Bessie had given her. Later in life, when different Native individuals told Doris she had "Indian ways," she always replied it was because she had grown up with a Comanche family.

By the time Doris graduated high school, she had a set of marketable skills, thanks to her switchboard work, and an air of self-reliance unusual for her age. She applied for and got a job with Southwestern Bell in Oklahoma City. The company agreed to apply her years as a switchboard operator in Apache toward seniority with the company, and it offered her a higher wage as a result.

Before leaving Apache, Doris had one more important thing to do: visit her Uncle Evert. Sometime back, Evert had opened his own

country store, where he accepted paintings from local Native artists in exchange for gas and groceries. By the time he closed the store, he had accumulated quite a substantial number of Indian paintings and he continued to buy, especially from his Kiowa/Apache neighbor George Geionety.

Doris had often admired the paintings that Evert hung on his walls with thumbtacks. This time, her trip was to ask if she could buy one of them from him. He sold her the painting for a dollar, fifty cents more than he had paid for it. Although it was subsequently lost, either in storage or a subsequent move, this intimate, familial transaction contained in microcosm all the basic elements of what would become Doris's future in art.

"A collector is someone who's drawn to an artist's ability with color or composition. They aren't thinking about the work increasing in value. They do it from their heart and soul." --Doris Littrell

Chapter 4
Life Lessons Through Art

ORIS ARRIVED IN Oklahoma City, carrying only a suitcase, and went straight to the Southwestern Bell office. There she learned her paperwork was still being processed and it might be three weeks before she could report to work. The news sent her reeling. She had only enough cash to survive a couple of weeks without working. Not only that, but once she did finally start work, she knew it would be a couple of weeks until her first paycheck.

She doesn't remember how, but she happened upon an elderly couple that took her in, though she was too independent to stay long on a stranger's generosity. She found a job as a clerk in a neighborhood grocery store and used her first wages to rent a sleeping room. The room didn't come with sheets or blankets, so she slept on top of the bed, using her winter coat as a blanket. As if she needed further motivation, she kept a boiled egg on the windowsill "as a reminder that it was all that stood between me and starvation."

Even after she was called into Southwestern Bell, she continued to clerk at the store several more weeks. Besides needing the extra money, she wanted to give the store adequate notice. The only problem was the phone company had a policy that prohibited outside jobs, and one

day her female supervisor walked in while she working. "I know she saw me. I thought for sure she was going to report me, and I would be fired," Doris said. For whatever reason, the woman never said anything about the moonlighting, and Doris kept her phone job. Once she was back to one employer, however, she breathed a sigh of relief.

Doris had requested the swing shift at the phone company for several reasons. The pay was better, she was used to working nighttime hours, and she didn't want a social life, or so she told herself. Her hours certainly didn't encourage one. She took lunch at four a.m. daily at Bishop's Restaurant, one of the few twenty-four-hour eateries within walking distance of work. One red-eyed morning while walking with a girlfriend to Bishop's, she noticed a man standing at the doorway, watching people come and go. As it turned out, the man was a member of her girlfriend's bowling team. She introduced him to Doris and he joined them at their table.

Bob McCabe was a night owl by choice and a veteran, recently returned from Korea. Prior to his military service, he had studied law at the University of Oklahoma in Norman. After his discharge, he switched to a business major at Oklahoma City University but had yet to do anything with his degree. When he and Doris met, he was renting a room in a downtown hotel, working only as much as he needed to survive, and according to a family member, living "on a pack of gum a week." The only thing he seemed to take seriously was bowling. He never missed a practice.

Doris recalls Bob being mostly quiet during their first meeting, but he seemed amiable enough, listening and smiling in response to the women's conversation. He suggested they meet again, and before long he and Doris were dating. During those dates, she learned that Bob's mother had divorced his stepfather a while back and was living in San Diego with her new husband, Bob Ferguson. She had been pressuring her son to join her there, a move he'd been resisting when he met Doris.

Although the young veteran appeared easygoing and relaxed, Doris soon learned that any strong display of emotion left him uncomfortable. If he had any deep thoughts or feelings, he never shared them with her. Once, on an outing, as they stood beside a tree, she impulsively threw her arms around him in a gesture of affection. He pushed her

away brusquely, without explanation. Any one of these characteristics, combined with his lack of steady employment, should have warned her away from marriage, but Bob was her first serious relationship, and Doris desperately wanted to believe it could work. Her own emotions were often tumultuous, and at times, she could be seized by anxiety for no apparent reason. Bob's unwillingness to be ruffled by anything seemed to counter that. "I felt a quietness come out of him, and I needed quiet," Doris said.

They married in a civil ceremony in 1951, a year after they met, without the presence of family or friends. Bob showed up at the courthouse in his bowling shirt, claiming it was the closest thing he owned to a dress shirt.

The couple had never discussed art during their courtship, and it didn't come up as they set up housekeeping either. Their first acquisitions as husband and wife were more basic: a bed and a few other sticks of furniture.

That summer, during Doris's vacation from Southwestern Bell, the couple began what would become an annual ritual for them: traveling to California to visit Bob's mother, Ethel, and Ferguson.

On that very first trip, Doris and Bob stopped in Old Town Albuquerque where Doris fell in love with a small, black Santa Clara pot in one of the shops. Bob, who was usually noncommittal about her purchases, seemed to like it as much as she did. That made her like it even more. They couldn't afford to buy the pot outright, so they put it on layaway and drove back to Albuquerque at Christmas to pick it up.

The following summer, on their next trip west, they purchased a Navajo rug. While in Albuquerque, Doris couldn't help but notice that the stores were full of paintings by Southwest artists, and after the couple returned home, she broached the subject of wall art. "I grew up in a town full of Indian painters," she told Bob. "Let's go to my uncle and see if he has paintings to sell us."

Bob had yet to visit Apache, and he had never met Evert, but the two men hit it off right away that first visit. Once again, Bob responded to the artwork, which despite their occasional arguments, seemed to knit them together as a couple. This time, Doris paid two dollars for her painting. Geionety's price had gone up, but her uncle's commission

held steady at fifty cents. "We started going down to Evert's as often as we could because, broke as we were, we could afford several of those," she said.

* * * * *

In 1952, the couple's first child was born, a daughter they named Toya. Bob was out of work, so he stayed home with the baby while Doris continued on at Southwestern Bell. By the time she became pregnant with their second daughter, Kim, he still hadn't found a job. When his stepfather called offering him one at the manufacturing plant he managed in San Diego, the couple felt compelled to consider it. It was hard to contemplate moving so far away, but McCabe's new salary promised to make it worth it. Having relied upon her own resources for so long and now aware of how comfortable Bob seemed to be with not working, Doris approached the move with caution. Instead of quitting her job at Southwestern Bell, she asked only for a leave of absence.

Shortly after they arrived in California, she found a job at a drugstore near their house, but she was often sick and lost weight during her pregnancy. Then her father was hospitalized, and she flew back to Oklahoma to help her mother with the dairy farm. A trip like that would have been stressful for any expectant mother, but for Doris, who dreaded being around her father, it was traumatic. Once she returned to San Diego, the couple remained there for another year, until in 1954, they moved back to Oklahoma City.

They had saved enough money to buy a house on the northwest side of the city, but making the mortgage payment required that Doris return to work. When they weren't working, they continued traveling to Apache for paintings and New Mexico for pots and rugs. Next, they added weavings and Southwest baskets to their purchases. Because they weren't buying directly from Native artists, they relied upon merchants to educate them about their acquisitions. "The dealers explained to me who the fine potters were, and what made this rug . . . a finer rug than that," Doris explained.

That changed, however, after a stop in Old Town Albuquerque with Doris meeting Navajo jeweler Arthur Lewis (Diné). She had ad-

mired Navajo jewelry before but never purchased any. Soon she was buying bracelets and rings from Lewis on every trip. "I followed him around and pestered him with questions. That's how I learned about silversmithing and turquoise," Doris said.

Upon her return to Oklahoma, she continued to deepen her knowledge about Native textiles and jewelry by checking out armloads of library books on the subject. She had stumbled onto one of the chief pleasures of collecting: the chance to learn more about the techniques, cultures, and individuals behind the art.

In 1958, Bob landed a full-time job in Oklahoma City, working in a Florsheim shoe store. Doris was elated at the news, that is, until he announced, in the same breath, that he wanted them to move. His brother, Jack, had a house in New Mexico, located on top of a hill, halfway between Cloudcroft and Alamogordo. The house was unoccupied, and Jack was willing to rent it to them. Doris was skeptical, but Bob reasoned that being in New Mexico would give them easier access to the art they both loved. He would continue working in Oklahoma for Florsheim and commute back and forth, and she could apply for a transfer to Alamogordo with Southwestern Bell.

After Doris confirmed that her employer had no openings in Alamogordo, Bob still insisted they stick to his plan. He would support the family with his wages, she could stay home with the girls, and he would join them twice a month. She would have the family car to get around in—an older, model Oldsmobile—and he would use the newer Volkswagen they had recently purchased. When she reminded him that she had never learned to drive, having never had the need and because he did all the driving, he assured her that his sister-in-law would be more than happy to teach her.

The arrangement worked all right during his first couple of absences. The pantry was well stocked, and Bob wasn't away for long. Doris loved the view from their hilltop perch, but she also felt at loose ends because, for one of the first times that she could remember, she wasn't working. She and the girls were also quite isolated on their hilltop. She had to walk Toya and Kim to the bus each day because the mountain road was too narrow for the school bus. It could not even accommodate two cars at the same time. Doris made several calls to her sister-in-law

about the promised driving lessons, but no one ever answered, and the Oldsmobile sat idle in the driveway.

The third time, Bob was gone much longer than before, and Doris grew anxious as she watched their food supply dwindle to almost nothing. She and the girls picked wild rose hips to distract themselves, and finally, out of desperation, she decided she had no choice but to try to drive to La Luz for groceries. After a nail-biting, turtle-slow crawl down the hill in the old car, she made it to the bottom, and hugely relieved, began the fifteen-minute drive to La Luz. It was mostly straight-away, but when the town finally came into sight, she was so excited, she turned the steering wheel the wrong way and promptly landed the car in a ditch.

She might have been there a long time had not a nearby Catholic parish been celebrating mass. Someone saw the accident, and before she knew it, a dozen men spilled out of the church to help. She got out of the car and watched in amazement as eight of them lifted the Oldsmobile out of the ditch and set it back on the road. Doris was physically unscathed, but she had lost her nerve. She turned around at the next junction and drove back home.

It never got easier. Whenever Doris drove the car down the mountain, Toya would have to run ahead of her to make sure no one was coming up it. If a car were coming, Doris would put the Oldsmobile in reverse and backtrack a few feet at a time all the way to the house. After three months, she'd had all she could stand and insisted that Bob move them back to Oklahoma City. It took another three months for her to get rehired by Southwestern Bell, and she never touched a steering wheel again.

With a family of four now filling their modest, two-bedroom house to the seams, Doris realized she could no longer collect paintings, pottery, and rugs as freely as she had in the past. Her tastes had grown more exacting with her knowledge as well, and so in order to be able to continue collecting, she would have to resell some of the art she and Bob had purchased.

Her plan started simply enough, with a couple of ads in the Oklahoma City newspaper, listing Native artwork for sale and her phone number. Prospective buyers could view the art at her house, so long

as Bob was there, or she would offer to meet them at lunch, in their office, or a nearby restaurant. Doris discovered that she enjoyed these transactions far more than she had expected.

Then Bob quit his job at Florsheim—the longest stretch of employment he'd ever had during their marriage—and their finances were thrown into turmoil once again. Collecting new art was out of the question. All the money she earned at the phone company would be needed for bills. She contemplated taking on a second job, but she had already regretted not being there in the afternoon when her daughters came home from school. Perhaps, there was something more to be done with the art . . . could it somehow be parlayed into a second income?

> *"The first white people came to the Bearfoot Park powwow*
> *around 1965. They were walking around in suits. Cheyenne*
> *headsmen went around telling the women, 'Don't worry. They're not*
> *going to take your kids away to boarding school. They just want to*
> *watch our dances. They're interested in our culture now."*
> —Merlin Little Thunder

Chapter 5

Indian Fairs, Trading Posts & Museums

THE BUSINESS OF BUYING and selling Native art was far from new when Doris started her art dealing. Commerce in Oklahoma Native art had evolved along several simultaneous lines, but it also tended to concentrate in localized pockets.

Some of the first large-scale venues for Native art in Oklahoma were Indian fairs, an outgrowth of the popular agricultural fairs of the nineteenth century. Land run settlers brought agricultural fairs to Oklahoma, using them to promote their newly established towns. Part carnival, part livestock auction and produce showcase, the fairs usually took place in late summer and fall, in conjunction with the harvest. They drew isolated rural residents together, generated revenue, and created a sense of civic pride. The federal government and mission churches encouraged attendance at the fairs by Native Americans so as to inculcate them with Euro-American farming and homemaking practices. But in places with dominant Indian populations, the fairs also came to include Native cultural interests and entertainments, hence the term, Indian fairs.

Indian fairs were open to the public, and among their offerings were hand-game tournaments, archery, Indian-style foot races, and

horse races, as well as arts and crafts exhibits. The famed Santa Fe Indian Market started as an Indian fair in 1922, focusing on Pueblo dances, arts, and crafts. From the beginning, one of its main purposes was to help Native artists by allowing them to sell directly to the public without middlemen.

The most well-known fair in south-central Oklahoma was the American Indian Exposition of Anadarko, referred to simply as Indian Fair. Launched in its present form in 1936, it was famous for its parade, its Indian village, and a large intertribal powwow. The fair drew Native Americans from far and wide for a week of camping, visiting, feasting, gambling, and horse trading.

Kiowa beadworker Richard Aitson has memories of going to the grounds a week and a half early because his grandfather was camp crier at the fair: "[Artist] Stephen Mopope and his wife would already be set up. There'd be Cheyennes camped on the north side, Caddos, Wichitas, and Delawares. ... Behind us was the Gooday family, where I learned about Apache Fire Dancers," Aitson recalled.

Indian Fair was also Anadarko's biggest tourist attraction, bringing in thousands of visitors in its heyday. Besides offering booths for Native artists, it had a juried art component with cash prizes. Other area powwows such as Colony, Bearfoot Park, and Comanche Homecoming, to name just a few, featured arts and crafts booths and served as sales venues for Native artists. Many started out as same-tribe dances with little vendor activity, but as the dances went intertribal, the opportunities to buy and sell increased, as did attendance by non-Indians. Exposure to other aspects of Native cultures clearly encouraged interest in Indian art and vice versa.

Indian trading posts, or Indian stores, had been a fixture in Oklahoma for decades. In the 1940s, McKee's Indian Store in Anadarko was one of the largest, selling jewelry, moccasins, beadwork, and numerous other items, most made for the tourist trade. Yet it wasn't only a gift shop; it also sold materials to the creators of these items: beads, shawl fringe, bells, broadcloth, leather, and rawhide, and plenty of dyed chicken and (domestic) turkey feathers.

The first museums in Oklahoma did not emerge until the 1940s, and a large number of them were devoted to the Native arts. One of the

oldest is the Southern Plains Indian Museum in Anadarko, established in 1947 under an agreement between the U.S. Department of Interior and the State of Oklahoma. Southern Plains Museum promoted Native art through educational displays, but it also offered sales exhibits. Having a solo show at the museum was considered a career milestone by most artists—and not just because the museum always produced a large brochure about the artist for each show. The museum's main shortcoming was it rarely purchased artwork for its permanent collection. It did have a gift shop that purchased items, but it focused more on cultural items than on paintings or sculpture.

Museums were, in effect, a different kind of middleman—purchasing art wholesale to sell through their gift shops and hosting sales shows for Native artists. Consignment percentages charged by museums during these sales varied, but they tended to be low, in keeping with a desire to encourage Native artists.

In northeastern Oklahoma, citizens of Native descent played a key role in the establishment of Native art museums. In 1955, the Da-Co-Tah Indian Club, comprised of women of Indian heritage, raised money to convert the former Creek Indian agency in Muskogee into the Five Civilized Tribes Museum. As its name suggests, the museum's competitive shows were tribally restricted to artists of Southeastern heritage: Creek, Seminole, Choctaw, Chickasaw, or Cherokee. The museum used purchase awards to acquire an impressive collection of works by virtually all the top Southeastern artists in their fields. It drew collectors from in and out of state and inspired generations of up-and-coming Native artists who visited its exhibits with their families or on school field trips.

A decade earlier, in 1945, Cherokee citizens started the forerunner of the Cherokee National Museum in Tahlequah, Oklahoma, however, the museum's first Trail of Tears Art Competition was not held until 1974. That show, named after a phrase often used to describe the Cherokee Removal from the southeastern United States to Indian Territory (present-day Oklahoma), started out as a one pony show with only one category of paintings: those that had a Trail of Tears theme. According to Cherokee historian Tom Mooney, the show was also initially dominated by a handful of artists, each submitting multiple entries.

Then, with the help of an artist advisory board and a donor chairperson, the Trail of Tears show expanded its categories and its media, adding sculpture, pottery, basketry, and eventually cultural items. It took on a national profile, attracting artists from as far away as Alaska and New York. Still, the category with the largest purse remained the Trail of Tears Award, with entries limited to depictions of the forced relocation of one of the Five Tribes.

Perhaps the best-known Native individual to endow a museum in Oklahoma was oilman Thomas Gilcrease, whose wealth came from the Glenpool strike on his Creek allotment. Gilcrease attended Bacone College for a year in Muskogee, Oklahoma; met his first wife there; then moved north to the Osage Hills of Tulsa to make a living ranching. After a short time, he changed course, investing in his own oil business in San Antonio, Texas, and feverishly collecting Native and western art. Eventually, Gilcrease decided to build a museum for his art in the Tulsa hills, and hired Potawatomi artist Woody Crumbo as his artist in residence. Crumbo helped him identify other Native artists for commissions and, in doing so, helped guide Gilcrease's collection, which also included numerous cultural items. When the museum opened in 1948, built largely by Native American labor, its Quonset, long-house inspired entry with Crumbo's peyote bird painted over the door, proclaimed the importance of Oklahoma's Native cultures to all.

In 1950, after a second marriage and divorce and some bad business deals, Gilcrease found himself saddled with $2.25 million dollars of art debt. Friends and colleagues lobbied the Tulsa City Council for help. They put forward a bond issue to pay the debt, and the collector transferred ownership of the museum to the city of Tulsa.

Philbrook Museum, the legacy of non-Indian oilman Waite Phillips, was also built in Tulsa, located in what formerly had been Phillips's summer villa. Founded in 1946, its collection always consisted mostly of European paintings and to a lesser extent, western art and Native cultural items. Then in 1949 the museum launched an Indian art competition that would quickly become one of the premier Indian art shows in the country. Woody Crumbo is often credited with coming up with the idea for the Annual, in which entries were divided into geographic categories based on subject matter: Woodlands, Southwestern, and

Plains. Later, a "Reject Room" was established, where art that had been juried out of competition could still be displayed and sold. Much of the museum's current Native art collection was acquired by means of purchase awards from the show.

The month-long sales show eventually would attract more than four thousand works of art by more than a thousand Native artists and be attended by a throng of individual and institutional collectors. While the Philbrook Annual was ahead of its time in recruiting Native artists as judges, it was also the place where the notion of Native art as a field limited to a handful of styles was called out on the carpet.

The public shaming came from Oscar Howe, a Yanktonai Sioux, whose cubist-inspired entry in the 1958 Annual had been rejected because it didn't "fit the guidelines" for Indian painting. Howe's response was swift and pointed: "Whoever said that my paintings are not in traditional Indian style has poor knowledge of Indian art indeed."

The Yanktonai artist was referencing Native art's ancient use of abstraction, and he was also voicing his disenchantment with the emphasis on conformity and repetition in Native art. He expressed what many other Native artists were thinking but had not voiced publicly: "Are we to be held back forever with one phase of Indian painting, with no right for individualism, dictated to as a child? . . . 'you little child, do what we think is best for you, nothing different.' Well, I am not going to stand for it." To the credit of the museum, the following year, a new Special Category was added. Moreover, as soon as it went into effect, it became the category of choice for the majority of Native artists entering the show.

Despite all these venues—Indian fairs and festivals where artists sold directly to the public; Indian stores and gift shops that purchased and resold art; and Native and mainstream museums that mounted sales shows—the works of Oklahoma Indian artists in one part of the state rarely showed up in another. Indeed, it seemed to many artists, particularly those from the land settler areas, that Native art was better received within the former boundaries of the Five Tribes than it was in the western part of the state. It was as though an invisible cultural and economic wall separated the two areas and only the most successful Indian artists moved back and forth between them.

As a result, the economic landscape of Native art in the state resembled a draw-by-numbers map with a lot of missing numbers. There was no way to understand what the map actually looked like because there was no way to connect the dots. Indian art dealers of the day, and the collectors they sold to, played a valuable role in adding additional dots to the map, circulating works by Native artists from one area to another and introducing Native art to stores and businesses in the state that had never handled it before.

"When I first started dealing, people thought nothing good could come out of Oklahoma. It had to be Santa Fe. If it came from Oklahoma, it wasn't fine art, it was hobbyist stuff." —Doris Littrell

Chapter 6

Becoming a Dealer

D ORIS STARTED OFF SELLING paintings by Southern Plains artists in what is often referred to as the flat style, popularized by the Kiowa Five—James Auchiah (1906–1974), Spencer Asah (1905/1910–1954), Jack Hokeah (1902–1969), Stephen Mopope (1898–1974), Monroe Tsatoke (1904–1937)—and the often forgotten sixth member, the woman of the group, Lois (Bougetah) Smoky (1907–1981).

The Kiowa style was derived in part from hide painting and ledger art drawings, the latter so-called because they were drawn on paper from government-issue ledger books. Cheyenne Dog Soldiers, among others, procured ledger books during raids around Julesburg, Colorado, in the mid-1800s and recorded their war deeds against other tribes and against U.S. soldiers in them.

Fort Marion, Florida, is the site most associated with ledger drawing. In the dank Spanish fort that imprisoned hundreds of Native American prisoners, drawing helped ease the hardship and boredom of captivity. Artistically inclined warriors from diverse tribes held onto their sense of self by recording their exploits in combat, including their victories over white soldiers and other exploits. Some may have found

it amusing that both the soldiers who guarded them and local tourists were so eager to purchase drawings in which Indians were often depicted as having the upper hand when they encountered U.S. soldiers.

The strongest connection between the ledger artists and the Kiowa Six was a shared sense of the importance of their history. The flat style practiced by the Kiowa Six involved stylized, streamlined compositions, dramatically suspended in negative space. Their principal subjects were dance, ceremony, and cultural lifeways, and the figures they portrayed were usually men. People and objects were drawn in pencil, often on white mat board or watercolor paper, and afterwards filled in with bright colors of a single hue of gouache, watercolor, casein, or tempera. Sometimes figures or objects were outlined in with a thin,black line. There was no attempt at shading or modeling, little if any foreground, and no background elements. Although the flat style is sometimes disparaged as lacking technical sophistication, in reality, it requires skillful draftsmanship, a precise hand in applying paint, and lots of patience with less room for error than a realistic style.

In the beginning, Doris procured almost all her flat-style art on consignment because she lacked the means to purchase work from the artists themselves. One of her first sources was Ruth Cox, a tax accountant in Anadarko. Cox was said to have wanted to help support artists by buying their work. Ironically, she never displayed any of it so she or anyone else could enjoy it. She kept all the Native paintings she'd bought stacked in a closet, and she was happy to have Doris sell them for her and pay herself a small commission.

Doris also secured paintings on consignment from Joe McBride Jr., editor of the *Anadarko News*. McBride senior was a businessman who had once owned an interest in thirty-four small newspapers. McBride, Jr., inherited his father's business acumen, but he also pursued an education that would turn him into a journalist. He worked in the newspaper business overseas during World War II, and afterwards, earned a journalism degree from OU. When he moved home to Anadarko to manage the *News*, he started buying paintings in some quantity from local artists. Unlike Cox, however, he displayed the art in his home and office so others could enjoy it too. He also sold art to dealers and was willing to consign to Doris because of her financial situation.

None of these paintings were matted or framed. That became Bob's role in the business and the place where he finally found his calling. Once the art was matted and framed, Doris could sell it for a better profit than the consignment percentage she would have received from the art alone. Given her Anadarko sources, much of the art she obtained on consignment came from Mopope and Tsatoke of Kiowa Six fame. She also sold paintings by Acee Blue Eagle (Creek/Pawnee), Archie Blackowl (Cheyenne), and Woogie Watchetaker (Comanche).

As before, she concentrated her sales efforts in Oklahoma City, where her clientele ranged from secretaries and teachers to doctors and lawyers. To her surprise, she also, inadvertently, made a convert of her father-in-law, Bob Ferguson.

Ferguson first saw the art Doris and Bob were selling while on a Christmas visit to Oklahoma City with his wife. Listening to Doris talk about it and how she had come to sell it, he became so enthralled that he asked her to take him to her uncle's house. There he picked out several paintings, including some Geionetys, but Doris paid for them because, as she explained, "Evert wouldn't sell to anyone but me." Once back in the city, her father-in-law reimbursed her. Then, to her astonishment, Ferguson asked her to keep the paintings and sell them for him. He explained he would pay her a small commission just as her other suppliers did. Although she and Bob were struggling financially at the time, Doris was convinced Ferguson was not just trying to help them financially: "I think my excitement just spilled over to him and got him interested."

He may have been moved, also, by her changing view of her sales work. She was starting to see her efforts as benefiting Native artists as well as a way to supplement her own family income. Given that, up to this point, except for Lewis's jewelry, she still hadn't bought any work directly from the artists, her musings might have sounded patronizing to some, but she always planned to buy from the artists as soon as she had adequate funds to do so.

"I knew better than to ask for consignment when they couldn't afford it," she explained.

By the following year, she had set aside enough money to buy from several different painters.

The next time her in-laws came for a visit, Doris gave Ferguson a tutorial in Indian art. First, they went to the Philbrook and Gilcrease museums in Tulsa; the next day, they drove out to George Geionety's. Ferguson enjoyed meeting the painter, but he was shocked by the poverty he saw on the old Kiowa/Comanche reservation. It reinforced what Doris had told him about the lack of jobs and the economic importance of Native art for Indian families.

Once back home, the Californian wrote Doris that he would like to try selling Native art in San Diego. He started writing letters to Geionety and sending him money for paintings, which Doris would then pick up from the artist, turn over to Bob for framing, and then package and ship to Ferguson for a small fee.

It was now the mid-sixties, and in California, as elsewhere, the federal government's Urban Relocation Program was nearly a decade old. Thousands of rural and reservation Indians had moved into the nation's largest cities on promises of employment and training opportunities. (Celebrated Mvskoke Creek artist Jerome Tiger received help to move from Muskogee, Oklahoma, to Cleveland, Ohio, to attend the Cooper School of Art, albeit just for a year.) Some Native individuals found jobs and a better life in the city. Many others, however, fell through the cracks. The concentration of so many Indians from different tribes in the same poor neighborhoods—and the habit of intertribal affiliation solidified during the boarding-school era—served as fuel for the Native American activism of the sixties and seventies.

The flat-style paintings by Geionety and other Southern Plains artists that Ferguson introduced to his friends in San Diego bore no direct reference to this activism. Yet that didn't mean flat-style art was disconnected from it. Watching television coverage of the occupation of Alcatraz and admiring a painting of a Southern Plains war dancer did not strike Native activists as incongruous. Positive images of Native American culture, in any format, were important tools for these advocates of change. Native art worked in tandem with activists' efforts to offset negative stereotypes of Indians at the same time that they took on failed government policies and broken treaties.

As for Ferguson's clients in San Diego, they likely knew little about Native Americans and their lifeways. Flat-style paintings offered them

a chance to educate themselves. One could hope that the art he showed his clients encouraged them to be more understanding of, if not empathetic to, the call for change from the Native people who had made it.

Artists thrive on visibility, and visibility, in addition to income, was precisely what Doris offered her painters back home. Besides Geionety, other Caddo County artists she bought from at the time were Clara Archilta (Kiowa/Apache/Tonkawa), Doc Tate Nevaquaya (Comanche), and Bobby Hill (Kiowa). Hill had taken his uncle's name White Buffalo as his artist's sobriquet; his mother, Alice Littleman, was a sought-after beader and buckskin dressmaker. Like many other Native artists of World War II, Hill was already artistically inclined when he entered the service, and his drafting work for the U.S. Air Force added to his training. After the war, he secured jobs in technical illustration and commercial art. He also painted movie sets for Hollywood westerns in Los Angeles. When Doris first encountered his paintings at Indian Fair, Hill had just moved back to Oklahoma from California.

Doris would be the first to admit that she personally didn't embrace Hill's realistic approach right away, but she bristled when dealers and collectors told her, "'Don't buy that. That's not traditional Indian art.' I thought to myself, 'Who are we to tell Native artists what to paint?'" If such arrogant thinking shocked her, and recalled Howe's protests to the Philbrook Annual, it was old hat for Native artists. White culture had yet to acknowledge that the first Native painting executed for commercial markets was, in and of itself, new. The flat style developed by the Kiowa Six had never been seen in Oklahoma until they brought it forth. Yet, somehow, a rule of thumb emerged that "tradition" meant pressuring each new generation of painters to do what the generation before had done.

Naturally, most Native artists found such a demand impossible, at odds with their reason for being artists. And because it's what artists do—be they Native or non-Native—they continued to experiment. From the Kiowa Six on, even those painters who were labeled "traditional" selected from this notion of "tradition" those aspects that they liked, retaining certain elements from their predecessors, borrowing elements from other kinds of artists, and adding to the repertoire of Native paintings through their individual styles. Bobby Hill's contribution

to Native art, according to Doris, was to help create more acceptance for landscapes in Native art, on the heels of flat-style painting. He was also a gateway artist. His work sold readily to collectors who had never seen Native art before and were more comfortable with western-style art. "Once Bobby got them interested in Native subject matter, they could go on to appreciate flat-style art," according to Doris.

With nine children to support, Hill had no choice but to paint in volume—and any artist who does that is bound to make mistakes here and there. Once Doris bought a painting that Hill had forgotten to title, and so she suggested one herself. "When I asked him, 'Bobby, what do you think?' he told me, 'Sounds like a white woman named it!'"

Doris wholesaled many of the paintings she bought to gift shops, stores, and museums, which means she bought the paintings from the artists for an agreed upon price and then, like a shopkeeper would an armoire or a couch, she marked that wholesale price up for retail. She paid the artists half of wholesale, a practice known as "keystoning." While not ideal for artists, Doris's keystone payments to Caddo County painters were roughly what they might have made selling to a local rancher or farmer. She was always sensitive when it came to issues of fairness when she keystoned with artists. "They might name a price, but sometimes I set the price higher because I was thinking about its real value," Doris said. At the same time, and without necessarily being conscious of it, she was establishing a baseline price for artists' paintings that would benefit both her business and theirs down the road.

Her monthly and bimonthly visits to artists were important in other ways, besides income. Her willingness to travel to their homes for paintings helped them realize their work was important. And they gained confidence from knowing their work was selling in Oklahoma City to a crowd that had its choice of art in museums and galleries.

Naturally, as a businesswoman, Doris factored travel expenses into her prices, along with matting and framing costs. When she wholesaled art, her profit margin was low. She made up the difference, however, when she sold to individuals. Some of her collectors were newcomers to Oklahoma, but the vast majority were Okies. Indian art had been a kind of scenic backdrop for them all their life, something glimpsed from the corner of their eye, but rarely examined up close. Doris changed

that by taking the work to their homes or offices, where they could spend time with it and absorb and appreciate what they were seeing. As she explained what she knew about the artists and their paintings, the collectors would find themselves interested in seeing more. Each of her sales had a ripple effect. People showed off their newly acquired paintings to family members, friends, employees, or coworkers, some of which, in turn, would contact the dealer and ask if they too could look at her art.

* * * * *

In 1964, Doris's mother, still living in Lawton at the time, was diagnosed with Lou Gehrig's disease. Doris's brother, Bill, wanted to move their mother to Plainview, Texas, so he could oversee her daily care, and Doris agreed. She was still working days in the accounting department of Southwestern Bell and was increasingly frustrated with her schedule. It changed randomly from week to week, and if a coworker failed to show up, she was the one called in to substitute. All this had already made it difficult to schedule art appointments, but now her primary concern was being able to visit her mother. Taking to heart the doctor's warning that her mother might not last a year, Doris left the company where she had worked for decades and found an accounting job with General Motors in Oklahoma City.

There she found the consistent schedule she needed as well as a supervisor who didn't mind her selling art during her lunch hour. She kept her lunch dealing pressure-free: she simply put paintings on top of her desk and if people asked questions, she would answer them. She soon discovered that a few of her coworkers weren't as tolerant as her supervisor of her extracurricular work. "I think they got tired of me and my Indian paintings," she confided.

To help defray travel expenses, Doris sold art on her trips to Plainview to see her mother. The Amarillo Art Center was one of her stops. The center had lots of tourist traffic, but very little Native art, and soon Doris was selling to them regularly.

From the start, her marketing ingenuity knew no bounds, especially when it came to getting the art out to the public. For several years,

she rented a booth at a weekend swap meet in Oklahoma City. She sold paintings at church bazaars and arts and crafts shows. Once she talked the owner of a music store into letting her host an art show and the unusual venue earned her a small feature article in *The Oklahoman*. In the process, she became acquainted with other dealers in Oklahoma City who introduced her to Native artists from the Woodland and Southeastern tribes, such as Jean Bales (Iowa), Acee Blue Eagle (Mvskoke Creek/Pawnee), and Joan Hill (Creek/Cherokee) to name just a few.

One of the first dealers she met and got to know well was Phil Anderson of Anderson's Antiques and Indian Arts. Anderson was a bit compulsive about his furniture purchases. Doris remembers his showroom floor being so crowded with antique tables that the accompanying chairs had to be hung from the ceiling. When it came to Indian art, he was a slightly harder sell, but Doris liked that he was willing to look at newer artists' work as well as established names. One day while visiting the store, she noticed a group of Fred Beaver paintings sitting unframed on top of a table. "I was shocked. All that wonderful work, sitting there unprotected, gathering dust or people's thumbprints on them," Doris recalled. Despite that, she and Anderson soon became friends, and he began asking her to purchase paintings for him on her buying trips to Caddo County.

On one trip, he insisted she and Bob take his black Cadillac to Anadarko instead of their car because they could fit more art in its trunk. When they stopped at the Southern Plains Indian Museum, people started to whisper. A few minutes later, Doris overheard one local comment, "'Look at her in that big Cadillac. We paid for that! Don't deal with her!'" While it hurt her feelings momentarily, Doris also recognized the reason behind it. She understood such feelings of resentment within the Native community in the context of a market where dealers continued to have the upper hand. If the artists she dealt with appreciated her services and knew her to be fair, those who didn't know her couldn't help but be skeptical of her and her intentions.

As she expanded her art-dealing activities to the northeastern part of the state, she began attending shows at the Five Tribes Museum in Muskogee and later at the Cherokee Heritage Center in Tahlequah. She also paid regular visits to Barry's Waffle House in Wewoka, a place

she first came to hear about from other collectors who told her its two owners handled quite a bit of Native art. Doris and Bob drove up one weekend to investigate, expecting to see a restaurant filled with paintings. They didn't see a single one. They decided to eat lunch there, regardless; after ordering, Doris asked the waitress if the owner was on hand.

The woman pointed to a man ringing up people at the cash register. When Doris approached him to ask where his Native art was, he reached down and brought up a pile of paintings from behind the counter. Jim Chaddick and his partner had started acquiring art during the Depression, offering meals in trade plus a small amount of cash to local Native artists. After that, they moved into dealing art and buying paintings, still mostly from area Creek and Seminole artists.

It was Chaddick who introduced Doris to Gary Montgomery (Seminole), an artist who had recently moved to Shawnee after a stint in Dallas, Texas. Montgomery had been born in the town of Seminole, and had played baseball at Murray State Junior College and East Central University in Ada, Oklahoma, where he also took art classes. An admirer of western artist Frank McCarthy, Montgomery's realistically rendered paintings always had a strong emotional base, supported by strong drawing skills. Doris recognized his talent at once and bought several of his paintings from Chaddick, who then put the two in direct contact with each other.

Chaddick would go on to supply her with art by Lee Joshua (Creek/ Seminole) and Danny Kaler (Mvksoke Creek), the latter a graduate of Santa Fe's Institute of American Indian Arts. One year, Chaddick invited her to host a show at the restaurant, something he had never tried himself. "I don't think I sold anything," Doris said, "but it was good exposure because his restaurant drew people from around the state."

One of the most celebrated art dealers that Doris encountered was Nettie Wheeler of Muskogee, owner of Thunderbird's Gifts and Antiques. Doris never purchased more than a couple of paintings from her, and she never got to meet Wheeler's greatest claim to fame, Mvskoke Creek artist Jerome Tiger. Tiger had drawn and painted throughout high school, but his first foray into intentional Native art came after his wife, Peggy Tiger, asked Wheeler "what went into . . . a traditional

Indian painting." Peggy once related in the *Oklahoma Chronicles* that after she told her husband what Nettie had said, he did several paintings based on that formula and sold them to her.

Their meeting was a turning point for the artist, whose meteoric rise to fame ended so cruelly at age twenty-six. Wheeler persuaded Tiger to quit his job at a local Laundromat, so he could devote himself to painting full time. She purchased his work, and entered it in competitions, including the Philbrook Indian Annual, where he won First Place in Painting in 1962. She arranged shows for Tiger in various venues, and paid him to mentor a rebellious Cherokee teenager, who would later become the artist Donald Vann.

After Doris opened her gallery, people would often compare her to Wheeler. But in fact, their managerial styles were completely different. Wheeler dismissed Tiger's desire for additional art training, and was dismayed when he left Muskogee for the Cooper Art School, however briefly. The Muskogee-based dealer also objected to the curator of Philbrook Museum offering Tiger a solo show in 1966. She feared the museum would be "overexposing" his work, which had become extremely popular with collectors. Doris would take a very different tack with artists when she opened her gallery, encouraging them to pursue any training opportunities that came along and believing that multiple venues could only benefit both artists and collectors.

More than a decade after Tiger's accidental handgun death in 1967, Doris began doing business with his widow, Peggy. Peggy and her cousin, Molly Babcock, were determined to continue Tiger's legacy by publishing and marketing prints of his paintings.

They launched their business in 1972, visiting several galleries in Texas where the male owners refused to take them seriously as a sales team because they were women. This negative experience led to an idea. Molly would act as the salesperson for the company, and Peggy would answer the phone on behalf of the owner, "M. Babcock." The M. stood for Molly, of course, but they knew male gallery owners would all assume M. Babcock was a man. After that, the business took off, because in Peggy's words, the gallery owners all thought the company "very modern" to have two women employees, one in sales and one answering the phone who knew "everything there was to know

about Jerome Tiger." For her part, Doris was happy to deal with two businesswomen like herself. She provided a steady sales outlet for their limited prints as well as for the powerful biography Peggy wrote, *War to Peace, Death to Life: The Life and Art of Jerome Tiger.*

"I always felt lucky to work in a business I loved and that loved me."
—Doris Littrell

Gandhi's
Seven Social Sins

Wealth without work.
Pleasure without conscience.
Knowledge without character.
Commerce without morality.
Science without humanity.
Worship without sacrifice.
Politics without principle.

(Dori kept a handwritten copy
of this, written on the back of a 2006
gallery invite postcard in her desk.)

Chapter 7

State Fairs & Festivals

T HE WORK THAT DORIS HANDLED as a dealer in the 1960s continued to increase in diversity and in its representation of more of Oklahoma's Native peoples. This called for bigger venues like the Oklahoma State Fair, held annually in Oklahoma City. Each September, for many years, the north side of the capital city's fairgrounds was set aside for the Cottonwood Post, a showcase of Native dance, foods, and arts and crafts.

Arts and crafts booths in the Cottonwood Post were available to both dealers and artists, but dealers predominated because fair organizers required payment six months in advance. Once again, dealers had the advantage because as Doris explains, "Most artists couldn't come up with that kind of money so far ahead."

She applied for her first booth in 1968, listing the name of her business as "Oklahoma Indian Art"—the first time she remembers using that name. Besides showing art she already owned, she encouraged artists she bought from to bring paintings to sell for themselves. That would help them, she reasoned, because they could keep all the proceeds; it would also help her to have artists present in her booth to visit with fair-goers.

Artists from Apache, Lawton, or Carnegie rarely took Doris up on her offer, because traveling back and forth was too expensive, but Truman Lorentz, a Ponca painter who already lived in Oklahoma City, came out to the booth as did the Comanche artist and champion fancy dancer Woogie Watchetaker, who was also at the fair as a dance troupe leader. When Doris discovered fair organizers weren't providing food for Woogie and his fellow Native dancers, she took it upon herself to start bringing soups and stews to them.

That year the person who proved the biggest draw at Doris's booth was Virginia Stroud, the reigning Miss Cherokee and a gifted artist in her own right. A painter, Stroud had recently graduated from Bacone's art program, and while Doris can't recall if Stroud actually had any paintings in the booth, each time the artist dropped in to help, "people just swarmed around her." Partly it was her warm smile and, of course, her title, but those in the know also noticed something different about her dress. At a time when many Woodlands and Southeastern tribal princesses wore an intertribal style of dress, heavily influenced by Plains Indians, a group of Cherokee women had decided to design something specifically Cherokee for Stroud's inauguration as that year's princess. They took for their inspiration an 1870s tear dress, so called because in early times, Cherokee seamstresses had to tear their material for lack of scissors. Prior to Stroud's inauguration, the tear dress had not been seen in public for a hundred years; today it is considered official traditional dress for Cherokee women.

Selling at the Cottonwood Post was always a marathon for Doris, due to the fair's two-week run. At the time, she was still working at GM, which meant Bob had to cover the booth by himself during the week. The fair ended up not being a particularly great venue for the art, either. It drew more "looky-loos," said Doris, than buyers, but she always made a few important contacts and usually sold enough art to come out in the black.

Business was better at the Spring Arts Festival in April, which drew art lovers from across the state and featured all genres of art, including Native art. By then, Bob was no longer limiting himself to matting and framing but had begun to buy and sell art to his own clients financing his endeavor with his own money. Unlike Doris, however, he hadn't

focused much on paintings. He preferred handling rugs, jewelry, and pottery, the staples from back when he and Doris first began collecting. That changed, however, when the couple met Robert Redbird, which, to the best of Doris's recollection, happened sometime in the mid-1960s. Artists abounded on both sides of the Redbird family: George Geionety was one of his uncles and the Kiowa Six painter Monroe Tsatoke was his maternal grandfather. Redbird's father had abandoned him as a child because he suffered from epilepsy, and his paternal grandparents had taken him in. He went on to attend Fort Still and joined an art club in his teens, where he made friends with other artists, most notably Doc Tate Nevaquaya (Comanche), David Williams (Kiowa), and Oscar Howe. But Redbird continued to be stigmatized for his condition, and it wasn't until he met his wife, Joquita, that he came to believe marrying and having a family was possible for him. Possibly as a result of these trials, he worked hard to create a "boss is in the house" kind of presence, which combined with his naturally booming voice, could make him seem overbearing at times.

As Doris tells that first meeting, she and Bob were sitting inside their exhibitor tent when a brown hand lifted up the flap closest to them. Before they could even see the face that went with it—a male voice challenged loudly, "And who are you?" Doris recoiled. She was certain Redbird was challenging their right to sell at the show. Native artists had begun booking their own booths at the Festival and quite naturally, voicing strong objections to the presence of such intermediary sellers as art dealers. Her fears were unfounded. Redbird just didn't have a booth, and he'd been wandering the festival, hoping to find a way to sell his paintings through less official channels. He couldn't have been happier to stumble across two dealers who specialized in Native art, as he later explained:

> *I went over [to Bob McCabe] and asked him, "Do you all buy Indian artwork?" and he said, "Yes, we buy Indian artwork. Who are you?"*

> *I told him, "My name is Robert Redbird and I'm an artist," and he said, "Well Mr. Redbird, let me see what you got."*

I ran all the way back to my car, which was several blocks away, and got my paintings. And he started looking at them. "Say, these are just as good as what I got here. You selling these?"

I said, "Yes, sir."

"What do you want for all of them?"

I said, "I don't know. Whatever you feel like you want to give me for them. If you want to buy them, I'll sell them to you."

He gave me three hundred dollars. Now, (for) a young, twenty-year-old kid in them days, three hundred dollars was a lot of money. That was a power boost in my life.

He said, "You go home, and you paint me some more, and you bring me some more artwork and don't stop until I tell you to."

Although Doris admired Redbird's art, their personalities were so different she tried to keep her business transactions with him to a minimum. From the beginning, he was Bob's artist, and the two became so close that Redbird took Bob as his adopted father, looking to him for guidance and advice, as well as income.

For her part, Doris was feeling more and more distant from Bob, having denied her own gut instincts too long, trying to maintain their marriage. After her daughters graduated high school, she discovered that their relationship with their father had caused them to suffer as well. This added to her remorse and feelings of guilt. She coped the only way she knew how: by picking up the pace and volume of her art dealing. That's how she ended up at the Oklahoma Arts Center around 1968.

"Doris was a blessing to all the Indian artists in Oklahoma. She was responsible for a lot of people having a biscuit on the table and something to eat." —Bert Seabourn

Chapter 8
Opening the Doors

THE OKLAHOMA ARTS CENTER had moved from downtown Oklahoma City to Fair Park, as it was then called, adjacent to the state fairgrounds in 1967. It consisted of three semi-independent units: a non-profit museum focusing on twentieth-century American painting; a for-profit bookstore that leased space in the building; and the for-profit Sales and Rental Gallery. The gallery was owned by Imogene Mugg, who had a business arrangement with the center that allowed her to buy and sell art independently. However, in the case of special shows, she and the OAC each shared a percentage of the profits.

In the fall of 1968, the OAC museum hosted a touring exhibition of Native painters from the Southern Plains Indian Museum in Anadarko. Doris caught Native art shows whenever she could. She was especially interested in this one as it featured several artists she handled, as well as work by Kiowa/Caddo artist T. C. Cannon, a recent graduate of the Institute of American Indian Arts in Santa Fe. Cannon's name would become synonymous with IAIA and a movement of modernist Indian art.

After the exhibit, Doris wandered into the center's Sales and Rental Gallery. Most of the work on display was by Jack Vallee, Imogene

Mugg's brother. Vallee was a popular artist from Oklahoma whose suggestive realism had earned him a national reputation. There were paintings by other artists as well, but no Native art that she could discern. When Doris asked the clerk about this—Imogene was gone that day—she was told the gallery focused on local and regional artists, the implication being that Native artists did not fall in that category.

As its name suggested, besides displaying art for purchase, the Sales and Rental Gallery leased art for periods of a week to six months. In Doris's view, the lack of Indian art for sale was one problem, but the absence of Indian art for lease was another. This was a missed opportunity to introduce businesses and individuals to the art that both made Oklahoma unique and that was as good as anything being done in the world.

Determined to correct the situation, she returned to the S&R Gallery with a portfolio full of Native paintings. One, by Comanche artist Rance Hood, was so big she couldn't zip her carrier shut. As she struggled to keep the rest of the art from falling out of the carrier, she failed to make the poised and organized entrance she had planned.

She passed through the bookstore first, and not seeing anyone, asked for the gallery owner. The woman in the bookstore called Imogene in her office and a few minutes later, Mugg materialized. Doris explained she wasn't trying to sell her something: she simply hoped to persuade her to accept some work on consignment. Mugg wasn't interested. "I didn't know it at the time, but she didn't do *new* very well," quipped Doris.

Fortunately, the bookstore owner interjected, "Imogene, either you take a look at them or I will." With that the gallery owner reluctantly invited Doris back to her office where she thumbed through the works silently, one by one. Then, without a change of expression, she announced she would take them all. A month later, Doris received a check for several pieces that had sold. Thirty days later, she got another check with a thank-you note. In July, Mugg called Doris at home. "We don't have a show here in August. It's too hot. No one will come. Would you like it?" she asked.

When Doris said she would, Mugg explained that any profit she made would have to be split with the gallery and museum. That was fine with Doris, who couldn't have been more excited about having

her first show right next to a museum. The forty originals she gathered represented artists she had handled for years such as Bobby Hill, George Geionety, Woogie Watchetaker, and Doc Tate Nevaquaya. It also included artists who were younger or still relatively new to her: Jean Bales, Ben Harjo (Shawnee/Seminole), Gary Montgomery, Robert Redbird, Bert Seabourn, and Virginia Stroud. Mugg used the OAC mailing list to send out invitations, describing the show as a "sales exhibit of Oklahoma Indian Art." There was no reception. The only media coverage was a one-line mention in the city newspaper's calendar of events.

Opening turnout was small. Most attendees were members of the Oklahoma Arts Center, but they were also the most important group for Doris to impress. Soon after the opening, perhaps the first weekend of the show's run, a young Indian man with wavy black hair and sunglasses appeared in the gallery. Fortunately, Doris was there, for no one else recognized him. It was T. C. Cannon, come to view the exhibit.

Cannon (who, like Jerome Tiger, died young and tragically at the age of thirty-two in a car accident outside Santa Fe) was not famous yet, but his work was selling readily in Santa Fe. For that reason, Doris knew better than to ask him to submit something to her show. Still, her instincts about his importance as an artist led her to ask if he might "want to add a photograph or paragraph on his work." Apparently, he already knew his place in history. He told her that he "was an important artist and had no interest in doing that."

By the end of the show at OAC, three-quarters of the paintings had sold, and Doris, Mugg, and the Arts Center had all made a bit of money. After the highs of a show, however, there is always a low, and for Doris, that low was extremely personal. She told Bob she was filing for divorce. As she had anticipated, he didn't object, and she began to make the necessary arrangements. She helped him apply for his own separate business license, and she continued paying him to mat and frame art. Eventually, the wounds from her marriage would heal, but at this point, their only neutral ground was Native art. "We couldn't live together, but we could still be in business with each other," she figured.

After the success of Doris's show, Mugg confided that she would like to try a Native art show herself, one with the artists in attendance.

The problem was she didn't know how to get in touch with any of them. She feared that even if she did, they might dismiss her invitation because they didn't know her. Doris offered to share her list of contacts and also talk to the artists on Mugg's behalf. Then Imogene raised another issue, that of consignment. The artists must understand she could not afford to purchase work outright. Doris smiled and nodded: the store owner would have to figure that out herself.

Back home, Doris excitedly got on the phone, contacting Doc Tate and Virginia Stroud first. She told them about Mugg's plans and urged them to introduce themselves to her. Naturally, both arrived with paintings to sell, and Mugg was smart enough to realize a "no buying" policy would not earn her any goodwill with these artists. Over the fall, she began to acquire an inventory of Native paintings in spite of herself. The S&R Gallery had become a new sales point for Native artists. Her gallery added quite a bit of inventory in the months leading up to the show—this time scheduled for July—but she continued to remind the artists that consignment would put more money in their pockets.

Mugg's first show at the Sales and Rental Gallery was billed as an Exposition of Oklahoma Indian Art, and she leveraged all her connections at the OAC to publicize it. Although the gallery was for profit, its location in the Arts Center, and her profit-sharing arrangement with the museum, gave the event a nonprofit mantle. Free public service announcements aired on radio and television and *The Oklahoman* ran a feature on the event. The affable and well-spoken Doc Tate was the spokesperson for the show, and his ability to play Native flute (in 1990 he would perform at Carnegie Hall in New York City), an art he had recently revived for the Comanche, added greatly to his media cachet.

Doris volunteered to help hang the show, never suspecting what a painstaking process it would be. She was ordered to measure the length and width of each painting to ensure the spacing of the art around the room was consistent. She also had to measure the distance from the floor to the painting's hanging wire because Mugg wanted everything exactly eye level, no guessing. Doris agreed the end result was impressive, and she returned as a volunteer for opening night.

It was the first fine art reception she had ever witnessed and as such, it was a revelation. Watching artists mingle with collectors and

talk about their work enhanced the experience for everyone. The best moment came at the end of the evening, when Mugg sat down to write checks to the artists. Those who had brought paintings on consignment received 70 percent of their purchase price. For many, it was their first experience with consignment, and an important educational step forward in their career, according to Doris.

The invitational All-Oklahoma Indian Artists Exhibition would become one of Oklahoma City's most popular and well-known art events, running from 1970 to 1981. It was the first large-scale Native art show in central Oklahoma where painters could sell important work for a decent price, and Doris was there each and every year to help prepare and hang the show. She was also charged with keeping a scrapbook on it.

Gary Montgomery's images appeared on several of the show invitations and advertisements, but Doc Tate continued to be the official media spokesman. One year, a reporter plaintively asked if Mugg couldn't send someone else for a change. "Doc is the only Indian artist I know who will show up and be there on time," she snapped.

It was clear from the show's beginnings that the number of Native artists and the range of their styles were expanding rapidly. In 1976, a reviewer for *The Oklahoman* noted an abundance of abstract work. He called this evidence of "Indian liberation in the making" and attributed it to Native artists increasingly studying art under Native American teachers. As the show grew in popularity, the paper trumpeted its attendance in the same enthusiastic tone as its art offerings. One city reporter gushed, "Few other shows can match its quality or rush of sales. On opening day that year, Mugg counted 850 patrons and the first week lured 1,043 more. Sixty-two paintings, lithographs, etchings, and silk screens were sold in the first seven days." Perhaps the only other Native art show with similar sales and attendance was the by then quarter-century old Philbrook Indian Annual.

An 18 percent jump in Oklahoma City's population during this time helped fuel the high turnout at the show. Even as other parts of the country experienced a recession, Oklahoma City's energy-based business scene was flourishing. New residents poured into the area; among them, military personnel at Tinker Air Force Base, which at its

height employed 30,000 workers. The price of oil tripled during this period. More people had more money to spend, and a good many of them, corporations and individuals alike, were spending it on Indian art. Corporations began to compete with each other to acquire Native art collections. After being on the cultural sidelines for years, Native art suddenly found itself center stage.

Ironically, as interest surged, Mugg never acknowledged Doris's starter shows or thanked her for eight years of volunteer service on behalf of the show. Only once did she introduce her to a reporter, referring to her as her sales assistant. She told one writer that she got the idea for the show because "so many visitors to Oklahoma would come in saying, 'you don't have any Indian art.'" The slight didn't bother Doris, who exulted, "That show gave me and the artists more exposure than anything we'd ever done."

"I think I've always had a kind of teaching gene in me."
—Doris Littrell

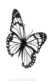

Chapter 9
Hitting the Road

ALTHOUGH SHE DID her best to keep her personal and business life separate, word eventually got out among the artists that Doris and Bob were divorced. One painter suggested she date him, citing as proof of their compatibility the fact that he wore his long-sleeved white shirts ironed and starched.

Doris, however, did her best to avoid romantic entanglements, especially at work. When not selling art herself or working at GM, she spent her free time hanging out at the Sales and Rental Gallery. That's where she found herself one day when Mel Littrell showed up with a briefcase full of Navajo jewelry. "I had just been saying to Imogene, I'd never marry again and in walks this handsome Cherokee man," Doris said, laughing.

Mel was no stranger to her. She had run across him at the Cottonwood Post, among other places, throughout the years, but she was more familiar with his brother, Art, who lived in Winslow, Arizona, and regularly sold jewelry to her and Bob. When Art called on the couple, they would all adjourn to the guest bedroom. Doris would sit on one twin bed; Bob, on another, as Art laid out his jewelry on the dresser. "He would pick up a piece, and I'd call it and put it on my

bed," Doris explained. "Then he'd pick up another, and Bob would call it. We never chose the same thing."

Mel had also visited the couple once, but she barely remembered anything from that encounter. Now she found him to be charming. He was a natural salesperson, bantering with Imogene as he showed his wares, but clearly noticing Doris. As they fell into conversation, he told her he was also divorced, and soon the two began dating and traveling together. "Partly, it was a chance to get to know him better," Doris said, "but I also wanted to see if I could do this art business full time."

Although her day job with General Motors still restricted her travel to weekends and vacations, Doris was able to cover new sales territory with Mel, especially back East. His taste in jewelry was not as exacting as hers, and he didn't always sell top-of-the-line items. However, between his jewelry and her paintings, they rarely struck out completely.

While traveling with Mel, Doris made connections with stores and galleries in Tennessee and New Jersey, but her most important sales contacts were made in the West. She visited museums, gift shops, trading posts, and galleries that regularly purchased art by Southwestern Indian artists, but were relatively unfamiliar with Oklahoma Native art. If a merchant declined to buy, she would offer to leave paintings on consignment. "You had to be willing to work on a very small percentage, but that got the art out," she noted.

Since it cost them nothing up front, retailers, especially gallery owners, welcomed her sales calls. She took pride in connecting the painters she handled with other galleries where they could meet new clientele and expand their own sales range. The Nadler Gallery in Scottsdale, Arizona, sold so many of the Bert Seabourn paintings Doris provided, the owners asked her help in hosting a solo show for him. At that point, she put the artist in contact with the owners, so they could do business without her, then made a point of returning to the gallery for Seabourn's opening.

One lesson she learned while traveling was to stock up on inventory. It was better to come back with leftover art than run short during a trip. One time she stopped by Ben Harjo's apartment when Harjo, who had attended IAIA and Oklahoma State University, was just finishing up thirty-five intaglios. "They were hanging on a clothesline, drying, in

the middle of his apartment and I bought the whole series," she said. Bert Seabourn's wife, Bonnie, recalled that Doris would often purchase twenty to fifty paintings from her husband prior to a trip. "Some dealers only wanted to buy names, not Doris. If she liked the work and thought she could sell it, she bought it," said Bonnie.

As she deepened her relationship with the artists she carried, Doris began submitting their art in competitive shows. While the rules are different today, at that time, neither the Scottsdale National Indian Arts Exhibition nor Gallup Intertribal Ceremonial required artists to deliver work in person. Other people could enter paintings for them, so long as they had written permission. Robert Annesley (Cherokee), Joan Brown, Bobby Hill, Gary Montgomery, and Harvey Pratt (Cheyenne) were just a few of the artists whose work Doris put into juried shows. They paid her a 20 percent commission for the service, and she noted with pride, "Over all those years, no one ever failed to pay me." She would also submit art from her own inventory in competitions on such occasions when the painters themselves didn't have anything ready. In those instances, the profits from the sale were hers, but she always sent the prize money and ribbons to the artist.

In 1975, while traveling with Mel, Doris entered a painting for Gary Montgomery at the Scottsdale National. People saw the realistic style, read the last name on the painting, and assumed he was an Anglo artist who had sneaked into the show. The buzz grew even louder when his entry won First Place in Painting. "All around us, they were whispering, 'Who is this Gary Montgomery?'" Doris said, smiling at the memory.

Her instincts for what would sell and what would win were almost unerring. That only added fuel to the fire one year when she ran afoul of Tom Woodard at the Gallup Intertribal Ceremonial. Woodard was a third-generation Gallup trader who had bought a number of Oklahoma Indian paintings from Doris. In Native circles, however, he was known, less favorably, for wining and dining Indian artists to get a better price from them. That year, when Doris arrived at the sales room in Gallup, she was told by the show volunteer that her paintings had to be framed to be accepted. Woodard, who was standing nearby, had just entered a stack of unframed art. When Doris pointed out the double

standard, the trader lost his temper. "He told me he would never buy from me again. And he didn't."

For artists who lacked the time or resources to enter shows themselves, Littrell's trips out West were a godsend. As Gary Montgomery observed, "I didn't even have to go and I won something!" The payoff was more ribbons and cash awards, all quite welcome. The visibility Oklahoma Native artists gained from these shows gave them a national profile while simultaneously raising regional demand for their work.

The old trope that prophets are never recognized in their own countries was a paradox that Doris had recognized for years. "After the artists won a few out-of-state prizes, collectors here began to take their art more seriously," she noted.

"Doris got me into a lot of shows. She got me into Philbrook, and I think, back then, Gilcrease [Museum]. I painted in oils and the first couple tries, Gilcrease wouldn't even look at my work because I didn't do flat work." —Gary Montgomery

Despite her vow to stay single, Doris married Mel Littrell and took his last name. Based on their similar interests, the relationship should have worked. He was Cherokee from Oklahoma, and he loved the business aspect of art, seeing new places, meeting new people, and feeling the rush of adrenalin that came with the sell. But he was also secretive, making animated phone calls from pay phones when they were on the road and refusing to tell her, afterwards, who, exactly, he'd called. Much of the time that she worked at GM, he traveled on his own, and suspicions about his faithfulness began to creep into her thoughts.

In Oklahoma City, when the couple threw dinner parties at Doris's house, their guests were mostly painters and Doris's women friends. A frequently served dish at those dinners was a Green Chili Stew that Mel said he had learned how to make from his Hispanic first wife. He guarded his recipe jealously, though Doris was privy to it, since she usually found herself cooking in the kitchen when he made it. After dinner, while Doris cleared the table, Mel would enthrone himself in an easy chair in the living room, light a cigar, and bask in their company's compliments on his stew.

Doris had no idea how much her new husband needed to be the center of attention until the two of them made a business trip to Santa Fe. At one stop, she made several transactions, but Mel didn't sell a single ring or bracelet. She could tell he was seething as he started the car, and within a few minutes, he swerved abruptly to the curb. "They wouldn't even look at my jewelry. It's always about you and your paintings," he yelled as he got out. Then he opened the door to the backseat and began to dump her paintings onto the sidewalk.

Doris was shocked. As she stepped out of the car to retrieve the paintings, a few passersby stopped to help her. Others watched disapprovingly from their shop doors and windows, shaking their heads at Mel's temper tantrum. Finally, he calmed down, and Doris was able to get her things back in the car, but by the time he drove off, she was shaken to the core. "He couldn't understand why I was so upset," she said. "I cried all the way back to Oklahoma because that's when I knew it was over."

Upon arriving home, she informed Mel that they would have to live separately for a while. She hoped that by setting a boundary in this way, he would be persuaded to examine his behavior. Instead, he disappeared completely from sight, and did not resurface again for several years. Later, she learned he had been involved in a number of shady business transactions and had even done some jail time.

Given that he had vanished, Doris felt no pressure to initiate a divorce; as for changing her surname once again, it was more than she could contemplate. Still, her relationship with the jewelry dealer had at least made one thing clear: She could indeed make a full-time living selling art, if she chose to do so.

"You can be the best at anything and there's going to be two people walk up that don't like it, don't care about it, don't want to see it. So percentage-wise, if you get three or four out of ten, you're doing alright." —Bill Rabbit

Chapter 10
Native Art Programs

THE ALLURE OF NATIVE ART had created a bumper crop of Native art students, among them former Vietnam veterans, who drew upon their GI benefits to pursue careers in art. Native students enrolled in art programs in a variety of institutions: in public colleges and universities, as well as junior colleges and even technical schools offering commercial art. Two schools, however, stood out because of their specific focus on Native art: the Institute of American Indian Arts in Santa Fe and Bacone College in Muskogee.

There were any number of reasons why mostly first-generation, college-age Indian students found art attractive. One was the cottage industry notion that regardless of where they chose to settle, they would be able to support themselves with their art. It would keep them from being at the mercy of a business or corporation that could lay them off; they would be, in effect, their own managers and bosses.

Another was the promise of social mobility. As the one minority group at the bottom of every socio-economic indicator, be it income, education, or projected life span, American Indian young people were looking to escape poverty and share in the material prosperity that their non-Indian neighbors seemed to take for granted.

Of course, college itself was supposed to facilitate that move; and other professions, besides art, extended the same promise of a change in social and economic position. But in choosing Native art, young people who were already artistically inclined seemed to get an extra set of perks. They did not have to temporarily set aside their cultural identity to conform to mainstream norms. They could dwell there every minute that they worked on their art; in Native art, the reference to "living one's art" acquired a whole new layer of meaning. They could do so, moreover, while engaging in an occupation that conveyed a position of status within their own tribal nations.

The Institute of American Indian Arts opened at the Santa Fe Indian School in 1962, partly as a result of the success of the Southwest Indian Art Project. The workshops conducted by SIAP were intended to help students "develop an individual creative consciousness" and to grow their talents "without the loss of pride" in being Indian. They were also designed to expose students to "world art traditions" and "a more thorough knowledge of Indian traditions" of art, along with the fundamentals of design. These ideas became the basis for the curriculum at the IAIA, which upon its opening, took high school students as well as high school graduates, seeking an associate's degree.

As many scholars have noted, both the Southwest Indian Art Project and the IAIA curriculum were driven largely by outside forces. The insistence of non-Indians on preparing Native artists for "the commercial and aesthetic demands of modern society" completely ducked the benefits that might come from challenging those demands. Even so, the classes were predominantly taught by Native teachers, who did so in their own manner and with their own priorities. The study of world art as well as a range of Native art forms clearly spoke to students of the day. While Indian students from Oklahoma were always a minority at the school, they were a minority whose artistic influence far exceeded their numbers.

At the other end of the spectrum was Bacone College, with an art program that was only one of its many educational offerings. Founded in 1880 in Tahlequah by Alma Bacone, a Baptist minister and former teacher at the Cherokee Male Seminary, it was relocated a year later to a one-hundred and sixty-acre tract of land near Muskogee, granted to

Bacone by the Creek National Council. Originally known as Indian University, it was both a college and a boarding school that offered primary, preparatory, and university courses.

Native Americans played key roles in the launching and administration of Bacone's art program, within Baptist mission parameters, of course. The first among those was Chickasaw performer and teacher, Mary Stone McClendon, best known by her stage name, Ataloa, or "Little Song." An English teacher at Bacone who saw a need for an art and music center at the school, she began raising funds for that purpose, and in 1932, the Ataloa Lodge opened on campus, designed by McClendon to resemble a hunting lodge. Offerings included classes in weaving, painting, and silverwork among other media. The point was not simply to give Native students on campus a creative outlet but to train them to start cottage industries in the Indian arts.

At a time when most examples of tribal arts were held by far-away museums, McClendon solicited donations of pottery, basketry, weaving, and beadwork for the center. She wanted Native students to discover the objects made by their ancestors in real time, not through photographs or book illustrations. The idea was that by holding and examining them students could figure out the techniques their ancestors had employed to make them.

Bacone's formal art program began in 1935 with the hiring of the painter Acee Blue Eagle, who was succeeded a few years later by Woody Crumbo. Other outstanding artists soon followed as students; Mvskoke Creek artists Solomon McCombs and Fred Beaver, who also worked for the Bureau of Indian Affairs. After Crumbo left Bacone, Cheyenne artist Dick West, himself a graduate of Bacone, took over, assisted by Choctaw/Chickasaw artist and painter Terry Saul. Even at its height, however, the art program never received the kind of funding directed to IAIA as an experimental art school. Yet for several decades, it produced an impressive roster of graduates, preponderantly from Oklahoma, who went on to distinguished art careers.

Despite the association of Bacone with the flat-style and narrative subject matter, its teachers encouraged their students to find and develop their own artistic voices. The strongest emphasis at Bacone was not on either style nor subject matter but rather tribal research. Both

Saul and West insisted their students do research with people, and not just books. Consultations with elders and those who had a substantial knowledge of their tribal ways were considered part of the preparatory work of painting. Joan Hill recounts that despite her family's prominence in Creek history, she never contemplated doing Indian art until Dick West began to nag her. "When I told him, I wasn't brought up on a reservation, he told me, 'Well, you can do research.' 'I do research,'" she told him. As a result of his urging, she asked her parents to take her to one of the Creek ceremonial grounds. She asked if she could take photographs, explaining she was not going to publish them but rather use them in her paintings, and because one of the men knew her father, permission was granted. Later, she was allowed to take photographs for her paintings at the (Cherokee) Redbird Smith stomp grounds.

Graduates of Bacone, particularly women, noted over and over in their interviews the encouragement they received from their artist/ teachers Saul and West. Joan Brown was in her mid-twenties, selling paintings at booth shows, when she first met "Chief Saul," as he was affectionately called. After admiring her work, he asked why she wasn't in school and urged her to enroll in Bacone's art program. A few months later, having saved some money from her job, she showed up to enroll in a single art class and was standing in the admissions line when Saul happened to pass by. He recognized her, pulled her out of line, walked her to the president's office, and announced, "This is Joan Brown. She has talent and has no money." A few minutes later, Brown was filling out admission papers. She left the president's office with a full scholarship.

Naturally anxious to show her gratitude, Brown enrolled in Saul's painting class where her first impulse was to copy his painting style. Referring to the work he had seen in her booth, he scolded, "You have a style started. That's hard to develop. Don't go away from that." Because of his encouragement, she went on to perfect her domestic watercolor scenes of 1940s and 1950s Creek and Cherokee women. Saul also pushed her to enter competitive art shows. When she showed up at the Five Tribes Museum one year, the woman taking entries said, "Oh, yes. Terry Saul's been telling me about you." The judge for the show, who gave Brown third place, was another former Bacone teacher, Woody Crumbo.

The artists Joan Hill, Jeanne Rorex (Cherokee descent), and Sharron Ahtone-Harjo (Kiowa) all recall similar positive experiences from studying with Dick West. Native art scholar Jeanne Snodgrass King has said that West brought out more talents and helped establish more careers than anyone else. Jeanne Rorex noted, "Sometimes you would get down on yourself. You didn't think you were doing good enough. He'd encourage you to do what you needed to do. When I did work for him, I felt like I did works of art." Joan Hill recalled that Dick West was constantly referring her for teaching jobs, including one as painting instructor at IAIA. West also thought highly of Sharron Ahtone-Harjo, giving her an entire set of paintbrushes before she graduated, saying, "You can do this. You have a career waiting for you."

Years later, after West's retirement, Ahtone-Harjo caught up with him during one of his visits to Oklahoma. She presented him with one of her paintbrushes this time, but what he most appreciated was the beadwork she had done on the handle. "He couldn't stop saying 'thank you,' but I was the one saying thanks because of what he did for me," she said.

> *"My second grade teacher at Fort Cobb, Ms. Byrd, said, 'All of you Indian kids can draw.' I figured if I'm going to wear the mantle, I better wear it well. I wished she'd said, 'cook.'"*
> —Richard Aitson

Chapter 11
Marketing from the Artist's Side

UNFORTUNATELY, THE artists' emphasis on research and getting details historically correct didn't always find support in the markets. In the 1970s, despite the pioneering work of Cecil Dick (Cherokee), McCombs, and Beaver, Southeastern Indian artists who took paintings of their own tribes to art shows often found they didn't sell. As Doris had discovered with Bobby Hill, the public tended to embrace what it was used to, and what it was used to was Plains imagery, also a favorite subject of non-Indian artists. The romantic images of Plains Indians that circulated in magazines and art books, many promulgated by western artists, couldn't help but impact Native artists, just as it had everyone else.

Some were genuinely drawn to the visual drama offered by horse raids, tipis, and buffalo hunts. Others simply saw dollar signs. When Southeastern artists picked up Plains subjects, the Plains painters often grumbled that they got it wrong, although it was hard to tell where research stopped and artistic license began. As Spencer Asah once complained in a newspaper interview, "Indians didn't wear war bonnets when they hunted buffalo, yet many of our modern boys are painting that way." He was realistic about how the market worked,

adding, "I can't criticize them too much if they make money doing it."

Perhaps the least attractive aspect of Native art markets was the power they gave the public to influence subject matter or styles, simply by virtue of what people bought. Dick West was only one of several Native artists that enjoyed working in an abstract style as well as the flat-style he was known for at the time. Yet much like a Hollywood star, who is typecast after his first few roles, West never found acceptance for his abstract works. After he left Bacone to become dean of liberal arts at Haskell Indian University in Lawrence, Kansas, West shared his disenchantment with fellow Cheyenne Edgar Heap of Birds. Heap of Birds was a painting major at the University of Kansas in Lawrence and had not yet adopted a strong political stance in his work. When the subject of Native art came up, he recalled that West had once told him Native artists should take "the white man's expectation and feed it back to them and make them eat it." Hearing this from someone he considered an elder statesman of Indian art, gave Heap of Birds another reason to take a different tack with his own art when he graduated.

For most young Native artists, earning an art degree was the easy part. The real challenge was getting their art before the public. And where better to catch the American public's attention than at shopping malls? Non-Indian art shows had been organized at malls for several years by various art guilds in Oklahoma City, and in the late 1960s and '70s a number of Native art shows began to follow suit. One of the best known was the Shepherd Mall Indian Trade Fair, which, according to artist Rance Hood, initially was held outdoors. Space was on a first-come, first-serve basis. Artists could show up the same day, throw a blanket over a table, and sell their work for a modest fee. They could also luck out and not have to pay a fee at all, as Woogie Watchetaker did one year. As Watchetaker once shared with a reporter, he arrived at the show just as another artist left, put his work in the booth, and sold all his paintings in thirty minutes.

At mall shows newly emerging painters could set up side by side with such established artists as Rance Hood and Fred Beaver. According to Seabourn, the better-known painters had prices from fifty to seventy dollars on their canvases, whereas he was "lucky to make two dollars a day—enough to buy a couple of hamburgers" on the way home.

Some shows also had a juried component and gave cash awards as well as trophies. The shows were competitive enough that Native artists often listed such awards on their resumes. Doris secured a booth at Shepherd Mall as a dealer early in the show's evolution, but the following year, organizers told her the show would henceforth be for artists only. She had seen this coming and acknowledged the rightness of it. At the same time, her involvement with Native art had become, in many ways, her reason for waking up each morning. She began to think about her future in Native art, and how she might continue her work without harming the financial interests of the art makers. The answer didn't come right away.

Defying stereotypes of artists as poor businesspeople, Native American artists in the 1960s and '70s were endlessly inventive at marketing. Cheyenne/Arapaho sculptor Charlie Pratt tells about walking into a store in Oklahoma City (probably Anderson's Antiques and Indian Arts) with a dozen paintings to sell. The store's owner turned him down, but as Pratt was leaving, he spotted a Crumbo silkscreen on the wall. He offered to trade all twelve of his paintings for the silk screen. The owner agreed. Pratt truly admired Crumbo's work, but as a starving artist, acquiring paintings by other Indian artists was a low priority for him. His goal was to get his foot in the door with the gallery, and it worked. When he returned a few weeks later, all twelve of his paintings had sold, and the owner was anxious to buy more.

Once Pratt shifted his focus from painting to sculpture and hit his stride, he started a small foundry in Oklahoma City. He also opened a store in southwest OKC, where he faced the problem of how to display his work, particularly the large pieces. Rather than spend his money on print advertising, for several summers in a row, he rented a circus tent near Penn Square. He invited other Native artists to show with him; the booth fees they paid helped offset the cost of the tent rental.

Painter and sculptor Enoch Kelly Haney (Seminole/Creek) was perhaps the most successful artist/businessman of his day. One of nineteen Native artists selected for Rockefeller funding and the Southwest Indian Art Project, he later acquired a background in economic development. He opened his own gallery, the American Indian Arts Collection in Shawnee, Oklahoma, two years before he won a seat in the

state's legislature (to date, the only full-blood American Indian to serve there). When a state art committee solicited proposals for a sculpture of a Native American to be placed on the Oklahoma capitol dome, Haney first wrote the state's ethics committee to see if he was qualified to compete. After being informed that the monies for the sculpture would come from private funds, he drew a sketch for *The Guardian*, a twenty-two-foot-tall bronze, selected blind by a panel of judges that now graces the dome. Haney handled other artists' originals in his gallery as well as his own, and his art shows sometimes included competitions. He also produced limited prints of his work and others' and wholesaled prints to retailers and art dealers.

Perhaps the most colorful marketing stratagem for Oklahoma Native art came from Kiowa artist Woody Big Bow, who studied art at OU, before working on the East and West coasts. He once told Doris he traded his car every year for the latest showroom model because "artists should appear prosperous, and not like they needed a sale." It wasn't just any car, either. It was a Lincoln Continental, and although Big Bow may have traded some art for the car—many artists did—he undoubtedly also had some monthly payments that may have added to his financial pressures.

During World War II, Big Bow had been asked to design the yellow-and-red Thunderbird insignia for Oklahoma's celebrated 45th Infantry. Big Bow chose the Thunderbird as the symbol best able to defeat the power of the swastika. Historically, before its perversion by the Nazi regime, the swastika had been used by numerous ancient cultures around the globe, including by Native Americans, with its meaning, either as a broken cross, sun symbol, or turning wheel, varying from tribe to tribe.

Big Bow's adaptation of the Thunderbird gave him a product that he could market in quantity, though he was also a prolific painter. In his seventies, he was still painting and selling his paintings when he hired twenty-year-old Charlie Pratt to drive him around. The two artists would stop at banks and businesses where Woody had collectors, and whenever Pratt brought work, he would sell for him, too. "He always gave me what I asked for it," recalled Charlie, with a laugh, "but I never knew what he sold it for."

Bert Seabourn once did a show with Woody in Odessa, Texas, and he remembered what happened when Woody was not making the sales he needed. "He gets on the phone and calls Imogene Mugg at the S&R Gallery. 'I'm so and so with such and such oil company. I'm going to be in Oklahoma City in a few days, and I'm looking for some Big Bow paintings. Do you know where I might find any?'" According to Seabourn, Imogene promised to see what she could do, and the next day Woody strode confidently into the OKC gallery with paintings. Imogene bought them eagerly, never suspecting she was buying from the same person who had called her from Odessa.

When sales of his own work slowed, Big Bow was known not to be adverse to copying the paintings of his fellow artists and selling them. He did so in meticulous detail, down to the signature, a mark of his artistic facility. Most of the forgeries were not discovered until after his death, and more than a few Oklahoma collectors were subsequently crushed after a visit to the appraiser's to learn the original Mopope or Blue Eagle they cherished was, in fact, a Big Bow forgery.

"Indian artists had to live by their wit. If you were good, you might make it. If you were not good, it would be very difficult."
—Robert Redbird

"An Indian artist has to have a gimmick."
—Doc Tate Nevaquaya to Robby McMurtry

Chapter 12
New Developments

B OB AND DORIS HAD continued interacting in a business capacity even while she was married to Mel. They hadn't, however, done any traveling during that period of her life. After Mel vanished, the exes were free to discuss that possibility and ways they could do so, without infringing upon each other's business.

From the beginning, Robert Redbird had been Bob's artist, but Doris also bought paintings from Redbird. She had been Gary Montgomery's dealer, initially, but lately Bob had been buying paintings from Montgomery, too. In the case of both painters, Bob was primarily looking for images that would translate into successful prints.

Native artists had experimented with fine art multiples since the 1930s: silk screens, intaglios, woodblock prints, and eventually lithographs. Their interest came from the creative challenges the various media posed and the aesthetic differences between each. As with artists everywhere, they were also interested in maximizing the profit from their works, so as to give themselves more time to create. They could reap twelve to fifteen printings from one intaglio carving or woodblock etching. These could be marketed at a somewhat lower price than their originals, but were still valuable because of their hand-produced nature.

Woody Crumbo had distinct ideas about fine-art multiples and worked incessantly to solicit sale shows of his prints with libraries, universities, and museums. He would pack and ship his silk screens and etchings in sturdy wooden cases, so that whatever art remained after the show could be returned in the same cases. According to Linda Greever, he believed "there were two ways to become famous. One was to die and the other was to quit painting." He should have added a third way—fine-art multiples—for in many ways, it was his silk screens and etchings that introduced his work to a national and global audience.

Greever said Crumbo was also convinced that producing large amounts of multiples, while cutting back on paintings, would raise the price of his originals—fewer canvases, more demand: basic supply-and-demand economics. If so, he apparently had changed his mind by the time he met Robert Redbird. When the Kiowa artist asked if he should start doing silk screens, Crumbo warned him away, saying it would ruin the market for his originals. Whenever the public has a choice, he told Redbird, they gravitated to work that was less expensive.

In fact, even fine-art multiples were too expensive for the man on the street. This situation, however, was soon remedied by mechanical reproduction. In the 1970s Native artists embraced offset printing as a kind of golden goose, a way to make possible large quantities of affordable work. Offset prints could be priced differently, depending upon whether they were a closed or open printing. Closed editions were limited in number, while open editions could be reprinted as desired to accommodate demand. Unfortunately, both types of printing required a substantial outlay of upfront cash. Consequently, it was mostly non-Indians, often art agents, dealers, and later gallery owners, who produced Native art prints.

Bob McCabe jumped into the printing business with zeal even as he looked to Doris for some of his start-up cash. His typical arrangement with the artists was to offer them two-thirds of the prints he pulled in exchange for the right to reproduce their images. This was not the norm. Many dealers inverted the formula, keeping two-thirds of the prints themselves and offering the artist a third or a quarter. Still others charged artists for the printing, or in the worst abuses, reproduced and sold their images without their knowledge.

McCabe printed with only three artists: Redbird, Montgomery, and Doc Tate Nevaquaya, and he usually let them know in advance which images he was interested in. Once he ordered, paid for, and picked up the prints, he would contact the artists to come after their share. They would be as excited as he was, for prints gave them a flexible product they could keystone, wholesale, or sell retail to individuals.

One time, however, in his enthusiasm to take advantage of a cheap quote from a printer, Bob produced five hundred card-sized prints of Doc Tate's dancers without his knowledge. After the prints were delivered, he took the artist out to lunch. As the two were eating, McCabe casually asked how he would feel about printing the images in question, and Doc granted he thought it would be a good idea. "Bob wasn't about to drive home, wait a while, and make another appointment to show him what he'd already done," Doris said. "He went to the car, got a box of prints, and put them on the table for Doc."

Offset prints proved to be an important factor in Oklahoma artists being able to participate in a rapidly expanding circuit of Indian art shows. There was Colorado Indian Market in January, the Scottsdale National Indian Arts Exhibition (later the Heard Museum show) in March, followed by Gallup Indian Ceremonial in July, and Santa Fe Indian Market in August. Although the Santa Fe Indian Market prohibits the sale of reproductions, having prints in the car was still a good backup for the artist. If booth sales were less than spectacular that year, they could wholesale the prints at gift shops and trading posts on their way home.

During the late seventies, as Doris and Bob expanded their traveling out of state, prints became Bob's stock in trade. Doris stuck with originals. She valued the creative effort they represented, and she liked the way they kept her in constant touch with the artists. Her Kilroy-like merchandising didn't necessarily hurt Native artists who later happened to stop at sales points she had already visited. Once a store's owner found a particular artist's work to be salable, the owner was usually eager to purchase more, especially when the painter showed up in person. Still, once an artist established a sales relationship with a store's owner, Doris quickly bowed out. "I never wanted to get in the way," she said.

The fact that she and Oklahoma Native artists were crossing paths, however, gave her pause. The Native art landscape was shifting once again. Lately, she and Bob had been talking about its newest development: the emergence of the first Native fine art galleries. Oklahoma galleries periodically had carried works by Indian painters, but Native art was never their focus nor a significant source of their income. That changed when Beverly Baum, a collector formerly married to a doctor, established the Tribal Arts Gallery in Oklahoma City in 1976. Baum, however, handled only two artists: Acee Blue Eagle and Rance Hood.

If a Native art gallery is defined by the presence of more than two artists, the distinction of being first on the scene then belongs to Linda Greever in Tulsa. Greever, a Kansas native, purchased the Art Market in 1976 as a way of supporting her family while her husband was in law school. When she bought the business, she also inherited its inventory: hundreds of factory-produced European Impressionist paintings. Artist Robby McMurtry (Cajun/Irish/Comanche) once described them as "art to put over your couch. . . . no local flavor at all."

After moving to Tulsa, Greever collected a few Native baskets, but always said she knew little about Native American painting at the time that she founded her gallery. No sooner had she opened the art gallery's doors, however, than various Indian painters began dropping by to see her. They soon persuaded her to shift her emphasis to Native art. Over the years, she developed close relationships with a number of them and employed several artists as part-time sales help at the gallery.

The Art Market's opening was followed that same year by the arrival of Otis and Neva Wilson's Western Heritage Gallery in Tulsa. In 1977, Reba and Clarence Olsen would open the Galleria in Norman, Oklahoma. Doris and Bob visited them all, and Bob became convinced the two of them should go in as partners on a gallery. But Doris, ever cautious, waited for a sign. It came about two years later in 1959; at age fifty-five, she was offered an early retirement plan by General Motors. That small financial cushion was all she needed. The joy she derived from selling Native art had long ago turned any other kind of work into a grind. From now on, she would channel all her creative energy into her gallery business, redefining artists' and collectors' expectations of what a Native fine art gallery could do and be.

"I never planned on opening a gallery. It was something that just happened. And I never thought of myself as a salesperson. My natural makeup was to want to learn and share. What (the painters) shared with me, I tried to pass on to others. I just enjoyed talking with people and sharing about the art."
—Doris Littrell

INDIAN ART GALLERY FOUNDINGS IN OKLAHOMA

1976
Tribal Arts, Oklahoma City
The Art Market, Tulsa
Western Heritage Gallery, Tulsa

1977
The Galleria, Norman

1979
Oklahoma Indian Art Gallery, Oklahoma City
American Indian Arts Collection, Shawnee

1981
Indian Territory Gallery, Sapulpa

1982
Gallery of the Plains Indian, Colony

1983
The Gallery of Art, Anadarko
Mittie Cooper White House Gallery, Oklahoma City

1985
Susie Peters Gallery, Anadarko

Chapter 13
Taking the Plunge

EXIT EAST OFF INTERSTATE 44 and onto Southwest Forty-Fourth Street in Oklahoma City, and one soon comes upon a remarkable sight: an impeccably maintained farmhouse with an oil pump in the back, frozen like a bee in amber, in the middle of the city. The property, now a historic landmark, was once part of a dairy farm owned by Mary and Vince Sudik, descendants of Czech immigrants. In 1930 the Indian Territory Illuminating Oil Company began drilling on the farm, then located far outside the city limits. The oil workers christened their wells with the woman of the household's name, and on March 26, 1930, they struck oil with Mary Sudik Number One. Unfortunately, they also failed to mud the hole and use a safety head. The well went wild, spewing twenty thousand barrels of oil into the air for eleven days straight. Oil spilled into neighboring fields and was carried as far south as Norman on the wind, prompting passage of the first-ever safety regulations for oil drilling.

Radio stations and newspapers across the country followed the disaster daily, and newsreel footage splashed the exploits of the well they had dubbed "Wild Mary" on screens across the country. Now a household name, the actual Mary Sudik was besieged by offers for movie and

vaudeville roles. She wisely ignored them. Instead, she and her husband moved into the city to quietly enjoy their new wealth, and upon their deaths, were buried in the Czech National Cemetery up the street.

In 1979, when Bob McCabe drove down Southwest Forty-Fourth, he likely wasn't paying attention to either the old farm or the cemetery. He and Doris had been looking for a gallery space to rent and everything they'd seen so far was either too small or too expensive. On this particular day, he had no newspaper listing—he was simply driving, keeping his eyes peeled for prospects. He knew the street to be a busy artery, an area where home businesses rubbed shoulders with small restaurants and automotive shops. As he pulled up to Agnew Street, just catty-corner to the Czech cemetery, he spotted a small, nondescript strip mall with a "For Lease" sign taped in one of the windows. He pulled into the parking lot, jotted down the number, and then drove to the closest phone booth.

A familiar voice picked up on the other end of the line. It was Nancy Hughes, a Native art collector who had purchased some Southwest pottery from Bob and Doris years earlier. Bob immediately realized the advantages of having a Native art fan for a landlord. He asked a few questions and knew he had a live one. As soon as he hung up, he dialed Doris, insisting she come look at the space right away. "He said, 'if you don't want it, I'll rent it myself,'" she recalled.

At four-thousand-square feet, it was bigger than many other places they had toured. Its central feature, a large, open room was ideal for an art gallery. It also had a number of smaller rooms that would allow each partner a separate working area. The only other occupant in the mall was a printing company, open Monday through Friday, eight to five. That would leave plenty of parking for gallery openings, evenings and weekends. Besides its modest rent, what Doris most liked about it was its ease of access. It was minutes away from two major interstates (Interstate 40, one of the United States' major crossroads and Interstate 240), a ten-minute drive from Will Rogers World Airport, and about the same from downtown.

Despite the address's strong points, however, it would clearly take work to transform the space into a proper art gallery. Lighting throughout was poor; some of the walls needed patching and repainting; others

were covered with dark wood paneling. Fortunately, the landlord was willing to let the couple make whatever changes they needed, so long as they paid for them.

As usual, it was Doris who bore the expense of bringing the store up to par. She bought materials, hired a work crew, and once the renovations were finished, brought in antique furniture, Navajo rugs, and Southwest pottery to finish off the decor. When the landlady's husband stopped by a few weeks later, he couldn't believe the transformation. "He kept saying, 'It's so comfortable, I could actually move in here,'" Doris said, proudly.

Despite her years of art dealing and the time she had spent at the Sales and Rental gallery, working with Imogene Mugg, Doris was anxious about opening her own retail store. As usual, she dove into reading to prepare for it. The first challenge was what to call it. One book suggested anyone starting a business should always include her own moniker in the name of the enterprise. This not only personalized it, making it more attractive to the public, but it also signaled that the owner stood behind her product or services. Doris ignored that advice because as she explained, "It was never about me. It was about the artists." She decided instead on "Oklahoma Indian Art Gallery," basically the same name she had used selling art at booth shows.

One friend scolded, "That's the dumbest name I ever heard. Can't you name it something like Nuwudahi?" (Nuwudahi was a well-known Native art gallery in Austin, Texas). Another reassured her that the choice was brilliant because it so clearly described what she sold. Doris found the latter to be true. "I got more business off that [name]. They would be looking in the phone book for Indian art in Oklahoma, and there I was."

Another book that Doris consulted proclaimed the benefits of a striking business logo. Doris chose a butterfly. It was an apt metaphor for this new incarnation in her art-selling life, and she liked its significance within some Native cultures as a spirit messenger. She sketched her own geometric version of a butterfly and printed it on her business cards, stationery, and brochures. Later, she was surprised to discover how closely it resembled the butterfly symbol in Southern Plains beadwork.

With that, she began to plan her grand opening, choosing works from her inventory by forty different painters and carefully arranging them throughout the rooms. While she worked, she covered the gallery door and windows with brown paper, a practice she adopted from other galleries of the day to keep the paintings a surprise until she opened.

She paid for a newspaper ad and listed the opening in the area calendar of events, but there was no feature article, no radio or television coverage. As a private business, she knew she would not draw the same attention as the S&R Gallery did, operating under the aegis of a nonprofit art museum.

Yet Doris couldn't shake the hope a business reporter for the local paper might wander in. None did. She mailed invitations to friends and other store owners, but collectors were noticeably absent from her list, save for the few she had met volunteering at S&R Gallery. "I'd been working so much as a wholesaler," Doris explained, "businesses knew me but collectors didn't."

Not surprisingly, opening night was disappointing. Of the artists she invited to attend and bring work, only Woody Big Bow accepted. Until now, Native artists had known her as a dealer who came to their homes to buy wholesale; picturing her as a gallery owner who handled retail sales would take time. Nonetheless, the art for the show was beautifully displayed, the reception table well stocked, and Doris sold several paintings. Imogene Mugg showed up for the opening and after walking through the gallery, remarked, "You did a good job"—the only compliment she ever gave Doris.

Reviewing the evening afterwards, Doris realized "forty painters was too much." It wasn't simply a matter of space. She needed to clarify for herself the kind of Native painters she wanted to handle. Until then she had assumed all the artists she had carried as a dealer would be happy to follow her into a gallery. The first to puncture her balloon was Bobby Hill, who informed her straight off that he would never set foot in her gallery. For the record, it should be noted that he was drinking heavily at this point, and although his response hurt her feelings, Doris continued to buy his paintings until the end of his life.

In the end, Hill's response was not that unusual, for there was a different attitude between painters of his generation and the newer

generation. Except for the most traveled and accomplished painters, old school Indian artists tended to view galleries, like most retail establishments, with an attitude of mistrust, based upon the negative encounters they had experienced with them as well as stories they had heard from others. The younger generation of Native artists, however, often as a result of their time in art school, had at least been exposed to the idea that galleries could play a critical role in an artist's career. As a result, even if they'd never been in a gallery before, they were more willing to work in partnership with Doris.

Each time new artists approached her, Doris tried to spend time talking to them, "to get a feel for how serious they were, and how they might grow and get better." She no longer wanted painters who saw art as one of several ways to raise money. She wanted painters who were driven to do what they did, for whom art was as essential as breathing.

Shortly after her grand opening, the adjacent printing company moved, and Doris acquired that space as well for a slightly higher rent. The first thing she did, with the landlady's permission, was tear down one of the store's inner walls so she could have more room to display the art. No sooner did the wall come down than Bob announced his unhappiness. "He wanted a great big working area for his framing, and I wanted a big sales area," Doris said. He packed up his framing equipment and moved out abruptly, leaving her alone to pay rent and recoup the initial expenses of opening the business.

If Oklahoma Indian Art Gallery survived its first year, it was from sheer persistence on Doris's part. She called every business she had worked with as a dealer, from California to Washington, D.C., and wholesaled paintings to them. She was her own publicity machine, delivering brochures to the chamber of commerce and dropping others off in hotel lobbies, restaurants, and businesses.

Most importantly, she never took a single visitor to the gallery for granted. Everyone who entered was greeted warmly and invited to sign her visitor's book. They left impressed by the quality of the art and her knowledge of it. She made her converts, one at a time, and in the face-to-face community of Native art fans, that was all it took. Every person went back and reported to friends the amazing find: a Native art gallery hidden inside a mundane-looking building in the most unlikely part of

Oklahoma City, which, even in the minds of its own residents, was still regarded as pretty much a big cow town.

It didn't happen overnight, but Doris eventually perfected a gallery look best described by the Japanese word *shibu*: a combination of the complex and elegant with the simple and homespun that evokes an overall sense of tranquil well-being. That was the feeling people had upon stepping into the gallery, where Doris brought her own personal artistry to her displays: her feeling for color, her imagination, and her aesthetic sensibility all found expression in how she arranged and placed the art. The gallery was her canvas, assembled from ever-changing art pieces that somehow managed to come together to convey an organic whole: Paintings soared over Mission-style sofas, alabaster sculptures reigned over end tables, Navajo weavings cascaded from quilt racks, Southwest pottery filled every nook and cranny—and vases of fresh flowers were everywhere. "I didn't say to myself, 'I want to show them how this looks.' I did it for my spirit," Doris said.

In her early marriage to Bob, Doris had finally acquired the gardening skills that had eluded her as a girl. From that moment on, she indulged her passion for growing lilacs, roses, coneflowers, astilbes, lavender, hollyhocks, and many others at whatever house she occupied. As the flowers bloomed, she would cut them, bring them to work, and arrange them into bouquets. It was not interior decorating; it was another unique form of self-expression. "During the time that I was raising my children, I wanted to stay home but I couldn't," Doris said. "So, when I opened the gallery, I decided to bring my home there."

"What we had to show was the [artists'] talent. How do you present it? You present it as if it was their home and mine."
—Doris Littrell

"My mother and I had been all around central Oklahoma, looking for Indian art. We'd stopped at places in small towns, odd curio shops, all the tourist spots. . . . My first impression walking into Doris's gallery, was this was a first-class art gallery."
—Bill Wiggins, Arkansas collector

OKLAHOMA INDIAN ART GALLERY
ARTISTS ROLL
(birth | walked on)

Evans Anquoe
Kiowa
(1923–1988)

Acee Blue Eagle
Pawnee/Creek
(1907/1909–1959)

Spencer Asah
Kiowa
(1905/1910–1954)

Lee Bocock
Cherokee/Choctaw
(1954–)

Fred Beaver
Muscogee Creek/Seminole
(1911–1980)

Blackbear Bosin
Kiowa/Comanche
(1921–1980)

Dennis Belindo
Diné/Kiowa
(1938–2009)

Parker Boyiddle
Kiowa/Delaware
(1947–2007)

Jean Bales
Iowa
(1946–2004)

Joan Brown
Cherokee
(1938–1990)

Jay Benham
Kiowa
(1945–)

Benjamin (Bennie) Buffalo
Cheyenne
(1948–1994)

Woody Big Bow
Kiowa
(1914–1988)

Sherman Chaddlesone
Kiowa
(1947–2013)

Harrison Begay
Diné
(1917–2012)

Robert Chee
Diné
(1937/1938–1972)

Mars Biggoose
Ponca
(1943–2000)

Mirac Creepingbear
Kiowa/Pawnee/Arapaho
(1947–1990)

Archie Blackowl
Cheyenne
(1911-1992)

Woodrow (Woody) Crumbo
Potawatomi/Muskogee Creek
(1912–1989)

OKLAHOMA INDIAN ART GALLERY
ARTISTS ROLL
(continued)

Mavis Doering
Cherokee
(1929–2007)

Edmond Joshua Jr.
Creek/Seminole
(1936–2005)

George Geionety
Kiowa
(1913–1998)

Lee Joshua
Creek/Seminole
(1937–2001)

Bill Glass Jr.
Cherokee
(1950–)

Jerry (Hosteen Nez) Lee
Diné
(1944–)

Brenda Kennedy Grummer
Citizen Potawatomi
(1947/)

Barthell Little Chief
Kiowa
(1941–)

Benjamin Harjo Jr.
Seminole/Absentee Shawnee
(1945–)

Merlin Little Thunder
Southern Cheyenne
(1956–)

Narsico (Ha-So-Deh) Abeyta
Diné
(1918–1998)

Al Momaday
Kiowa
(1913–1981)

Jonny Hawk
Creek/Seminole
(1934–)

Stephen Mopope
Kiowa
(1898–1974)

Jack Hokeah
Kiowa
(1901/1902–1969)

Raymond Naha
Hopi/Tewa
(1933–1975)

Rance Hood
Comanche
(1941–)

Doc Tate Nevaquaya
Comanche
(1932–1996)

Albin Jake
Pawnee
(1922–1960)

Fernando Padilla
San Felipe Pueblo/Navajo
(1958–)

OKLAHOMA INDIAN ART GALLERY
ARTISTS ROLL
(continued)

Charlie Pratt
Cheyenne/Arapaho
(1937–)

Carl Sweezy
Arapaho
(1879/1880–1953)

Harvey Pratt
Cheyenne/Arapaho
(1941–)

James Tartsah
Kiowa
(1934–1984)

Bill Rabbit
Cherokee
(1946–2012)

Robert Taylor
Blackfoot/Cherokee
(1951–)

Robert Redbird
Kiowa
(1939–2016)

Lee Tsatoke
Kiowa
(1929–1986)

Cathy Rutledge
Choctaw/Cherokee
(1937–)

Monroe Tsatoke
Kiowa
(1904–1937)

Bert Seabourn
Cherokee descent
(1931–)

Bobby (White Buffalo) Hill
Kiowa
(1933–1984)

Ben Adair Shoemaker
Quapaw/Shawnee/Cherokee
(1945–)

Jimmy (Beatien Yazz) Todd
Diné
(1928–)

Lois Bougetah Smoky
Kiowa
(1907–1981)

Gary Yazzie
Diné
(1946–)

Ernest Spybuck
Absentee Shawnee
(1883–1949)

George (Woogie) Watchetaker
Comanche
(1916–1993)

Virginia Stroud
Cherokee/Muscogee Creek
(1951–)

Chapter 14
Shop Talk

A S A CONVERSATION WITH ANY non-Indian artist in the state will confirm, mainstream fine-art galleries rarely, if ever, buy from their artists. This stands in contrast to Native fine art galleries, which from their first appearance on the scene, and for all the reasons previously noted, have always directly purchased inventory. As more Native fine-art galleries opened around Oklahoma, Native artists grew more flexible about consigning as well as selling. But the balance always tilted heavily in favor of purchasing, and Littrell's gallery was no exception.

When she opened, she borrowed some from the business practices of other Native gallery owners, but she always seemed to refine upon what practices she borrowed. Most Native art galleries had shows, but Doris had shows as though she were on a mission. It wasn't just about raising income for her and the artists; it was about keeping the artists and her gallery in front of the public year round. She had one to two solo shows each year, and a series of group shows—one in the spring, one in the fall, and one during the winter holidays. Not all shows were accompanied by formal openings, but that didn't necessarily reduce the time she spent communicating with artists and collectors about them.

One unplanned, if fortuitous result of this heavy show schedule was that it kept the artists constantly working. Between Doris's demands and the demands of the other venues they supplied, painters couldn't help but hone and refine their skills because they were using them on an ongoing basis.

Other gallery owners were aware of the importance of cultivating a collector base, but Doris grew hers with single-minded efficiency. She developed a customized method of selling in which she kept track, not just of customer purchases, but of the kind of pictorial subjects, styles, and even palettes that interested them, their favorite artists, their favorite mediums. Based on this information, as soon as a painting arrived in the gallery, she could pick up the phone and know whom to call.

In those pre-Internet days, she also regularly corresponded with her clients, particularly those who lived out of state. She would send them photographs of artwork, along with a handwritten note, giving the title, medium, measurements, and price for the piece in question, as well as any information the artist had given her.

The photos were taken by Bob McCabe, who after a year or so of self-exile, had returned to rent a framing space from Doris and become her photographer. Every time a piece of art entered the gallery, it was photographed and several copies were made, one of which went into her records. She kept file folders of newspaper and magazine articles as well as brochures and pamphlets—anything that had to do with her artists or Native painting in general. When she ran across any writing about American Indian art, she read it closely, often recording her own thoughts and observations in the margins.

She was not alone in helping artists identify the best-selling price for a piece, but no one could touch her ability to set prices for an artist that reflected both the artist's degree of talent and her knowledge of what the market would bear at the time. If an artist named a price for a painting that she considered too low, she would suggest a higher price in its stead. If the price got too high, she would assure them their painting was probably worth even more than what they quoted, but she doubted she could get that price (which meant no one else could, either). And unlike most gallery owners, she watched closely for opportunities to raise her artists' prices. Special awards and museum shows,

the artists' individual rates of production, and the number of collectors asking for their work all factored in Doris's personal pricing equation. "When you can't keep the work on the wall, and you don't have any inventory, then it's time to go up (on price)," she observed.

Consistency was important, too. If a painting of a certain size and quality was consigned to her for five hundred dollars, it should be five hundred in other galleries as well. The exception was booth shows. She understood why Native artists might sell to the public at a somewhat lower price, as those did not have to carry her commission (initially 30 percent although she eventually raised it to 40 percent). Still, if the discrepancy between their booth prices and gallery pricing was too great, it undercut her ability to represent them. The longer she was in business, the more the artists discovered that they, too, had a vested interest in keeping their booth work sticker price as close to the gallery's price range as possible because it also made a statement about how they valued their art. If they were willing to part with their paintings too cheaply, or if they constantly flip-flopped on prices, collectors might begin to have second thoughts about the desirability of their work. As they did with other products, Doris's collectors tended to equate consistency of pricing with quality.

Part of the unwritten but universally acknowledged code among gallery owners and artists decrees that so long as the two are working together, selling directly to the gallery owner's clients is unacceptable. Booth shows are an obvious exception, but apart from those occasions, any transactions between an artist and the gallery's clients should take place through the gallery. Even so, it happened more than once that a painter, after being introduced to Doris's clients at a show, would contact them later, behind her back, to try to sell them work. It was self-defeating in the end. Word always got back to Doris, often through the collectors themselves, and the artist would receive a phone call the next day "to please come pick up your things."

Although she refused to tolerate such behavior, she could better understand it from her artists than she could from her established collectors whom she assumed knew better. She paid rent for the gallery, bore all its advertising and marketing costs, and often paid to mat and frame unframed art that painters brought her. Why would they want

to cut her out? As for the artists, they were mostly hurting themselves, trading quick cash for what could have been a partnership of ongoing exposure. "You can only sell to the same individuals so many times," Doris explained. "[While] a gallery can promote you to a broader range of people."

Once she set the market for an artist, Littrell considered it her duty to make sure nothing threatened it. Sometimes that meant attending auctions or estate sales with work by artists she handled to make sure the art didn't sell too cheaply. If a painting started to fall short during bidding, she would bid on it herself, even if it meant she ended up buying it. "When you've gone to all that trouble to build up an artist's prices, you don't want to have the auction houses ruin it," she observed.

"Doris was the one who made me think maybe I could be an artist and have a business, too. When you see a strong, successful woman who runs her own gallery, you start thinking, maybe I can do that."
—Traci Rabbit

"With Doris, the artist always came first."
—Robert Taylor

Chapter 15
Building a Reputation

AS WORD OF HER EXACTING eye and high standards spread among the artists, some gallery owners sought to leverage those stories to their advantage. Otis Wilson of the Western Heritage Gallery in Tulsa told Robert Taylor, an artist of Cherokee/Blackfoot/ Osage descent, "You know how each time you bring me work, I buy one or two paintings and send the rest back? When I start buying all of them, that's when you'll be ready for Doris." My own husband, Merlin Little Thunder (Southern Cheyenne), got a different kind of warning from Shirley Wells, owner of the Indian Territory Gallery in Sapulpa: "If you get into Doris's gallery, you've got your foot in the door, but you're going to have to work hard to keep it there."

Most artists, no matter how confident they may appear to the public, walk a tightrope of psychic insecurity about their work. Award-winning painter Troy Anderson (Cherokee descent) was no exception. He attended one or two of Doris's shows but never asked her to represent him because he'd heard "too many stories about artists who tried and were unsuccessful."

Jane Osti (Cherokee), an early practitioner of Southeastern pottery, was also reluctant to approach Doris. It took fellow artist Ben Harjo

and his wife to force the issue by bringing one of Osti's hand-coiled, wood-fired pots to Doris, who immediately telephoned the potter to bring her more.

Bill Rabbit (Cherokee) was still in the early phase of his career, painting Cherokee homestead scenes, when he and his wife, Karen, made a cold sales call to Doris. "A lot of people were intimidated by her, because she didn't pull any punches," said Karen, "but whenever we dealt with her, we always got along great." Artists, who were used to circling around a sale, chitchatting about various subjects, were encouraged by Doris to get to the point. As Shirley Wells told Merlin, "She's going to be short and real professional. When (she) says, 'Thank you,' that means 'Now get out of here.' When she says, 'Will that be all, dear?' it means 'What are you still doing here?'"

Some artists gladly fell in sync with her rhythms, especially if they needed to cash a check quickly, while others found them difficult to digest. Mirac Creepingbear (Kiowa/Arapaho) once confessed to one of Doris's collectors, "I don't care for the woman much, but she sells a lot of my work. So what can I do?" There was a logic behind her tunnel-like focus. Just as an artist, inspired by an idea, grabs the closest scrap of paper to scribble it down, so Doris knew from her first glimpse of a painting which of her numerous collectors to contact about it. Cherokee artist Mary Adair recalled taking Littrell a fabric landscape with figures, one of only three such fabric paintings she did during the course of her entire career. Doris asked her to wait a minute and dialed the number of a collector in Atlanta who did quilting. She described the piece over the phone, and the woman bought it, sight unseen.

Tim Nevaquaya (Comanche/Choctaw) tells a different story of walking into the gallery to find a couple of collectors talking with Doris. "Right away, she introduced me. 'This is the painter whose work you were admiring earlier.' Before I knew it, they said they wanted the painting, and she was writing me a check for it."

Tim's appearance was serendipitous that day, but part of Doris's drive to sell came from her keen awareness of artists' circumstances. She understood the lengthy process involved in finishing a new piece of art, and she knew by the time it was delivered, the artist needed to be paid. Yesterday. Lee Bocock, a painter of Cherokee/Choctaw

descent who clerked in the gallery, observed, "You could sell a painting in Phoenix, and you wouldn't see your check for six months. If Doris sold something for you, she'd put your check in the mail the same day."

Littrell showed the same degree of thoughtfulness when things weren't selling; although, the point at which it became good business sense was not always clear. Nearly ten years before Doris took on Jane Osti, she was visited by the potter Mike Daniel (Seminole/Cherokee), and he consigned a group of delicately colored, wheel-thrown pots to her. Daniel was teaching at a Tahlequah high school, selling well in his own area, but he wanted an Oklahoma City outlet, too. A month passed. Nothing moved. That was fine with the artist, who had a day job, but Doris fretted that she was tying up his work. "She called me and apologized for not selling anything and told me I should try this other contemporary gallery in the city," he recalled. "She had already called the manager for me to let him know I was coming. Sure enough, it was better for me, and I sold a number of things there."

Doris was always aware of the painters' needs for multiple sales venues, and she delighted in connecting them with audiences in other parts of the country. The same collector who bought Mary Adair's fabric landscape (a native Oklahoman, of course) became enamored with Bill Rabbit's work, and she asked if she could host a trunk show for him in Atlanta. Doris not only agreed but also offered to buy the artist's plane ticket and ship and package his work for the show. When the painter confessed to her that he felt uncomfortable going to a strange woman's house by himself, Doris booked a ticket for herself as well and flew to Atlanta with him. The next day, during the trunk show, as Rabbit and the his hostess visited with their guests, Doris processed the sales transactions for him.

By the mid-eighties, Native art in Oklahoma was all the rage, and the number of players in the Indian art business had also grown. There were at least nine Native fine-art galleries between Oklahoma City, Shawnee, and Tulsa alone. Indian stores and trading posts were marketing more visual art in the form of prints to the public as well, and the first Native arts festival in the state, Red Earth, was about to open in 1986.

One quirky, if short-lived development, was the emergence on the Oklahoma scene of a number of Native art shows, sponsored by non-

profit organizations. They often offered artists free booth space in exchange for a percentage of their sales—and the public got an opportunity to buy Native art while supporting their favorite cause or charity. The result was a brief spike in living standards for many Native artists with one notable exception: Native women painters.

In trying to assess their own struggles to find a market, many of these women had only to look back to the Kiowa Six and its lone woman painter, Lois Smoky. Despite tremendous support from her parents who accompanied her in her move to Norman, Smoky lasted only a year at the University of Oklahoma. Whatever caused her to withdraw from the university, there is no doubt that as a Native woman painter, she encountered sexism as well as racism during the course of her stay. She was said to have been thrilled when the Kiowa portfolio was published, but that only added to the poignancy of her withdrawal from college and the historical vacuum left by paintings never realized. According to Richard Aitson, however, once back home, Smoky did go on to achieve several foundational breakthroughs in Kiowa beadwork.

Women artists of the eighties found their challenges similar to Smoky's, yet also uniquely their own. As Joan Brown explained it, many of them were single mothers, or the primary breadwinners of their families. Unlike their male counterparts, who could paint in the kitchen or bedroom while their wives ran interference or worked, they had to paint while babysitting—with no one to bring in a paycheck but themselves. In Joan Brown's case this literally required problem solving on a brand new level. "I'd be painting and those little kids would run up and hit the table. So, I'd stack two air conditioners and get on top and sit on that. The [air conditioners] were so heavy, it didn't matter if they hit those. The other alternative was to wait until everybody was in bed, asleep, and paint after midnight. I did a lot of that."

These women also faced the gender bias of the dominant society, which extended into every arena, including Native art judging. Jean Bales (Iowa), whose work Doris handled as a dealer, learned through experience to sign her paintings with the masculine sounding "J. Bales." Sharron Ahtone-Harjo used a gender-neutral signature: her hyphenated last name. She argues the main obstacle for women artists was not Native men painters, most of whom she found to be extremely

supportive, but white male gallery owners. "Sometimes they wouldn't handle your work because you were a woman. Some would charge you a larger sales commission to discourage you," she said.

Virginia Stroud, Joan Brown, and Mary Adair are believed to be the core group that finally generated the idea of staging a Native women's art show. Stroud took the idea to Doris, who was immediately enthusiastic, and in March of 1985, *Daughters of the Earth* made its debut at the Oklahoma Indian Art Gallery. This first all-Native women's painting show included works by Valjean Hessing (Choctaw), Jane Mauldin (Choctaw), Ruthe Blalock Jones, Mary Adair, Jean Bales, Joan Brown, Sharron Ahtone-Harjo, and Stroud herself, by then a painter of some note.

Besides offering a wide diversity of styles and approaches, the show featured a rich array of Five Tribes and Southern Plains imagery. After its launch in Oklahoma City, the show moved to Nebraska, then Colorado, Virginia, and Georgia, among other states. During this wide-ranging tour, new audiences were drawn to Native art, and the women artists achieved a much-deserved national profile.

It was not all roses. According to Brown, some of the exhibiting venues helped sponsor the women's travel, but most of the time they had to pay their own expenses. Undoubtedly, the initial sales they experienced at OIAG helped make it possible, not to mention sales many of them made individually to Doris in between some of the trips. Not all the women went to each show opening, but all felt themselves enriched and remotivated by the tour. "It was amazing. . . . The people who came out to see the work. It was a real boost for us," said Brown.

Of all her women artists, Littrell and Stroud had the longest, running history and the closest friendship. Yet their business dealings were still sporadic when Doris opened her gallery. Stroud was then living out of state, painting for Toh-Atin Gallery in Durango, Colorado, which had put her on exclusive contract. Her return to Oklahoma and her reconnection with Doris corresponded to one of the richest periods of her professional life.

"I first met Virginia Stroud when she was seventeen," recalled Doris. "There weren't very many women painters then and some more or less did what they'd grown up with, single figures, whereas she went ahead

and evolved. . . . Even though she was Cherokee, she was close to Kiowa material and I was close to Kiowa material, because that's where I grew up. When she was young, Jake Ahtone, Sharron Ahtone's father, adopted her, so she had Sharron as a sister. Sharron's grandfather was blind and would sit and tell her stories, so she had a father and grandfather that taught her Kiowa history. Sometimes people would come into the gallery and say, 'Where is that woman's work that has the red dot on the cheek?' In my opinion, she broadened the art scene tremendously because she could paint Kiowa and Cherokee. She knew both."

Besides painting on canvas and board, Stroud also began hand-painting unfinished furniture, covering benches, mirrors, end tables, and wooden chests with the richly colored flat images of women, children, foliage, and flowers for which she was known. Her pieces found a strong reception at Doris's gallery, as in many other places, eventually earning her an exhibit at Southern Plains Indian Museum in 1990. The painted furniture was whimsical, even magical, but not always sturdy. Stroud's gifts were more in the artistic realm than the world of construction. Her style lent itself to book illustration as well, but writing was new to her when she decided to write and illustrate *Doesn't Fall Off His Horse*. The picture book, based on a story told by her adoptive Kiowa grandfather, won several awards when published by Dial in 1994. It was followed by two more of her own picture books for Dial, along with illustrative work for the picture book *The Story of the Milky Way* by Joseph Bruchac (Abenaki), also published by Dial.

Stroud's restless, inventive mind was always searching for new formats for her art: sometimes it was dolls; sometimes Christmas ornaments or magnets, whatever caught her fancy. Doris appreciated most of her creative efforts, but on one occasion, Stroud brought in a set of mobiles that caught the gallery owner off guard to say the least. Mobiles, of course, have drawn the interest of artists for a long time—think American sculptor Alexander Calder, but on this day, Littrell happened to be deep in conversation with another artist. She politely asked Virginia to wait until they were done, but Stroud couldn't restrain her enthusiasm, and Littrell's pent-up irritation with the artist came to the fore. "Virginia, why don't you just paint?" she asked. Seemingly angered by this unexpected response, Stroud turned to leave, but as she

opened the door, a part of one of the mobiles flew off inside the gallery. Meanwhile, the artist Doris had been talking to disappeared into a side room, not wanting to be caught in the middle of the storm. By the time he resurfaced, the two women were cozily sitting and laughing at Doris's desk, and above them hung one of Virginia's mobiles.

In 1995, Stroud received her first big mural commission from the University of Oklahoma. It was followed by yet another for the OU Children's Medical Center and a series of commissions for the Cherokee Nation, including a major work for the Cherokee Heritage Center. Stroud was excited about the OU commission until she discovered she couldn't afford the volume of canvas and paint needed to do it. No start-up funds were included in the commission, so she turned, as she knew she could, to Doris. The gallery owner loaned her the money, and Stroud reimbursed her when the project was completed.

Many artists were known to reach out to Doris when they found themselves in a financial bind, for loans or advances on future work. Most of her aid, however, came in the form of purchases, even at times when she wasn't sure about covering her own expenses. Bill Glass observed, "I don't know how many times some bill had to be paid or they were going to cut us off, and Doris would buy pots from me. That's what saved us."

Artist Lee Bocock (Choctaw descent) witnessed the gallery owner's generosity from yet another vantage point. Bocock, who provided the gallery with paintings, also worked part-time for Doris. "Lots of people came to her for help, not just artists," she recalled. Sometimes it was an elderly woman in need of groceries, or an Indian family stranded in the city, without gas money to get home. Littrell saw those moments as her chance to give back to the Native communities that had sent so many artists her way. "She not only had a passion for Indian art, she had a passion for Indian people," said Bocock.

"As I established a gallery, I think the first thing I felt (about the artists) was their Indianness—even before their paintings, that a spirit lived with them. I brought that in from my grandmother and everyone that had touched my life, and it went over to them."
—Doris Littrell

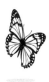

Chapter 16
Meeting Doris

IN 1983, FOUR YEARS AFTER she opened her gallery, Doris commissioned Creek/Seminole painter Jonny Hawk to create a sign for it that turned out to be its own work of art. His canvas was two four-by-eight sheets of plywood, and Hawk approached it like a flat-style painting. "Oklahoma Indian Art Gallery" floated in graceful white letters against a sky-blue background. The hand-drawn letters were outlined first in persimmon, then dark blue. Doris's butterfly logo hovered next to the gallery's name, also outlined in persimmon and dark blue. On each side of the sign, Hawk listed the artists whose work was carried by the gallery, including himself. They numbered sixty-five in all, a compendium of the state's most accomplished artists.

There were still a few names to come, including my husband, Merlin Little Thunder. We didn't meet Doris until late 1985 under circumstances that will be explained later. She was in her mid-sixties then. Her fine features and periwinkle eyes were framed by a crown of silver hair, pulled back and twisted in a bun. Her manner was warm yet business-like, and her speech was as precise as a teacher's, permeated by a Southern politeness. Each of her business transactions ended with the words "Thank you, dear." She still wore the Native-inspired clothing that she

had adopted as an art dealer, although she now favored flat shoes and Mexican housedresses over high heels, broom skirts, and blouses. It was obvious, however, that her clothing was simply a backdrop for the jewelry that was her true artist's remarque: an Arthur Lewis bracelet, an antique pin, and one of her many old pawn, silver-and-turquoise squash blossom necklaces.

From the beginning, both Merlin and I noticed how sensitive she was to the cultural etiquette and needs of Native artists. She followed the hospitality rule: always offer your visitors something. If you don't have anything to offer, offer them water. She kept the gallery refrigerator well stocked with soda and the makings for sandwiches, and always had a pot of coffee on—coffee being the go-to drink for many of the artists who arrived with work in hand, work that they'd likely stayed up late, if not all night, to finish.

An art collector from Chicago once noticed Woogie Watchetaker eating lunch on an antique chair, and after the artist left, he asked Doris why she would let anyone eat on her expensive furniture. "In Indian homes, if someone visits you, you offer them food. So that's what I do," she replied.

A certain amount of Littrell's gallery inventory was actually meant not for collectors but for the artists themselves. She kept a number of cultural items on hand that she knew Native artists might want or have a need for: shawls, cedar boxes, Pendleton blankets, and rattles for gourd dancing—all valuable for doing a bit of horse trading.

Many a time on our way to an honor dance in western Oklahoma, we would drop by the gallery with paintings to sell. Invariably, Doris would ask if we needed any giveaways for the dance, and we immediately started combing through her ever-changing treasure chest. Giving away blankets, shawls, and other special gifts to the head staff at a dance, to special people you want to acknowledge, to relatives, friends, visitors, and children is a time-honored Plains tradition.

On one particular trip, we selected two vintage traveling blankets with yarn fringe. When the emcee called up the elderly women honorees we chose to receive them, they couldn't see what they were getting until the blankets were placed on their shoulders. Then their smiles and handshakes said it all. They were the blankets of their childhood, the

kind they used to wrap around their waists when they got in a wagon, threw over their shoulders at a dance, or tucked around their legs to go horseback riding.

"Going to visit Doris at Oklahoma Indian Art Gallery was amazing. You just wanted to turn her on and let her talk. . . . No one knew as much as Doris, particularly about Plains Indians [art], but really, just about everything, about basketry, about jewelry, about German silver . . ."
—Robert Henry,
17th president of Oklahoma City University
and former U.S. federal judge

"She was excited to be in business. It was interesting to her, and you got that feeling. That's how I knew that I wanted to do business with her."
—Monroe Cameron, artist

"Doris was more like a museum curator than a gallery owner."
—Rex Page, collector

Chapter 17
Matchmaking

OKLAHOMA INDIAN ART Gallery's success rested on a tripod base: one leg was the artists, one leg was Doris, and the third was her collectors. What attracted them and ensured their return, show after show and year after year, was world-class art and the amazing education they received at her gallery.

Littrell's knowledge of Native painting went well beyond memorized facts about an artist's life, such as tribal affiliation(s), preferred media, awards, or exhibitions. It also included the cultural background and context of the work that the artists had passed on to her.

"The delightful thing, for me," Doris said, "was always to share what I knew because that way, it would continue. A collector would share what they knew with another friend or family member and that would benefit the artists and my business down the line."

Besides being familiar with each artist's body of work, Doris was conversant about the history of Oklahoma Native painting as a whole. Walking through the gallery with her was akin to taking a survey course of the state's Native art from the 1930s to the present day. As one Houston couple explained, "In Santa Fe and other places, you're looking at Indian art mixed in with other things. At Oklahoma Indian

Art Gallery, it was all Indian art. Lots of different styles and different periods all in one place."

Littrell affectionately referred to her collectors as her "patrons," an old-fashioned word but one that reminded them of the active role they played in keeping herself and her artists employed. It would have been easier and probably more profitable for her to specialize only in works by deceased artists. Indeed, a number of the older artists had passed on and more would follow too soon. She had plenty of their paintings in her inventory, acquired over years of art dealing, however, she wanted to promote living artists and their work in particular to get ever closer to her goal of helping these men and women earn a living wage.

It had been a long, hard road, getting people to recognize that Native art was fine art, despite her being assisted in that regard by a whole social movement. As her customers learned more about the amount of preparation and revision that went into each of the artists' paintings, they emerged with a renewed respect for the artistic process and were far less inclined to want to haggle over prices. Clients who came in boasting they had picked up some valuable painting at a garage sale or flea market got the cold shoulder from Doris. She would listen politely for a minute, then interject, "That's enough of that, dear. We're interested in building careers around here."

One community college professor confided that whenever she waffled about buying something, Doris would tell her about "Marceline," the law student, "who skipped lunch so she could buy art." This parable always had the desired effect upon the educator, because however modest her income might be, it was clearly more than Marceline's. Another couple confessed that when they first discovered the gallery, they would spend entire weekends pouring over the art and asking questions about it. After several months passed and they still hadn't made a purchase, Littrell told them they needed to tighten their belts, so they could afford the things they admired.

The most interesting object lessons were apt to come on Fridays when the artists were especially likely to drop by the gallery with paintings to sell. "It was like Indian Artist Day," enthused one collector. "They would come in and talk shop, and you'd hear these amazing stories just by being there." Robert Taylor observed that despite the

Doris,
The Gallery,
The Artists and the Art

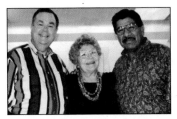

Doris with two of her favorites:
collector David Boren and
artist Doc Tate Nevaquaya.

LATASHA WILSON

The sign Jonny Hawk made for OIAG;
below, the gallery itself.

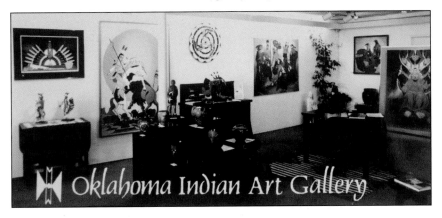

Left, five of the Kiowa Six (James Auchiah, Spencer Asah, Jack Hokeah, Stephen Mopopeand Monroe Tsatoke), with Oscar Jacobson, outside the Swede's home in Norman, Oklahoma. His abode would become The Jacobson House Native Art Center. Not pictured: Lois Bougetah Smoky. (Photo, above, and images on opposite page courtesy of the Arthur & Shifra Silberman Collection, 1996.017, Dickinson Research Centerat the National Cowboy & Western Heritage Museum, Oklahoma City, Oklahoma.)

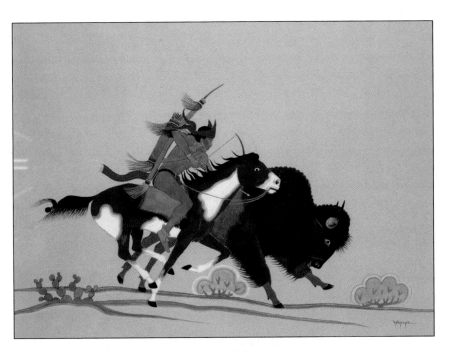

Stephen Mopope

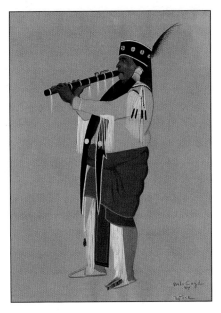

Monroe Tsatoke

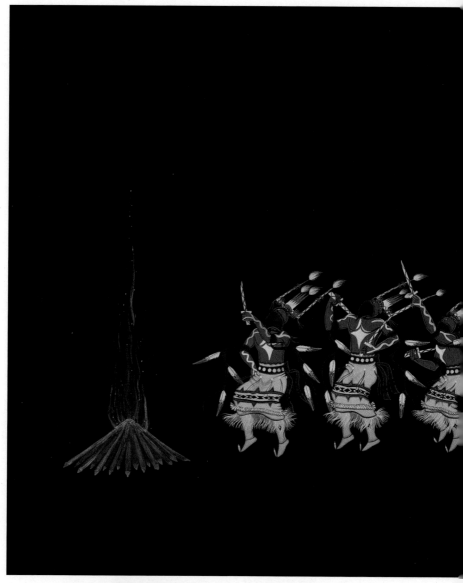

Fire Dancers |
Doc Tate Nevaquaya

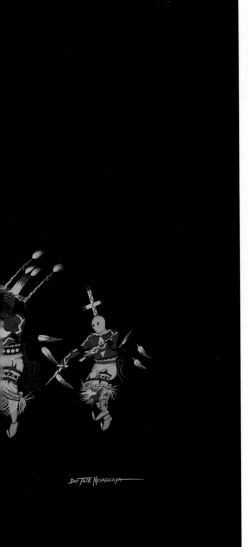

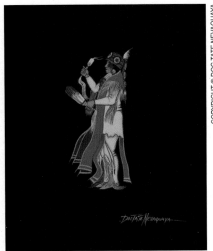

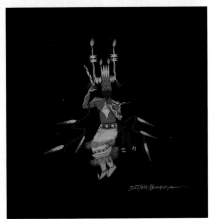

Dancer Series
Doc Tate Nevaquaya

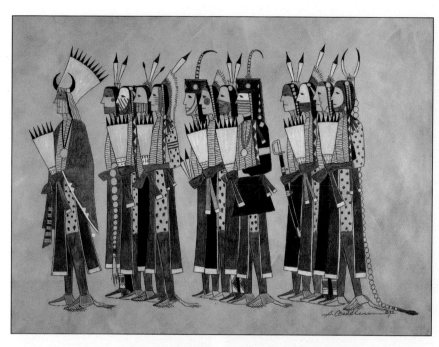

Kiowa Black-Leg Society Going to a Dance
Sherman Chaddlesone

Sherman Chaddlesone

Moving Day
Sherman Chaddlesone

Chicken Pull
Narsico (Ha So Deh) Abeyta

Narrow Escape
Narsico (Ha So Deh) Abeyta

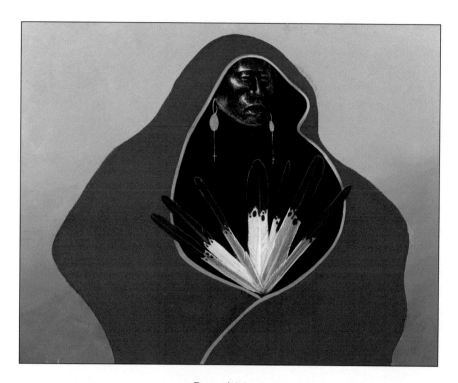

Road Man
Mirac Creepingbear

 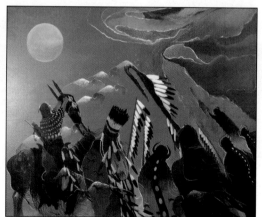

His Father's Society
Mirac Creepingbear

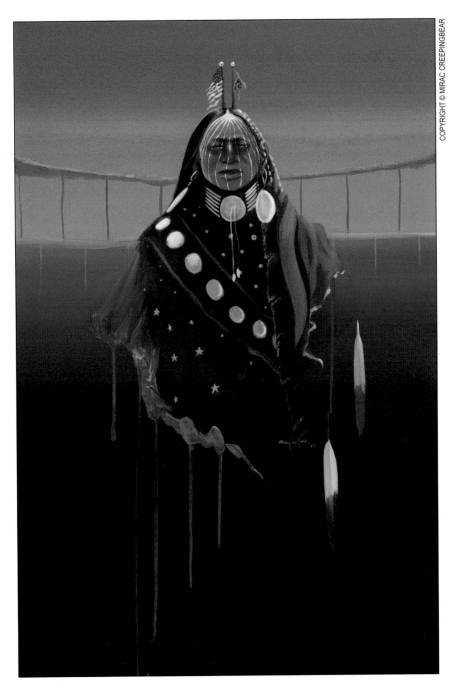

Kiowa Arapaho on July 4th
Mirac Creepingbear

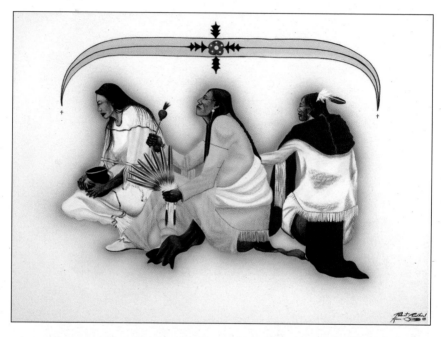

Peyote Ceremony, Bringing of the Morning Water
Robert Redbird

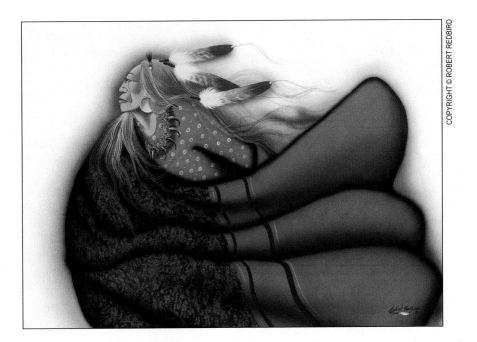

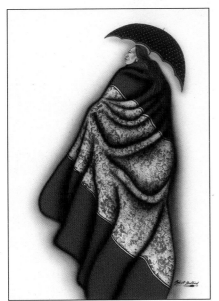
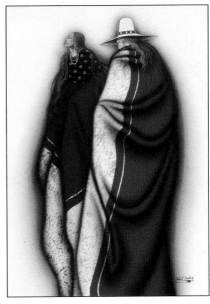

Robert Redbird

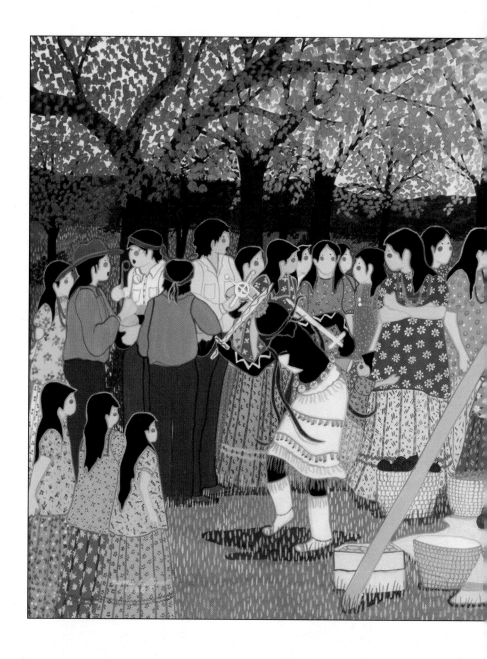

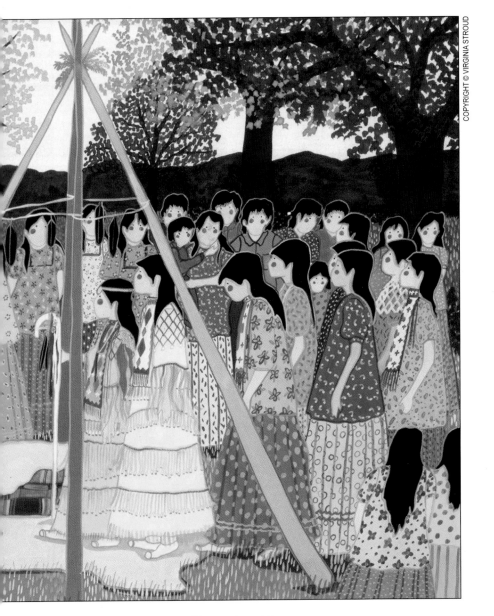

Changing Woman
Virginia Stroud

Hog Fry
Virginia Stroud

The Marrying Kind
Benjamin Harjo Jr.

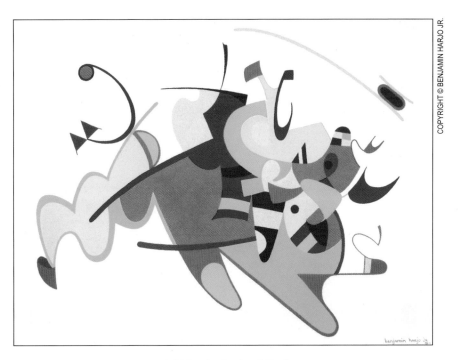

A Whole Lot of Bull
Benjamin Harjo Jr.

Waters of Life
Benjamin Harjo Jr.

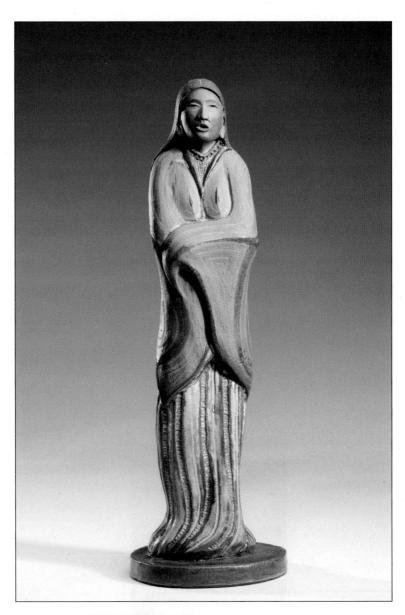

Singer
Bill Glass

Guardian of the Fire
Bill Glass

The Shield Bearers
Dennis Belindo

Warrior with Yellow Rifle
Dennis Belindo

Kiowa Gourd Clan Dance
Dennis Belindo

Speaks of the Sacred
Robert Taylor

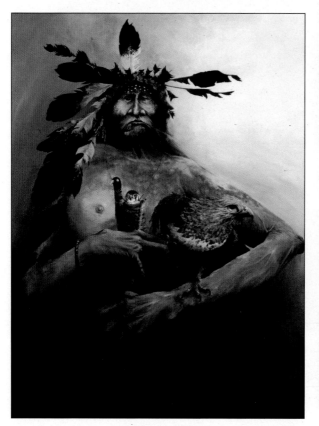

Eagle Man
Robert Taylor

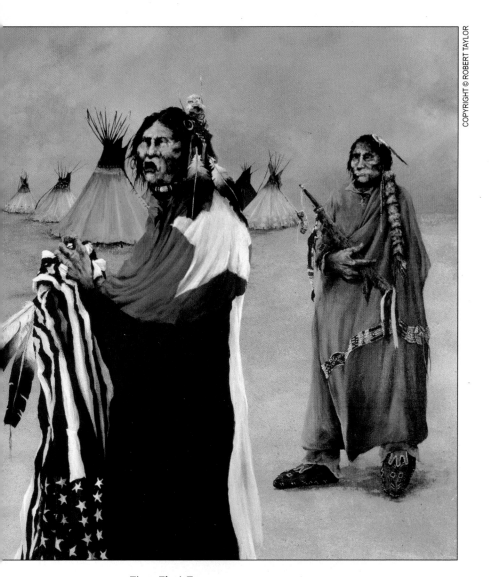

The First Texan
Robert Taylor

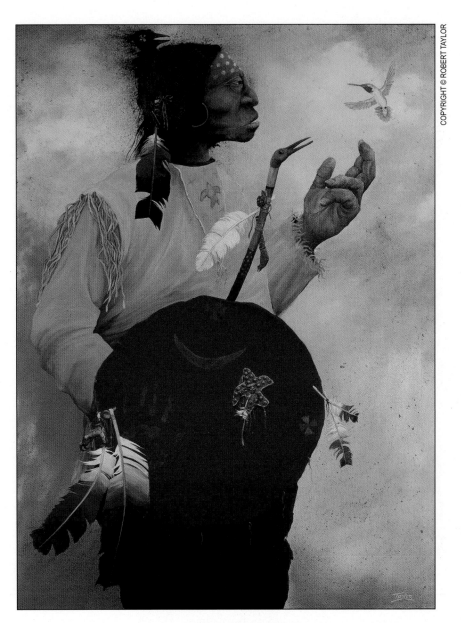

Learning a New Song
Robert Taylor

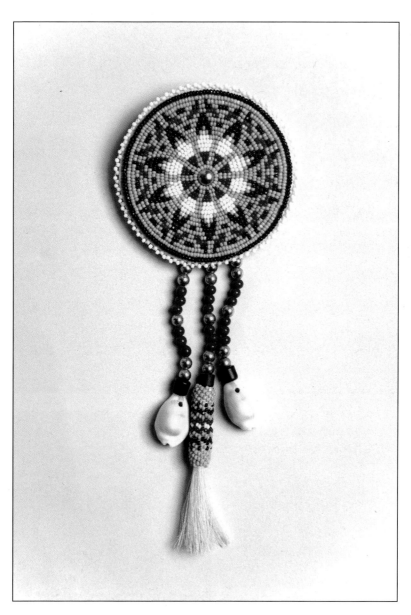

Beaded Pin Feather Medallion
Richard Aitson

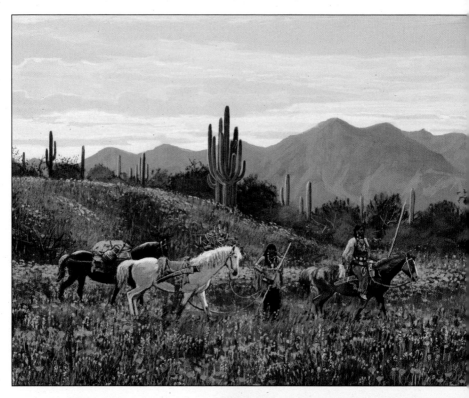

She Married a Man from Paradise
Merlin Little Thunder

First Born
Merlin Little Thunder

Through the Passages of Brighter Days
Merlin Little Thunder

The Twins and Their Twins
Merlin Little Thunder

Your Ancestors Came to Help You But You Went to Town
Merlin Little Thunder

Celebrations of Ordinary Life
Merlin Little Thunder

Brother and Sister
Merlin Little Thunder

Off to the Oklahoma Indian Art Gallery
Merlin Little Thunder

friendly, relaxed atmosphere, whenever artists and collectors gathered in the same spot, Littrell couldn't help but turn those moments into a kind of blue light special. "She'd be introducing you to people, you'd start talking, and naturally, they'd want to see examples of your work."

Doris did have a number of important out-of-state collectors, but a glance around her parking lot could be misleading. Half of the license plates marked Texas, California, or Illinois actually belonged to expatriate Okies for whom stopping at OIAG had become a homecoming ritual. One ex-pat explained, "Even though I grew up in Pryor around Bill Rabbit and the Tiger family, I didn't pay that much attention to Native art until after I moved away." Purchasing art to take back to Houston with her was a way of reaffirming and renewing her ties to her home state.

When a collector decided on a purchase—no matter how small or how big—Littrell's whole being would light up, and she would usher the party to her desk to process the transaction. Part of her excitement came from the knowledge that she had earned some income for the artist and herself, income that would allow them all to continue doing what they loved for another day. And part of it came from her belief that each painting needed a particular collector, just as each collector needed a particular painting. With each sale, a new bond that had not previously existed before was knitted between the artist, the collector, the art, and the woman who had made the match.

Western cultures like to explain art's impact as a neurophysiological dance between emotion and the senses, the unconscious mind and consciousness. Native Americans, however, believe that there is a spiritual explanation for art that transcends the physiological mechanics of perception. Some attribute art's power to the lingering presence of its maker's spirit, hence the need in some cultures, to create a "spirit hole," or incorporate a deliberate flaw in the work somewhere, to allow the spirit an escape route once the object is finished.

Others attribute the power of art to those transcendent forces that oversee the creative process, or to prayers that went out before the work was started. Because of these views, it is no stretch for Native peoples to believe that art contains healing abilities, abilities that continue to be borne out through scientific investigations. Man-made objects that are

pleasant to look at seem to reinforce the mind/body connection, in the same way that contemplating a scene in nature does. Contemplating art generates positive emotions, a feeling of well-being, and a sense of wonder and connectedness that in turn, translate into subtle physiological changes in a person.

More than one Native painter, including my husband, has heard from collectors about the calming impact their artwork had on them after falling ill. One man who was battling cancer had his painting moved from his study to his bedroom and placed across from his bed so he could see it whenever he was awake. Although the man passed away, his sons made a special point of telling Merlin how important that painting had been to their father, especially in his last days. Perhaps, it also helped ease his passage to the other side.

Robert Redbird said he once received a phone call from Los Angeles, California, from an addict/alcoholic who had been sober for several years. The man told Redbird he had gone to an Indian art show in Anaheim and had seen one of Redbird's paintings there. "I couldn't take my eyes from it. It was talking to me. I bought that painting. It's hanging in my living room to this day." The man went on to explain that after he bought it, he was able to stop his self-destructive behavior and recover from his addictions. Redbird had no doubt that seeing his "spiritual paintings," as he called them, could be a transformative experience just as the paintings of previous Native artists had been transformative for him.

No matter how you view art, or what kind of impact or influence you credit it with, there is a palpable chemistry between collectors and the art they choose. People often use phrases like "falling in love" with a piece of art. They describe what it feels like to "live with a painting" and often admit to feeling disoriented if they have to move or rearrange it. As one woman observed, "It's not a decorating thing. It's its own entity. You just let it have a space in your life."

Littrell has always understood this chemistry, and she possessed a unique gift for bringing collectors and artwork together so the sparks went flying. For one doctor, it was a process that transcended logic, because Littrell would contact him and his wife about paintings that were different in subject matter, format, even style from anything else

they had ever purchased. "It was like she was this matchmaker, she had this sixth sense, knowing what we would like even before we knew it ourselves," he said.

Doris's ability to predict her customers' aesthetic reactions was also confirmed by a professor from New York. "Sometimes when I visited the gallery, Doris would let me look around, and then she would tell me what I was going to buy. Other times, she'd tell me as soon as I walked in the door. Afterwards, she'd say, 'I'm glad you bought that. I knew you would be interested in it.'" Such prescience could occasionally work against collectors, if in her matchmaking capacity, she had decided a painting they liked was meant for someone else. This happened to another professor, later a dean, at the University of Arkansas, who recalled: "A lot of times, I'd be interested in something, but when I'd inquire about it, she'd say, 'There's only one left, and so-and-so's going to buy that—he just doesn't know it yet.'"

This collector had discovered the gallery in Oklahoma City by accident, while on an outing with his mother and quickly became one of Doris's most consistent patrons. His story reveals a lot about her ability to anticipate what even a first-time visitor might want to see. "She hardly said a word to me the whole time I was there, but every once in a while, she'd bring something out from the back, and those were always the best pieces."

Clearly, far from ignoring him, Littrell was mentally noting his movements, observing where he spent his time and what paintings he lingered over. She prided herself on being able to pick up on people's shopping styles, whether they preferred to be left alone or whether they wanted conversation and engagement. One Minnesota couple said she not only had remarkable powers of observation, but she also had super sharp hearing. "We were kneeling by a painting in the gallery, being very quiet and asking each other, 'How much do you think this is?' Suddenly, this clear voice calls back from three rooms over, 'It's such and such a price!'"

Perhaps due to her own pedagogical bent, a large number of Doris's collectors seemed to work in the field of education. They were already curious by nature, with a global viewpoint, and possessed of an openness toward other cultures, and at OIAG they could freely indulge

their love of life-long learning. There were so many questions to ask the artists, so many things to read up on, so many artistic expressions that they didn't necessarily need to own themselves but from which they came away with a deepened sense of what it means to be human, as well as a renewed delight in the sheer capacity of the human spirit for conjuring beauty. Too often one of the missing aspects of dominant society art is a lack of reverence for materials. Materials and their relationship to lifeways, to belief and kinship systems, remained at the core of the basketry, pottery, and weavings that Littrell exhibited.

For that reason, OIAG was not only popular with individual collectors, but it was also visited several times by the Collectors Club of Oklahoma City. The club was only one of several Indian art clubs that had sprung up throughout the city over the years, uniting people with a love of Native art just as bridge clubs bring together card players. Club members would meet at their respective homes once a month, where they would have a potluck dinner and a show-and-tell session based on a medium they collected. They also took field trips together and invited individual artists to give talks on occasion, paying them a small honorarium for their time. The club met at other galleries besides Doris's, but perhaps because of the ambience of hers, held several meetings there. One night, an artist who was scheduled to talk failed to appear just as Merlin and I walked in with a painting. Doris drew Merlin aside, explained the situation, and asked if he would mind speaking in the artist's place. Afterwards, when it was time for questions, one of the collectors asked how Merlin knew when a painting was finished. He pointed at me jokingly: "When she says it is!"

Club members thanked him repeatedly as they handed him the honorarium for the absentee artist, and Doris wrote him a check for his painting. We were just about to leave when she let him know discretely he might want to hang around as the art machine was still in play. His talk had inspired several members to take a second look at his other works there, and Doris ended up writing him a third check for those sales before she walked us to the door with her usual "Good-bye, dears."

"I never came home with money when I worked for Doris Littrell."
—Mimi Smith

Chapter 18
Behind the Desk

JUST A FEW YEARS INTO the gallery business, traffic through OIAG had become more than Doris could handle by herself. Remarkably, she never had to advertise for sales help. Future employees seemed to find their way there by migratory instinct. Many already were interested in Native art when they arrived, but under her tutelage, they became passionate proselytes.

Those who worked for her saw a different side of her than the artists and collectors—no less generous and no less committed to her calling—but one where her own artistic temperament occasionally rose to the surface. Not everyone shared her exacting tastes or her attention to detail, and of course, none knew the personality quirks and shopping styles of her collectors like she did.

Because so many of her patrons called ahead for appointments, she usually had ample time to bring her salesclerks up to speed in advance on each of them. But when people dropped in unannounced, she would somehow find a way to draw the clerk aside and give them a quick rundown of the person's shopping style, likes, and dislikes, after which she would conclude, "Of course, it's up to you, how you handle them, dear."

There were also certain jobs that Doris rarely entrusted to others, including hanging artwork. One woman clerk finally persuaded her to let her try, and was told, "Hang eye level and don't worry about measuring. Either you can do it or you can't." To her delight, the clerk passed the test and thereafter had the job of helping hang the paintings.

Given the number of people Doris employed over the years, it is no surprise that some possessed more sales skills than others. One sweet-tempered woman who did her best to be helpful was also, unfortunately, absent-minded and prone to making costly mistakes. One day while Littrell was gone, she sold a Navajo rug marked at $3,500 for $350, mistakenly dropping a zero. The collectors who bought it were new to the gallery and saw what was on the price tag, but were happy to let the sale proceed anyway. When Doris returned and discovered the mistake, she was understandably panicked. She called the couple, explaining what had happened and asking them to please return the rug, so she could refund their money. They refused, saying they had paid the price quoted by the clerk, and rather than fight with them, Doris let it go.

Then there was the time a retired professor from Norman, who worked part-time for her, let a collector trade three landscapes for some Doc Tate miniatures in her absence. While the landscapes were well executed, the artist was not Indian, and Doris never did understand the clerk's reasoning. "I could sell Doc Tates all day long," she explained, "I never did have buyers for those poplar trees."

The same clerk also liked calling dibs on paintings by his favorite artists as they came in, and then asking Doris to take what he owed for them out of his next check. She went along with this for a while, even as her resentment grew. She felt he was taking advantage of his position. He was supposed to follow her example, letting patrons have first shot at the work that came in. When she finally put a stop to it, the professor was crushed. For months afterward, whenever she was out of earshot, he would tell the artists in a mournful voice, "You know, Doris won't let me buy your paintings anymore." And they'd nod sympathetically, always double-checking to be sure she hadn't overheard.

This same professor harbored hopes of buying the gallery from Littrell when she retired. That was part of the reason he had taken the

job and probably one of the reasons he kept trying to buy the best pieces. He had discussed his aspirations with her, and she wasn't averse to the idea in principle. Unfortunately, a year into his job, he began introducing himself as the actual owner to new collectors walking in off the street. Doris found out and fired him. Remarkably, his disgrace did not keep him from attending art shows at OIAG or from purchasing a few paintings after that—the pull of the art was just too strong.

At the start of her clerks' employment, and regardless of their gender, Littrell would announce that she had one rule: "No dating gallery artists." The first employee to break the rule was a close friend of hers, who had emerged from a painful divorce. She took up with a painter/sculptor, also recently single, but a few months later, he was gone from the gallery, too. Not because of their romance, which Doris had come to accept, but because she caught the artist selling paintings to collectors in the store's parking lot from the trunk of his car.

Throughout the eighties, Oklahoma Native artists enjoyed a kind of rock star status with the public, complete with art groupies. While most of Littrell's artists had been married for years, we all knew at least one couple that had split because a would-be collector, or a self-described sales agent, ended up being more interested in the artist than they were in the art. Spouses who were already prone to wander, and wives and husbands who were naturally suspicious of them, could easily create an explosive situation.

Such was the case of an artist who did most of his business at OIAG and all of his visiting with Bob McCabe, yet somehow his wife convinced herself he was secretly enamored of Doris and that was the reason for his frequent trips to the gallery. One day, overcome by paranoia, she called the gallery and told the salesclerk who answered that she was coming after Littrell that instant, and she better be ready. Given the absurdity of it, Doris dismissed the threat as total nonsense and went about her tasks as usual. About an hour later, a car pulled up in front of the gallery, and the same clerk just happened to see the reflection of an Indian woman with a butcher knife in her hand in the gallery's glass door.

The woman was headed for the gallery, with her knife in full view, when she apparently thought better of it and slipped it into her large

117

purse. The salesclerk called out a warning to Doris, who hid in a storage room. When the woman entered the gallery and asked for Doris, the clerk told her Doris had just left. The unhappy wife hung around for quite a while before she finally gave up and left. The next time the artist appeared at the gallery, Doris raked him over the coals, telling him that she knew he was encouraging his wife's craziness somehow, and adding if he didn't put a stop to it, he would never set foot in the gallery again. There was no more trouble after that, and the only knife to ever be brought in again was a turquoise-and-coral-studded creation by Charlie Pratt (Cheyenne/Arapaho).

At its best, working for Doris offered a different kind of excitement: a chance to absorb some of her expert knowledge and observe her consummate business skills in action. Several people who worked under her went on to start their own galleries, and everyone who did so was eager to claim her as a mentor. Doris sometimes felt ambivalent about this, especially if she thought their subsequent business practices didn't quite measure up to her standards. She remembers one couple that visited her store toward the end of the 1990s, having stopped at several other galleries on the way. "Every time, we went in and asked what their background was, they would say they were trained by you. Is there anybody you didn't train?" they asked.

Some collectors assumed that Littrell "was rich and lived in a mansion" north of the city, possibly the same collectors that insisted she had opened her store on the "wrong side of the tracks." They were persuaded she could do better in a more affluent part of town when, in fact, she had all the business she could handle and then some right where she was. She bought two small homes at separate times during the years that she owned the gallery—all were within walking distance of the store, in the blue-collar neighborhoods that she preferred, where salt-of-the-earth people, just like herself, surrounded her.

Her homes always exhaled the same artistic serenity as the gallery, and the few pieces of art she owned were arranged with the same aesthetic. Many of these pieces were given to her by the artists as gifts, which was also the reason she was able to hold onto them. She owned no fancy electronics, never took a cruise or trip abroad. The only time she went on vacation was to visit her daughters back East. Despite her

driving phobia, she now owned a van that she let Bob use for sales trips and to drive her around when needed. Virtually all of her profits went back into her gallery. When artists had art to sell, she had to be ready to buy. One woman, who watched her and went on to work in the gallery for several years, eventually started her own Native art gallery in another city. Later, when she ran into Doris, she complained half-jokingly, "Why didn't you tell me you couldn't get rich selling Indian art?"

"I think the biggest business lesson I learned from Doris was how important it is to get to know your customers."
—Barbara Harjo

"I always felt rich because I could make a living at something I loved so much."
—Doris Littrell

Chapter 19
Home Sweet Home

BY THE 1990s, OKLAHOMA INDIAN Art Gallery had expanded from four-thousand-square feet to more than sixty-five hundred-square feet. It now occupied three storefronts in the little strip mall, spread over three floors. Each room allowed for a different kind of encounter with the art: sitting or standing, circulating with other people, or quietly contemplating paintings by yourself. Group shows were hung in the large room on the top floor, and a smaller room around the corner highlighted the work of one or two artists each month. Down one floor of steps was a narrow hallway lined with paintings and a smaller room with wall art and an antique writing desk, where Doris often consulted with clients.

The bottom floor was the one she had originally leased. She referred to it as the "The Pink Room" because of its pink carpet. There was a packaging and shipping table at one end and the celebrated "Back Room," cordoned off from the public by an old velvet movie rope. Littrell started the Back Room as a place where collectors could talk in private, but she soon began hanging it with works that she felt had special historical importance. Admission to the Back Room was restricted to her most important collectors, and most people who

entered the gallery never knew it was even there. Bob's workroom, like the packaging table, tended to float among the floors. In the 1990s, it was located next to the kitchen. He had a mat cutter there and a wood saw. A few tools hung on the walls, but its most striking feature was the rows of shelves lined with glass jars filled with screws, wood staples, hangars, metal corners, and nails—each indispensable for assembling frames and installing paintings.

The hub of activity was Doris's desk, which expanded or contracted in response to the gallery's size and prosperity. It started off as a small business desk when she opened, and by the time she closed, it had morphed into an antique rolltop secretary. In the 1990s, however, it was a massive corporate desk made of solid oak, seven-and-a-half-feet long and four-feet wide. Several full-sized paintings could be laid side by side on top of it and still leave room for Littrell's writing tablet, accountant-grade calculator, and a rolodex the size of a bingo ball cage, full of names and phone numbers. I know about the desk's dimensions because Merlin and I traded for it, along with a Mission table, and eventually, an antique bed. We might not have paid more than passing attention to any of them had we stumbled across them somewhere else. We couldn't afford vintage furniture, even if we had known what we were looking at. We wouldn't have been alone either, for another of Doris's gifts was her ability to anticipate trends in furniture, glass, and collectibles long before they caught the eye of the larger public.

This included Mission furniture inspired by Spanish colonial designs and adapted by Midwestern furniture makers in the 1890s. The simple design, solid functionality, and warm, neutral colors of Mission furniture were the perfect visual counterpoint to Southwestern pottery, weavings, and rugs. According to artist Lee Bocock, who scouted the furniture for her, Doris began collecting Mission furniture at a time when most people in Oklahoma knew nothing about it. By the time they began to seek it out, she had already bought up most of the state's supply. The same was true of the antique glass she gathered, including handmade Murano glass from Venice, which she kept in the gallery and in her home.

Although painting remained the focus of the gallery, by the late 1980s, Littrell was also exhibiting more three-dimensional artists and

inviting them to shows. Before she discovered art dealing, she had collected Southwestern baskets, ignoring Oklahoma basketry, most of which was produced by the Five Tribes. Mavis Doering changed that.

Doering, who was born in Pawhuska and schooled in California, came from a family of basket makers, but departed from traditional Cherokee basketry in her own work. She used commercial aniline dyes, often painted on her baskets, and incorporated feathers and other objects into them. Her passion for baskets was infectious, and whenever she had the chance, she would try to cajole her fellow artists into trying their hand at basket weaving. Of Doering's vast repertoire, Doris's favorites were her "pottery" baskets, influenced by the shapes of Southwestern pots.

Littrell was now also handling the artwork of Sherman Chaddlesone (Kiowa) and his wife, Allie (Kootenai), who grew up in Kalispel, Washington. The couple had met at the Institute of American Indian Arts in Santa Fe, and then spent several years in Washington State on the Kalispel reservation before moving to Sherman's home territory in Anadarko, Oklahoma. Sherman was primarily a painter whose formats ranged from ledger art to dramatic representations of Kiowa legends. He followed his wife into stone sculpture, primarily alabaster, and the two often finished sanding each other's work. Allie's subjects were women and children, their abstracted forms strongly influenced by Doug Hyde and Alan Houser. Sherman's male subjects were more detailed, and many were done as busts.

Although Littrell purchased some beadwork from Patricia Mousetrail Russell and Junior Weryackwe, this medium was not a big seller for her until she and Richard Aitson crossed paths. He had attended the Institute in Santa Fe, graduated from Oberlin College, and managed a Native art gallery in Aspen for several years. By the time he returned to Oklahoma, he was ready to make a career out of the beadwork that he had been refining since making his first dance outfits.

Aitson created his first miniature beaded cradleboards during the same period that he was showing with Doris. His best-selling items at the gallery, however, were his beaded medallions executed in stand-out colors. Up to that point, medallion necklaces were mostly seen on women's cloth and buckskin dancers as part of their powwow wear.

When Aitson began making them as fashion wear for non-Indian women, Littrell slipped them into her glass jewelry cases along with silver and turquoise Navajo jewelry, and they sold like crazy.

* * * * *

During the 1990s, a strong secondary market emerged for Native art, partly as a result of the sheer popularity of Indian art as a genre, but also as a ramification of a generational shift among collectors. As older collectors aged out of buying, their grown children wanted to have their own art yet didn't always share Mom and Dad's tastes. Often, the parents' or grandparents' paintings would end up on consignment at OIAG, many of them older, flat-style works.

Doris had been one of the first art dealers to establish a relatively high baseline price for these paintings. She continued to raise that price through her years as a gallery owner. Ironically, after she closed, other Oklahoma gallery owners lost sight of the touchstones Doris had established, and flat-style paintings, especially, whose prices Doris had nurtured even as their popularity declined, are once again undervalued relative to other kinds of Native art.

This was also the period in which Doris began doing art appraisals for individuals and organizations, so long as she hadn't sold them the art herself. It was not her favorite way to spend her time, but so many people came in requesting the service she finally made herself available. Unlike some of her peers, who had to seek out additional expert help, Doris seemed to walk around with all the knowledge she needed. Once she was contacted by PBS's popular *Antiques Roadshow* about a painting by an Oklahoma Indian artist that its staff had agreed to appraise on TV. Their researchers had estimated the painting's value at $20,000. Doris informed them that it was closer to $12,000.

She did museum appraisals of important collections for the Cowboy and Western Heritage Museum in Oklahoma City and the National Museum of the American Indian at the Smithsonian in D.C. But her most frequent calls came from her own collectors when they happened on a piece of Oklahoma Native art somewhere besides her gallery. One who relied on her extensively was the Arkansas dean, whose collecting

had not only taken over every inch of his house, but had also become his reason for being. Doris admitted she knew he was in trouble when he had his stove removed from the house and began taking all his meals out, so as to protect his paintings from any possibility of smoke damage. Now he was not only shopping with her, but traveling the country buying at art shows and other galleries. His questions were potentially high-stake ones, given the nature of his mission: to acquire a collection that would eventually be housed at the Sequoyah Research Center, the largest archive of Native American written and artistic expression in the world. Not coincidentally, the center was housed at the University of Arkansas at Little Rock where he worked. His budget was not unlimited, and he had to know he was getting the strongest possible works, in subject matter and execution, by the most important artists.

One of his early calls to Doris was about an Archie Blackowl painting he had found on black mat board. Should he buy it? Doris advised him no, explaining the black mat board being sold at the time that Archie was painting was notorious for fading. Blackowls on any other color board, yes. When the collector finally retired and opened his labor of love for its first public exhibition, he called Doris to tell her it was her collection, too. She had guided him, she had helped build it, and over a third of the twenty-three hundred pieces of artwork, ranging from Canada to Meso-America, had come from her gallery.

Not all the questions Doris fielded or appraisals she provided had such lofty outcomes. Some of her favorite and most relaxing times were the ones spent with neighborhood women, who would drop by with a weaving or lacework inherited from their grandmothers or aunts. They had no desire to sell it. They simply wanted to learn more about it. "They knew I was acquainted with stocks, materials, and fabrics because my mother did handiwork," Doris explained. She never charged for those consultations. The pleasant memories they brought back, along with the women's beams of recognition, were payment enough.

"I started handling Charlie Pratt's work when his ex-wife, Delores, came to the gallery and wanted to know if I needed any help. I knew about his work, of course, and I knew he was good. He was also good about getting markets for himself. He didn't make many shows in the

gallery because he had already moved to Santa Fe at that time. But Delores worked for me for over a year. She kept me supplied with his work because that's how he paid his alimony."
—Doris Littrell

"Walking into Doris's gallery was like walking into art heaven."
—Jeanne Devlin, former editor-in-chief,
Oklahoma Today Magazine

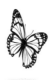

Chapter 20
Tastemakers & Culture Brokers

DORIS NEVER COURTED THE tastemakers or culture brokers of the day—they sought her out. Whether media or museum types, government bigwigs, or business moguls, they knew the information she provided would not be crafted to serve the interests of her business alone but also would take into account the welfare and interests of Oklahoma's Native artists.

One of her earliest visitors was Betty Price, a former music teacher and amateur painter. Price had worked as an assistant to Governor Nigh among others, before becoming public information officer for the Oklahoma Arts Council. There she helped plan Governor Boren's ebullient arts-focused inauguration, and went on to also initiate "Art Day at the Capitol," persuading fine artists to transport their paintings and sculptures to the state capitol at their own expense. Legislators and their staff were then invited to view the art and borrow pieces they liked for their offices.

The program was touted as a way for the artists to gain additional exposure for their work, although it was hoped that some of the borrowed pieces would sell to a permanent home from the public exposure. Because Art Day drew considerably more non-Native artists than

Native artists, Price quickly realized she needed to do some additional networking with the Indian community.

With the opening of the Governor's Gallery in 1979, she felt even more pressure to expand her outreach. The first show in the gallery was pulled from the state's small but growing art collection, which included six new pieces of Indian art by Fred Beaver, Solomon McCombs, and Blackbear Bosin, among others. However, what sent Price to Oklahoma Indian Art Gallery, and ensured her constant return, was the need to rotate the show with fresh artwork on a monthly basis. "She would ask who was doing important work, who was new on the scene, who was producing locally and how to find them," recalled Doris. Price made a point of attending many of the receptions at OIAG to meet the artists and ask questions about their work. As she gathered information and made connections, she also ended up buying a painting or two herself.

In 1985, Price became the executive director of the Oklahoma Arts Council, ushering in a golden age of public art at the state capitol and Oklahoma. She would serve until 2007 under eight governors, influencing legislation and funding for the arts and overseeing commissions for murals, sculptures, and paintings. During her tenure, two additional galleries were opened in the capitol, and the state acquired several pieces of public art by Native artists. Alan Houser's bronze *As Long as the Waters Flow*, which stands in front of the state capitol on its south side, is the most famous of these.

Houser (Chiricahua Apache) was teaching outside of Oklahoma in Santa Fe when Doris started her art dealing, so she never got to meet him. By the time she opened her gallery, he had already set aside painting for arresting depictions of Native subjects in bronze, steel, and stone. His genius at blending a modernist aesthetic with powerfully iconic images of Indian lifeways made him one of the most important, world-ranked sculptors of the twentieth century. In 1984, Governor Nigh named him Oklahoma's cultural ambassador, and five years later, through the lobbying of Price and others, the state acquired his bronze.

Doris was not involved in that effort, but she did work closely with Price to ensure that other Native artists were represented in public art venues around Oklahoma. The process by which commissions

were given involved the formation of multiple state art committees, and Littrell made at least two educational presentations to such committees. One was on Doc Tate Nevaquaya; the other, on Fred Beaver, whom she no longer represented but knew to be a worthy recipient of a commission.

Doris was a tireless advocate for public art, acknowledging that one important segment of the public was the next generation of Native artists. Many Indian artists had shared with Doris that their first experience with Native art, came not in a museum, but rather in a post office, park, or public school. Viewing murals by Mopope, West, Tsatoke, or Blue Eagle with childlike wonder, the spark of their own ambition to paint was lit. The murals had also strongly impacted generations of non-Native schoolchildren as well as the larger public, often providing both with their first exposure to Native artists. Doris counted herself among them, thanks to the murals in the post office of downtown Apache. Public art clearly had a multiplier effect upon people's awareness of art, and Doris was determined to see that Native artists received their share of the public art harvest.

> *"Many gallery owners, when they respond to the artistic temperament, they're responding primarily as business people. Doris understood the personal pressures, the professional pressures the artists were experiencing."*
> —Steven Grafe, curator,
> Maryhill Museum of Art, Goldendale, Washington

Ever since the first museums came into being in this country, the relationship between Native peoples and museums has not been a good one. In the war on Native cultures, material and cultural objects were part of the booty, whether stripped from dead bodies or dug up with human remains. In those rare instances when Native people presented themselves as sellers to museums (usually it was Native individuals selling to collectors, who in turn sold to museums), the items they wanted to sell much of the time were not theirs to sell. They were part of a cultural patrimony of a people, sources of embodied history and knowledge that were rarely intended by their makers to leave the land

or indigenous nation where they were produced. Ironically, as scholars have pointed out, by the end of the nineteenth century, the sheer volume of museum acquisitions around the nation helped spur the creation of the first Native art markets. Some of the cultural production the public had heretofore only seen in museums, they could now find versions of made expressly for sale at places like Indian fairs.

Thanks to their relatively late founding in the 1940s to 1960s within former Indian Territory boundaries, Oklahoma's museums were able to avoid some of the most egregious errors of other national institutions. Still, it took a series of cultural and social policy shifts, including the passage of the 1990 Native American Graves Protection and Repatriation Act, which mandated the return of certain burial items, sacred objects, and human remains once held by museums to Native communities, for Oklahoma's Indian peoples and the state's museums to begin to work more collaboratively.

The same is true of Oklahoma's Native artists. Notwithstanding the rich examples of Native art assembled by the founders of the Philbrook and Gilcrease museums, Native artists have not always been made welcome at the organizational table. As nonprofit institutions, museums are especially dependent upon their boards of directors, who may value certain facets of their holdings more than others. And since the board's primary responsibility is often to raise money for their institutions, its members sometimes wield a disproportionate philosophical influence upon the avenues that museum staff might wish to explore.

Despite the wild success of the Philbrook Indian Annual, which ended in 1979, the 1980s and 1990s seemed to mark its retreat from Indian art—not on the part of curators or directors. Indeed, during that time, several important exhibits were staged under Ed Wade and Lydia Wykoff, and the exhibit catalog *Visions and Voices*, showcasing the museum's collection of Indian paintings, was also produced in this period. Still, there was no interest in hosting Native art sales shows, and Merlin and I had it on good report that there were still a few board members who felt that the permanent displays of Native art at Philbrook were incompatible with its classical European art holdings.

In central Oklahoma, a different kind of argument played out between western art lovers and Native art fans at the National Cowboy

and Western Heritage Museum in Oklahoma City. In the nineties, the National Academy of Western Art show was the premier event at the museum. Competition among artists to be accepted to NAWA was stiff. There were two Native members of NAWA: Doug Hyde (Nez Perce) and Oreland Joe (Ute/Navajo). Both were sculptors who lived outside Oklahoma. There were no Native painters and no Native Oklahomans included in the group.

Merlin attended several workshops at NAWA where aspiring cowboy artist applicants to the group would perform demonstrations and give talks, hoping to increase their chances of membership. Once while he was there, he was told by a demonstrating artist, whose wife was friends with a board member, that a few individuals on the board had argued against a sales exhibit of Indian art at the museum because "Native artists already have their Red Earth Festival in downtown Oklahoma City." Fortunately, counterarguments were also offered up by museum staff as well as other board members, and eventually, the results were *Winter Camp I* (1999) and *Winter Camp II* (2001). Both were Native-curated shows, mounted at NCWH, that focused on producing Native American artists from Oklahoma. Although there have been no sales shows focused on Oklahoma Native artists since that time, they are still fairly well represented in NCWH's annual *Small Wonders*, miniature show. Doris deserves partial credit for both of these developments because she served as a resource for two curators of Native art at the museum, who were responsible for those shows, Mike Leslie and Steven Grafe.

"Doris had great leads on artists that I was unfamiliar with, and she was always willing to share."
—Mike Leslie, curator,
National Cowboy and Western Heritage Museum

"I didn't know a lot about contemporary Oklahoma Indian art when I arrived at the Cowboy and Western Heritage Museum. Doris was great to contextualize the artists with history and stories that a neophyte like me needed to get up to speed."
—Steven Grafe, curator,
Maryhill Museum of Art, Goldendale, Washington

Doris's relationships with the media benefited Oklahoma Native artists as well, and I was fortunate to play a role in that. Merlin and I first met Susan Hallsten McGarry, the editor of *Southwest Art*, at the Trail of Tears Art Show in Tahlequah in 1985. She had come to the Cherokee National Museum to judge the painting and graphic categories in which Merlin won First Place Painting. When she stopped to congratulate him, her friendly, accessible manner encouraged me to ask if she would let me submit an article on him. I assured her that my feelings would not be hurt if she felt she couldn't use it, and she agreed. As I remember, I didn't finish the article till that fall, but McGarry let me know fairly swiftly that it was accepted and would run in the magazine. At that point, I told Doris about it, and although its publication was still months away, she was as excited as we were and ordered a dozen copies in advance. A month before the issue containing my article hit the newsstands, McGarry returned to Oklahoma. This time she visited Gilcrease Museum and several Native and western art galleries in Tulsa and Oklahoma City. Doris's gallery was one of them, and after she showed up, everyone was abuzz with the news. *Southwest Art* had been growing in prestige and circulation and broadening its coverage of artists of color. Oklahoma Indian art looked poised to start receiving more national press attention.

In fact, after Merlin's article came out, McGarry asked me to do an article on Bill Rabbit, and eventually I wrote fourteen more pieces on Native artists. Not all of them were Oklahomans, not all of them showed at OIAG, but it felt like a significant step toward more national visibility for Native artists. The importance of media coverage for artists is only partly about increased sales, for as many will testify, the spikes in demand brought about by a television appearance or a feature article somewhere are temporary at best. What is far more crucial is the outside validation that media coverage implies, the fact that someone besides your spouse, relative, or peer is telling you, "This is good work." The questions that haunt every artist—"Am I doing this right? Does this matter to anyone but me?"—must be answered at least once or twice in the course of a career. The psychological and emotional stress of earning a living in art would otherwise be impossible to bear without some kind of outside validation.

There is no doubt that *Southwest Art*'s coverage of Native artists provided some of that validation. Native art sold magazines. And, according to Hallsten McGarry, covers by Native artists or featuring a Native subject outperformed all others by two to one. This coverage influenced art lovers, too. Beginning in the late 1980s, the Red Earth Festival and the National Academy of Western Art show often either overlapped or took place on consecutive weekends. *Southwest Art* had lots of readers among NAWA collectors, and the more they learned about Native art, the more interested they became. Soon those western art collectors were crossing over into Native art, attending events such as the Red Earth Festival after the NAWA show closed. And this time, they weren't simply buying pottery and jewelry as they might have in years past; they were also carrying paintings out of the city's convention center.

That said, with some magazines, there is a relationship between advertising and content that the public and even artists are not always privy to. Galleries that spend considerable chunks of money on advertising can frequently suggest to an editor or to the magazine's sales staff an artist they might want to cover. Then the gallery will offer to pay for an expensive ad to encourage the selection of that artist. McGarry, however, was known for balancing commercial and artistic interests at *Southwest Art*. She never assigned articles on artists that she didn't consider up to snuff. If she covered Littrell's artists as often as she did, it was because, in her words, "Oklahoma Indian Art Gallery was always at the top of the list for what was new in the field."

The publicity windfall reaped by Oklahoma's Native art scene during this period had another source as well: *Oklahoma Today*, the bimonthly magazine of the State of Oklahoma. Founded in 1956, the magazine in its early years had covered Native art, starting with the Kiowa Five, but by the 1980s that coverage had become nonexistent or sporadic at best. The 1990s, under the editorship of Jeanne Devlin, saw all that change, and it changed in large part because Doris was there to act as a guide for the young editor.

Devlin did her first special Native American art issue for November-December 1990, accompanied by an exhibition of works by thirty painters organized by the magazine's publisher, Sue Carter; by 1992, the special Native American art and culture issue was annual, and by

1993, Devlin had added a visitor's guide to the Red Earth Festival, which had been happening each June in downtown OKC since 1986. Much of *OKT*'s coverage was picked up in some form or another by other media both domestic and international, including the BBC.

As managing editor, editor, and then finally editor-in-chief, under three publishers and three governors (Democrat and Republican), Devlin made coverage of Indian Country a centerpiece of the state's magazine—while maintaining a strict separation of church-and-state, which meant that editorial coverage was independent of advertising.

In addition to profiles of Native artists and craftsmen, feature stories on Native languages, sovereignty, culture, and traditions were also added, and profiles of contemporary tribal leaders appeared. Over time, Devlin built a list of Native free-lancers and other contributors. I met Jeanne for the first time at one of Doris's shows, and when she found out I was writing for *Southwest Art*, she invited me to do free-lance work for her as well. Subscriptions rose, and the magazine won four International Regional Magazine Awards during this time, competing against magazines two and four times its size, something Devlin believes the expanded Native cultural content helped make possible.

Her use of Native art was not confined to Native content either. She tapped images by Native artists for any and every story she thought needed strong visuals. And again, her relationship with Doris proved invaluable. Explained Devlin, "Doris had the best of the best when it came to Native American art. She understood that a magazine like *Oklahoma Today* was not looking for run-of-the-mill generic things. We wanted to showcase Oklahoma food, art, and traditions that were world class—the reasons why a person should come visit our state or why an Oklahoman should be proud. We might not have the Alps for skiing or the fashion of Paris, but our Native arts and crafts rivaled anything in the world. Doris taught me that."

"Doris promoted the artists and encouraged them as much
as their own mothers did, maybe more."
—Karen Rabbit

"Doris's name kept popping up. I always tried to find Oklahomans

who were the best at what they did when it came to the stories we did, so I went to the gallery to pay her a visit. What I liked was that she was so warm and unassuming. I've lived back East, I've done the New York gallery thing, and I never liked the airs that go with it. Art is for everyone; it is important to each and every one of us. Doris embodied that. She loved, as did I, that for eons Native peoples have used art to beautify everything from their garments to their utensils— they lived daily with beauty. And the joy she got out of her work was obvious. When you've interviewed a lot of people, you learn those who stand out, those who are the best at what they do, also have a tremendous passion for what they do. At the age of sixty, seventy, or eighty, they bring an energy to their calling that completely exceeds what a lot of aspiring talented twenty-year-olds bring to the table."
—Jeanne Devlin

Perhaps the most celebrated public figures to frequent OIAG were the Oklahoma power couple David and Molly Boren. Doris met David Boren in 1973 while she was still selling art as a dealer and he was serving in the Oklahoma House of Representatives. Born in Seminole, Oklahoma, Boren's early exposure to Native culture included stickball games and feasts at the Mekusukey Mission. During his last year as Governor of the State Oklahoma, he married his second wife, attorney and Choctaw tribal member Molly Shi. Yet it was largely after he was elected to the U.S. Senate, the same year that Doris opened her gallery, that the Borens became avid Native art collectors.

For a while the Borens attended some of Littrell's gallery openings, but as the public spotlight upon them expanded, they began making appointments with her in private. They would come in to view the shows after hours where they could contemplate the art uninterrupted and ask questions at their leisure. When Boren moved from the U.S. Senate in 1994 to become president of the University of Oklahoma, they leaned even more heavily upon Doris's knowledge and expertise, partly because of the vision they had for the university.

One of Boren's early goals for the school, in addition to improving OU's academic standing, was to draw out its cultural uniqueness and enhance the physical appeal of the campus. Among other accom-

plishments, he oversaw a two-wing addition to the university's Fred Jones Museum and increased its donations of significant collections by 90 percent. Molly took charge of the campus's artistic transformation, which included the installation of fountains and sculptures and the addition of paintings in the OU rotunda, library, and student union. Much of the work added was by Oklahoma Indian artists, everything from mural commissions to commemorative posters, and many of the artists were ones she had met through Doris.

When the Borens had out-of-town visitors, besides showing them the usual Oklahoma tourist spots, they would take them to OIAG. Boren had long ago paid off an antique rocker at the gallery, and asked Doris to keep it there for his personal use. The minute their party hit the gallery, he would head straight for his rocker, sit down, and close his eyes. The first few times Doris thought he was simply tired and in need of a nap, but she quickly realized he was giving her the floor. "He knew that if he was watching, his visitors would use all their time talking to him, and he wanted them to be looking at the art," she said.

Boren often said publicly that Doris's "trading in art was not a business but a calling." But as someone who likes her praise with a pinch of salt, her favorite compliment from him was a backhanded one Boren made in 2011 at the University of Oklahoma's Children's Medical Center. Boren was there to help dedicate a collection of Native art given to the center by one of its teaching doctors. Although only a few of the pieces had come from OIAG, the donor, who also admired and often consulted with Doris, had invited her to attend. As Boren chatted with someone minutes before his official speech, he noticed the gallery owner sitting a few seats away. "When I was governor of Oklahoma," he said, raising his voice so she could hear, "I only owned one piece of Native art, but that was before I met Doris Littrell."

"I never had any formal training in art. I felt like it was God-given that I had a talent for picking fine painters."
—Doris Littrell

Chapter 21

Artist Stories: Doc Tate Nevaquaya

ORIS WORKED HARD FOR all of her artists, but her emotional investment in them naturally varied. She was human after all. One of her deepest bonds was with Joyce Tate Nevaquaya, also known simply as "Doc Tate." Their connection went back to their shared hometown of Apache where her younger brother, Bill, had attended school with the artist. She could never recall any school encounters with Doc, but he once confessed at a reception that he and his friends often played by Cache Creek near her house, and whenever they saw the "white girl with the pretty legs" approaching, they would duck under the footbridge for a better view.

Doc's unusual first name, Joyce, was one he shared with several men in Apache, a nod to Doctor Joyce, the town's physician, who had delivered them all. No one ever seemed to be able to recall why Nevaquaya was the only one of the men to carry the medical honorific of "Doc" as well. Perhaps it was because as a boy, Doc was a constant escort for his blind grandfather, and hence spent considerable time absorbing the words, stories, and wisdom of him and the other tribal elders. When he acquired eyeglasses—the same black glasses he kept for much of his life—he even had the look of a medical doctor. His

strong but proportionate features gave him a serious air, although in truth, no one was more prone to joking and teasing. He was fastidious about his appearance and style of dress, so much so that his family surname, Nevaquaya, "tired of looking pretty," was a misnomer by the time it reached him.

Doc loved drawing and art as a boy, but his interest was further piqued when his mother showed him a newspaper clipping about a local up-and-coming artist, Alan Houser. He may have pondered how rare it was for a Native man to be mentioned in the local paper. He may also have made a mental connection between this positive story and the fact that the man was an artist. Whatever Doc's thoughts, after he read the article, he began to keep a look out for Houser, who often rode through the area on his bay-colored horse.

When Doc was thirteen, his parents were killed in a car wreck, and his brother, Malcolm, went to work to try to keep the family together. Unfortunately, his wages couldn't support all seven siblings, and Doc was sent to boarding school at Fort Sill Indian School in Lawton.

Like other boarding schools in the 1940s, Fort Sill vigorously promoted art instruction for its students, but Doc refused to take any art classes there. Already blessed with a strong, independent streak, he didn't want the teachers imposing their ideas of Native art on him. Instead, he spent his free time hanging out with fellow Comanche artist and storyteller Leonard "Black Moon" Riddles, and he studied paintings by Acee Blue Eagle and Archie Blackowl on his own. After graduating from Fort Sill, the now aspiring painter attended Haskell Junior College and served a stint in the U.S. military. He taught at Riverside Indian School in Anadarko for a couple of years, selling art here and there on the side.

When Doris Littrell stumbled across his work in the Southern Plains Indian Museum gift shop, it may have been the first time he had placed work there. It was a rainy spring morning in 1955, and she and Bob were making a buying run to Anadarko. McCabe wasn't thrilled about driving in the rain, but Doris wouldn't be dissuaded. When they arrived at the museum, she walked right into the gift shop, as was her habit, to see what was new. Glancing at the locked glass case behind the shop counter, Doris spotted a miniature painting and

asked to examine it. It was a painting of a Comanche couple in buckskin dress, sitting atop their horses. She still couldn't quite make out the signature, so she asked the director, Rosemary Ellison, who had painted it.

"Doc Tate," said Rosemary.

"I didn't know Doc painted," said Doris. "Where does he live?"

Ellison nodded at a nearby Indian woman. "That's his wife, Charlotte. Ask her."

After Doris talked to Charlotte and heard they were living at Doc's home place, she didn't need directions to get there. She got back in the car and told Bob to drive west toward Apache. The rain continued to pour down as Bob turned off the main asphalt highway onto a gravel road, then onto a series of sodden dirt roads, pooling with water. By the time he pulled into the Nevaquaya's red-dirt driveway, Bob told Doris he wasn't getting out and would wait for her in the car.

Undeterred, Doris took off her high heels and stepped gingerly through the mud until she reached the porch. Then she wiped off her feet and nylon stockings as best she could, put back on her heels, and knocked on the door. It took Doc a long time to answer, and when he did, he didn't recognize the woman on his porch. After she prodded his memory, he opened the door a little wider. She told him she had seen his painting at the gift shop. Did he have any more for sale?

Doc's version of the story was even funnier, and in true storyteller fashion, he would tweak the details, depending on his audience. "It was raining, pouring down rain, and I heard a car honking at the gate. I wondered who could be coming out on a day like this. After a while, I saw this lady get out. She had a real nice business suit on. She took her high heels off and walked up the road, about ankle deep in mud."

When Doc told the story to an all-Indian audience, it became even more hilarious. He would describe the black Cadillac Bob was driving (Phil Anderson's Cadillac, in fact), with a number of "Boy, I tell you whats" thrown in. The mud grew increasingly deeper—from ankle-deep to shin-deep to knee-deep—until his audience was doubled over with laughter. Both Doris's and Doc's versions, however, shared the same ending: she bought four paintings from the artist and promised to return for more.

Nevaquaya often said that Littrell's visit was a career turning point. It convinced him that he could make his living in art. As they worked together, his ongoing growth as a professional artist would come to shape Doris as much as it shaped him. "I never had to advise him about business matters," she noted. "From the beginning, he had a strong sense of himself and what his paintings were worth." Doc Tate loved landscapes, and his grasp of anatomy and complex compositions introduced a new level of sophistication to the flat style he favored.

There was a waiting list at the gallery for his black silhouette paintings, which were usually structured around a rising or setting sun. First, he'd paint a tangerine-infused sky on white mat board. Then, go back with a black horizon line and paint the foreground black. Last of all, he'd add the black silhouettes of his subjects, stopped in their tracks by the sheer beauty of the scene. His paintings on black mat board, which had improved in quality by then, were equally dramatic and even harder to execute because, as Doris explained, a single erasure could ruin them. Of all the artists she handled, she always said, "Only Doc and Acee Blue Eagle had a touch sure enough to sketch directly on black."

Along with his painting, Nevaquaya single-handedly revived the Indian flute for the Comanche Nation. He learned to make and play the flute and collected Comanche flute songs. Doris recalled him playing the flute when he delivered art to her; he would stand in a corner of the house with his back to her and Bob, so he could summon up the mental image of a creek bed when he played, and modulate the sound accordingly. The flute also surfaced in his paintings, especially in courting scenes—playing flute being one of the primary ways young Comanche men tried to woo young women under the watchful eyes of their relatives.

Nevaquaya's mastery of materials didn't come without bumps. Once, he painted a night scene with a Comanche flute player for an opening at Doris's gallery, using tempera paint on black mat board, notoriously known for its slick finish. He was determined to give the full moon a three-dimensional effect, so he poured the tempera paint directly on the mat board, letting it pool in a large circle and then dry.

Doris found the perfect hanging spot for the painting, and almost as soon as she opened the doors that night, the painting sold. The cou-

ple that bought it was from out of town. They wanted to take it with them, and as they stood visiting with Doc, the salesclerk arrived to remove the painting from the wall. No sooner had she lifted the painting off the hook than the moon slid down to the bottom of the frame. The embarrassed artist offered to fix it, but explained he would have to take it home overnight to do so. The couple delayed their departure by a day, and when Doc brought it back, he explained he had repainted it with several thin washes of acrylic.

Doc earned numerous laurels over the course of his career. He played flute at the Kennedy Center during the Night of the First Americans, a fund-raiser coordinated by several Hollywood celebrities to benefit Indian education. He was the first Oklahoman to win a National Heritage Award from the National Endowment for the Arts and was later designated a National Treasure by then Oklahoma Governor Frank Keating. Mugg's early designation of him as her media spokesman undoubtedly helped prepare him for the subsequent national television appearances in conjunction with his honors. Still, despite his stature and artistic achievements, his financial situation was always precarious.

Doris did her best to fix that. She sold and promoted his work at OIAG, and also put him in touch with galleries in New Jersey and California, both of which hosted shows for him. In 1982 as Oklahoma's seventy-fifth birthday, the Diamond Jubilee, was being planned, one of the state arts committees asked Doc to create two coins for the occasion in collaboration with the Franklin mint. For one of the coins, Doc used the image of a gourd dancer from a painting that he had sold Doris. Then another party asked permission to reproduce the painting, and the coin and painting were marketed together, with the artist receiving a share of the proceeds.

In the mid-nineties, Doc's relationship with Doris became strained when he began selling to a different gallery inside the fifty-mile radius she considered her sales territory. If another artist had done that, she would have asked him to leave, but because it was Doc, she bit her tongue and did nothing. A few months later, she asked as pleasantly as she could how the new gallery was doing for him. "You know, you're the only one who ever sells anything for me," he snapped back. Perhaps because of this tension, Doc's wife was dubious when he told her one

Saturday that he was taking Littrell a Native American Church painting. But Doc knew the gallery owner's fondness for that subject, and, in fact, he had already described it to her over the phone. When he arrived at the gallery, there were so many artists and collectors surrounding Doris that she found it impossible to get a moment with him in private. "Finally, I wrote down on a piece of paper, 'How much?' He wrote his answer, and I wrote him a check," she recalled. "I still hadn't looked at the painting."

After everyone left, and she finally had time to peruse it, she thought about calling him. "I wanted to tell him how beautiful it was and how glad I was he had brought it in." She never got the chance, though. A few days later, the sixty-three-year-old painter succumbed to a massive heart attack.

Doris knew Charlotte and the rest of the family would be devastated, so despite her own shock and grief, she immediately began helping Charlotte with funeral preparations. On the day of the funeral, she rode to the services with a friend, and when they arrived, the high school auditorium in Apache was overflowing with people. Doris went to look for chairs in the back of the room for them. But Charlotte had been waiting and watching for her, and she sent someone after Doris to bring her up front so she could sit with her and her sons. She wanted everyone to see that Doris had earned her place with the family because of her lifelong commitment to Doc and his art.

Chapter 22
Artist Stories: Mirac Creepingbear

IF DOC TATE WAS Doris's polestar, artist Mirac Creepingbear was her Halley's Comet. The Kiowa/Pawnee and Arapaho artist grew up in Carnegie, a small town of some seventeen hundred residents and the Kiowa Nation's headquarters. Art ran in Creepingbear's family. His maternal uncle, painter Herman Toppah, provided him with his first drawing supplies.

As a teen, he had every intention of following his cousin Sherman Chaddlesone to the Institute of American Indian Arts in Santa Fe. Instead he ended up marrying his high school sweetheart, Janis Buffalohead, and went to work as an electrician to support his new family.

The only formal art training Mirac ever received was a six-month commercial art class at Okmulgee Technical Institute, and while some artists take pride in being self-taught, comments Mirac made led Doris to believe that the artist was always a little self-conscious about it.

She discovered his art in 1980, a year after she opened her gallery, on yet another trip to Anadarko. She and Bob were driving past the newspaper office in town when she spotted a large, brilliantly colored canvas in the window. It was a stylized image of a Kiowa man draped in a vibrant red blanket. "There was something about the strength of the

face that made it alive to me," she recalled. "I told Bob, 'That's the most exciting work I've seen in Oklahoma. Let's talk to McBride about it.'"

Despite her extensive interactions with Joe McBride as a dealer, she hadn't been in touch with him since she had opened her gallery. She told him she was interested in the painting in the window, and he agreed to sell to her, along with another Mirac he had. As she quizzed him, he explained that as far as he knew, the Kiowa/Arapaho artist had been painting for a living since 1974. He had won an Honorable Mention at the Philbrook Indian Annual in 1978 and Southern Plains Indian museum had recently mounted a one-man show for him in March. He also had sold a few works to the Galleria in Norman, which would soon include him in one of its group shows.

Yet for some reason, none of these shows had done much to boost his visibility with collectors. He still did most of his selling around the Anadarko/Carnegie area because he could not afford to venture any farther out. McBride agreed with Doris that Creepingbear's work deserved a wider audience than it was finding, and it wasn't long before he gave the artist her number and encouraged him to make a trip to Oklahoma City to see her.

Like other artists before him, Mirac must have recognized the quality of the art in the gallery and the aesthetically pleasing way it was arranged. He may have been caught off-guard, however, by the gallery owner's willingness to pay the first price he quoted her. Back home, McBride and other locals approached buying art as a bargaining process. The artist named a figure; the potential buyer came back with a counteroffer. Mirac was soon regularly making the round trip between Carnegie and OKC with paintings, confident Doris would not turn him down, thereby leaving him without gas money to get home.

His images moved her emotionally in a way few others had. "I could see thought and intention and heart in them. They never looked commercial." Because of that, six months after she bought her first painting from McBride, she told Mirac she wanted to schedule a one-man show for him. She promised to advertise it and buy as much work as she could in advance, but she also told him he needed to bring her paintings on consignment. Mirac did his best to produce for the show, which took place in September of 1981, delivering seventeen pieces of

art. Unfortunately, they were mostly drawings and a few watercolors—not exactly what Doris had envisaged.

This was partly a matter of finances. Mirac still struggled to find the funds necessary to buy art supplies, and watercolor sets, paper, and mat board were more affordable than acrylics and canvas. His style was still in flux, too, ranging from realistic portraits to more expressionist work, but most of his images expressed an ability to capture emotion and a sense of character that hinted at his major works to come.

Doris had Bob mat, frame, and photograph all the art and sent pictures out to her collectors before the show opened. All seventeen pieces sold during the opening-night reception, and word about the substantial turnout spread quickly. Soon Creepingbear found himself being invited to show in other galleries, at a group show in 1982 at the Galleria, and at a group show at the Nuwudahi Gallery in Austin in 1985.

Yet even as he started having the means to buy supplies and travel, even as his reputation began to grow, the artist's drinking became more of a problem. He didn't drink all the time, but when he was on a binge, he could lose days and occasionally weeks of painting. In 1987, he and his brother, Ted, a stone sculptor, took a booth at the Red Earth Indian Arts Festival in Oklahoma City. Mirac put one piece in the booth, *His Father's Society*, the largest acrylic he had ever painted, and then went off to party. He was gone for most of the show, although he reappeared at the very end, instructing Ted to call Doris and see if she would buy the painting wholesale. She did.

Indian humor can tackle all kinds of subjects, including drinking, and one of Mirac's exploits from that period has been told and retold in Native artist circles for years. As the story goes, Sherman and Allie had invited the painter to travel with them to Colorado Indian Market in Denver, where they were going to share a booth. Before they left, Creepingbear appeared at the gallery and asked to borrow one of his paintings from Littrell. He explained he hadn't been able to finish as much work as he had hoped for the show, and he needed more artwork to round out his booth display.

Often when Doris owned a painting by an artist, she would allow the artist to sell it and reimburse her. She was especially fond of this

painting, however, so she agreed, but with the caveat that she wanted it back. He assured her that he would mark it "Not For Sale" and return it right after the show.

Several artists from OIAG attended Colorado Indian Market that year, and afterwards, they started trickling in to see Doris. Some had paintings for sale; others simply dropped by to tell her about the show. Only Mirac failed to appear. At first, she assumed he was busy finishing something else so he could make a sale at the same time that he returned the piece he'd borrowed. Then she heard from another artist that the painting she'd loaned Mirac was sitting in the window of the Art Market in Tulsa. For sale.

Doris immediately called the owner, Linda Greever, who had, indeed, bought the painting, having no idea that it already belonged to Doris. She apologized and explained that she would be happy to return it, but Mirac had picked it up a day earlier to borrow it for a show. As soon as Greever heard herself say that, she realized she, too, had been fooled. Several months later, Littrell traced the painting to a third gallery owner who refused to release it for anything less than its full retail price. By the time Doris finally got the painting back, not only had its price tripled, but Mirac was looking more and more like Saynday, the Kiowa trickster.

Try as she might, however, Doris could never stay mad at the artist, especially since he often didn't remember what he had done during his binges. His dramatic imagery and explosive palette made any attempt to keep track of his offenses seem petty. In 1986 at Sherman Chaddlesone's invitation, Mirac and Parker Boyiddle (Kiowa/Delaware) exhibited at an all-Kiowa show at the Institute of American Indian Arts. The show assembled works by contemporary painters and sculptors alongside historical works by the Kiowa Six. According to Chaddlesone, Mirac loved being in Santa Fe, showing at the school he'd dreamed of attending when he was young, and IAIA students and instructors returned his affection, treating him like a valued alum.

In 1990, Chaddlesone, Creepingbear, and Boyiddle were commissioned by the Kiowa Nation to do a mural for the tribal complex in Carnegie. The mural had three separate sections: mythical, historical, and contemporary, and each artist chose what they wanted to paint.

Mirac chose Kiowa prehistory, although the mythical portion of the mural would also have suited his talents. The most enjoyable part of the project, according to Chaddlesone, were the "listening sessions" with Kiowa elders who visited the complex once a week to share tribal histories with the painters and provide cultural feedback on their work.

Throughout this period, Mirac's relationship with Doris remained productive, if complicated. He continued to enjoy Bob's company more than hers, partly because he saw Bob as a fellow artist for the way he matted and framed art. At the same time, Creepingbear could discuss serious matters with Littrell that he simply couldn't raise with Bob. "Sometimes he'd drop by or call on the telephone and asked me about painting things. Not how to paint, but how the different things he tried affected me as a viewer," said Doris.

He appreciated her taste in other areas, too. When he separated from his wife and moved into an apartment with his daughter in Carnegie, Doris learned through the grapevine that they didn't have a stick of furniture between them. She offered to do a partial trade on paintings for furniture, and he agreed, selecting several vintage pieces from the gallery.

She undertook another show for the artist in March of 1990. This time she made it clear the focus needed to be paintings. "I hope you'll paint for it and have income from it," she told him, "but if you don't, I'm going to have it anyway, and I'll buy the whole show from McBride." After that, he would call periodically to assure her that he was working, but as time slipped by, his communication became more erratic. Two weeks before her opening, she called him at his daughter's house. "I'm spending all my time on one large piece. I can't get the black right," he complained. "I wish I had gone to school, but then, I guess, it wouldn't be my work so much."

The news threw Doris into high gear, and she began pulling together watercolors, acrylic, and oils from her own inventory and others'. Soon she had assembled forty pieces, many of them older works, dating back to the mid-eighties, and none, except those she owned, were matted or framed. That put pressure on Bob, who somehow managed to finish all the framing and still photograph each of Mirac's pieces in time, making an extra set of photos for the artist as well.

Creepingbear walked into the gallery a few hours before the show with two pieces of art, the *Kiowa Sun Dancer*, which had given him so much trouble, and a small pastel. He was thunderstruck as he looked around and saw all the paintings Doris had gathered, spanning a period of fifteen years. "I did all this?" he asked.

He could not suppress his amazement at the prices, either. One painting that McBride had priced at $400 (and perhaps bought for $150), Doris had marked $4,200, "because that's what it was worth." She explained to Mirac that she would split the markup with him on pieces that she had repriced in order to protect the market she'd established for him among her collectors. Many of the paintings in the show were those associated with his mature style: metaphoric subjects crackling with energy, dynamic compositions of a world in flux in which a river of spirituality seemed to stand ready at any moment to burst through the world of appearances, like water through a dam.

Bob gave Mirac the set of pictures from the show, and the artist carefully put them in his wallet. Then before unlocking the doors for the public, Doris asked if he would let Bob videotape him that evening, talking about his paintings. She explained that she wanted to share the video with some of her collectors who might not be able to attend the show in person. Mirac consented, but he was clearly annoyed by her request. At various points throughout the filming, he would turn to the camera, as though addressing Doris, and ask, "Have I thanked you enough? Now have I thanked you enough?"

Opening night sales were fairly good, but it was not a sell-out show like before. There were a lot of paintings left by the night's end and Mirac was disappointed and worried. Maybe raising his prices was not such a good idea. Doris reassured him that after her collectors went home and thought about the work, they would come back and buy them at the prices she had set. She was right. By August of that summer, after she calculated his percentage of the new prices, he had earned enough money from the show to buy a small sports car with cash.

As soon as he purchased the car, he set off to visit his sister, Myra, in Los Angeles. Every time he stopped along the road, he would pull the photos of his paintings from his wallet and go over them as if to confirm the show had really taken place. A few days into his visit, he

was driving around the city when he got lost. As he stepped out of the car to ask directions, leaving his wallet in the glove compartment, he was attacked by a group of thugs who beat him severely and stole his car.

His mother, Rita, flew out to be with him as he remained in critical condition in the hospital. As soon as he was able to talk, he called Doris and told her what had happened. "He kept talking about the photos in his wallet," Doris recalled. "I think he was as upset about losing them as he was about losing his car."

Then he began to worry that Mirac Jr. would have to start school without new school clothes, so he sent his mother to buy some pastel crayons and paper for him. He did a small pastel drawing from his hospital bed, and instructed her to take it to the gallery when she got back home. Doris was hopeful the drawing meant that the artist was on his way to recovery, but he remained in the hospital two more weeks. After he was discharged, he lingered at his sister's house in California, hoping the police would find his car. They didn't. He returned to Carnegie in September by bus, a trip of more than twenty-eight hours.

On his return, he moved into his mother's house. He still didn't feel well, but his close call in Los Angeles had caused him to make some resolutions about his health. He began running and started taking a popular weight loss product, perhaps not knowing that he was diabetic. He also may have been trying to quit drinking. What is known is that on a night in early October, he rolled off the couch onto the floor at his mother's. He was rushed by ambulance to the Indian hospital in Lawton but never regained consciousness and died soon after.

In a repulsive phenomenon, known all too well to artists, his artwork immediately went hot. People who had never given his paintings a second look while he was alive suddenly had to have a Mirac Creepingbear. Those who had bought paintings from him for virtually nothing were offering to sell them to others for a huge profit. Doris, who paid the funeral bill for the artist, found the whole scene revolting.

After a year had passed, she organized a memorial retrospective of Mirac's work, inviting his family and artist friends, as well as collectors. There the sweep of his artistic vision and his transcendent imagery added another layer of poignancy to his premature death. A video player

was set up in one of the rooms, so that people could watch the only extant video of him, the one that Doris had asked Bob to tape.

It is difficult to speculate what Mirac's career might have looked like had he only been granted more time to paint. But it is easy to imagine what would have happened if Doris hadn't entered the picture. She recognized his genius early on, and it is no accident that he achieved his period of greatest artistic growth during the time she handled his work. She was the only gallery owner to give him two solo shows and to set a market for his paintings that allowed him to earn a living wage with his work. She worked tenaciously to see he got the recognition he deserved, at least a little of which he got to enjoy during his all-too-brief life.

*"In my work I try to show the strength
and character of our people."*
—Mirac Creepingbear

Chapter 23

More Artist Stories: Merlin Little Thunder

W HEN MERLIN THINKS BACK ON his career with Doris, many of his memories are focused around preparing for her shows. He has never painted as incessantly before or since, and the week of an art show, he would usually pull one or two all-nighters. It was a physically exhausting, spiritually demanding ceremony, and while I finished installing the last painting or so, he would jump in the shower and throw on his clothes. We would pack the paintings in the back, and I would drive, while he sat on the passenger side, insisting he wasn't sleepy, although twenty minutes later, he'd be out cold. He would wake instinctively as I turned off the interstate onto Forty-Fourth Street, and once inside the gallery, drink cup after cup of coffee even as the yawns came pouring out of him like air from a flattening tire.

He first heard about Oklahoma Indian Art Gallery from a fellow artist, Randy Wood, who had sold a few paintings to Doris off and on. At that time Merlin was selling to the Galleria in Norman, a Native art gallery owned by Reba and Clarence Olsen. He had to pay friends to drive him there, though, and because they usually bought what he had, stopping at Littrell's gallery on the way back to Tulsa would have

been pointless. One day, however, when he arrived at the Galleria, the Olsens were gone, and he asked his friend to stop at OIAG on the way back. Unfortunately, Doris was gone, too, and someone else was minding the gallery, but he walked around, looking closely at the art. "Some of her artists were really good. I didn't know if I could make it there. I thought they might overshadow me," he recalled.

Those doubts led to me being the first one to officially meet Doris when we found ourselves at a slow art show in Guthrie, Oklahoma. Merlin had borrowed his uncle's truck for the occasion, and we didn't have much inventory: a colorful oil painting, one small acrylic, and one framed print. The only thing he'd managed to sell by early afternoon was the print and a sketch he did on the spot, while sitting at the booth. That wasn't enough to cover the frames that we'd written a post-dated check for, or to ensure that after we put gas in the truck, we'd have money left for groceries.

He suggested we split our sales efforts. He would keep the less expensive acrylic at the art show, and I would drive to Oklahoma City and try to wholesale the oil painting at OIAG. We knew it might be a wasted trip, but given our situation, a risk worth taking. When I walked into the gallery, I had the same reaction as Merlin: this was a gallery unlike any other I had seen. Doris greeted me, and I asked if she was familiar with Merlin Little Thunder's work. She said yes, that she'd been "following his career with interest." That was my opening to show her the oil: a portrait of a Cheyenne man in an otter-skin hat, set against a background of loose swatches of yellow, purple, and red.

Doris examined the painting carefully, asking about my relationship to Merlin and where he was showing in Tulsa, although I suspect she knew the answer to the last one. The longer she looked, the more certain I was that I would leave with a check. Yet at the end of our conversation, she handed the portrait back. "I really can't sell one painting by itself. It takes at least three to make a presentation. If you'll bring me a grouping next time, I'll be happy to look again," she told me.

Normally, I would have been depressed about returning empty-handed, but not on this occasion. I was certain that Merlin belonged in the gallery and that Doris was genuine in her interest. Driving home, we discussed our fall-back plan. We would contact the framer to hold

our check and take the painting to our friend at the pawnshop who was married to an Osage woman and who never charged us interest. Then Merlin would start some new paintings for a grouping, as per her request. In a week and a half, I was back at the gallery with five paintings in hand. I was still by myself; Merlin had insisted on staying home to paint in case the trip didn't pan out.

Doris talked with me even longer that time, wanting to know about Merlin's background. I told her about his growing up in the country, in the Southern Cheyenne community of Fonda, the pharmacy classes he had taken at Southwestern State College, and the year he spent as an art student at Bacone. She asked me what I did for work and if we had any children. Then she offered to buy three paintings if I would consign two. She wrote me a check and gave me directions to the bank so I could cash it before it closed. A few days later, she called the house. "Merlin's a hit," she told me. "I've sold three of his paintings, and I've got bites on two more. I'm mailing you a check for the consignment pieces right now. Let me know as soon as he has more work ready."

We were stunned. The gallery owners we knew never called when something sold. If it was a consignment piece, they certainly didn't call the same day that it sold. In fact, they rarely told us when they ran out of work, figuring we'd show up with more paintings sooner or later, and as far as they were concerned, it was usually too soon.

There were other differences with Doris, too. When Merlin delivered art to her, she didn't merely look at his paintings, she studied them carefully. She asked thoughtful questions, often grabbing a pencil and notebook and writing as he talked. If the subject struck a strong chord with her, her eyes would brighten with tears, and she would hurry to write him a check and send him on his way. Then she would apologize for getting emotional, not realizing that was exactly the response he hoped for. "The most demeaning thing you can say to an artist is, 'That's nice.' You think either they don't understand this or it's not strong enough," said Merlin. He relished her emotional responses and soon took to pointing out paintings to me that he thought were especially strong and joking, "Look at this. This'll make Doris cry."

Once we started selling to her, everything changed: the way we did business, the way we lived, and especially Merlin's art. Prior to this,

we'd been selling at galleries in Tulsa, Norman, Sapulpa, and Siloam Springs. Merlin had even acquired a gallery in Colorado that year. Yet it was only after Doris started representing him that we were finally able to stop making sales calls to individuals.

That had always been a stressful, unreliable proposition at best. I could walk into an office one day and ask for a client, only to find out that she or he had lost her or his job. People got sick, they got divorced, they got transferred other places, and suddenly, that was the end of their collecting. Doris became our buffer zone. I no longer woke at night in a cold sweat, wondering who was going to buy the next painting. I knew even if every other gallery turned us down, she would come through.

As Merlin's work continued to sell, she began to talk to him about raising his prices. He was skittish about the idea. There is a saying among artists and gallery owners, "You can always go up, but you can't go down." We had watched so many artists effectively price themselves out of the market, often upon the bad advice of their art agents. Doris explained that she wouldn't hike his prices willy-nilly like that. She would do so slowly in fifty-dollar increments, so people barely noticed. She also pointed out there would be different sets of collectors for different phases of his work, and he needed to accept that. As his work evolved and became more expensive, the original collectors he started with might drop off, but new collectors would emerge to replace them.

Her ability to grow Merlin's collector base, along with his prices, impacted the quality of his art for the better. Prior to being at OIAG, he literally couldn't afford to do complicated, time-consuming pieces. He had to focus on "bean pot" paintings, the simpler the better, in order to put food on the table. With Doris's support, he became a perfectionist. He took his time, developing his concepts and executing them to his satisfaction. If he was working on a particularly ambitious piece and we ran out of money before it was finished, she would sometimes send us an advance in the mail to help us get through the week.

Our lives not only improved in a material way. Merlin's relationship with Doris played an important role in his newfound sobriety. Her appreciation for his work restored his sense of hope, dampened by years of drinking, and the enthusiasm of her collectors helped his confidence and self-esteem grow. He'd had some missteps with other

gallery owners during his drinking days, and while he had done his best to make amends to them, he didn't want to take such a chance with Doris. Even more pivotal to his sobriety and his spiritual growth was his decision to return to the Southern Cheyenne ceremonies he'd grown up with as a boy.

While the gallery in Oklahoma City had no direct bearing upon that part of his life, it was part of a mysterious convergence of forces that led him down a new artistic path. Because of his ceremonial experiences, he began to develop a whole new vein of work: expressionistic spiritually based work that he called "medicine paintings." Ironically, they started as a way for him to relax by setting aside his representational work and focusing on color and form. But as he experimented with them, adding in Cheyenne symbols from beadwork and other sources, he found his thoughts often went back to what he had learned at his ceremonies. Not everyone appreciated his medicine paintings. But Doris immediately recognized their originality and importance and helped build a following for them no other gallery could match.

The owner of the Western Heritage Gallery in Tulsa, Otis Wilson, had been the first gallery owner to point out to Merlin that miniatures were an art form. He tried to do a few smaller paintings for Otis but only at OIAG did he become a true miniaturist. He says he took that path in part because collectors would often comment they liked such and such an image but didn't have any wall space. "I figured if I did miniatures they couldn't say that anymore." In reality, he'd been fascinated by small objects since childhood, particularly the miniature drawings he would copy from the dictionary. The difference was that Doris made his miniatures worthwhile, by selling them at prices that reflected the time and care he lavished on them.

Like Doc Tate and other Native artists before him, Merlin incorporated landscapes in his work early on—in his case, lush, detailed renderings that could hold their own with any contemporary landscape artist. And as the others had been, at least in the beginning, he was criticized for it. While he recognized the artistic value of flat-style paintings, he also believed the sight of Native subjects, floating in negative space, made the public more comfortable with the fact that Native Americans had lost most of their lands. Whether conscious or unconscious, he felt

that was the source of the criticism leveled at Indian artists who painted landscapes. "It's like the public didn't want to see us in the environment that used to be ours. I wanted to restore our land base, to paint the places we belonged. I wanted people to see what a paradise it was."

Doris, however, embraced his landscapes from the beginning, and often told her collectors, he could have been equally been a wildlife artist or landscapist if he'd so desired. He hit a snag with her, however, the day he brought in a large, western-looking canyon scene, depicting Cheyenne warriors riding alongside a river. He was proud of its technical execution, and he offered to consign it, but she tactfully turned him down, telling him she didn't think it quite fit in with the other art she carried. In retrospect, he saw she was right. The painting had too much Frank McCarthy in it and not enough of himself.

Around the time of our first encounter with Doris, Merlin had become convinced that his future was with western art galleries, not Native art galleries. Native art galleries were supposed to be a stopover on his quest to apply and be accepted into the NAWA's *Prix de West* show. Once he began showing at OIAG, he no longer saw NAWA as the pinnacle of artistic achievement. It's not that he stopped admiring western realism, but he was finally free to accept his own bent for subject matter and his landscapes developed along more poetic lines.

Surprisingly, Littrell also turned down one of his Little People paintings early on. A number of well-known painters and sculptors, including Charlie Pratt, had depicted Little People, the guardians of the natural world known to play tricks on human beings, in their art. Perhaps if Merlin had persisted with his explorations, she would have come around. But at the time, it did not conform to what she saw as the through line in his art.

Despite his Plains roots, Merlin was far better known in northeastern Oklahoma where he lived than in the central part of the state where he had grown up. That soon changed, thanks to the exposure brought about by Doris's shows. She hosted his first solo show at her gallery in 1989; it sold out. She did another solo show for him the following year. It sold out, too. She had more solo shows with him than any other artist, in part because he never turned down an invitation to do one. Among those who discovered his work at OIAG was Rosemary Ellison,

curator of the Southern Plains Indian Museum in Anadarko. Not long afterwards, she invited him to do a one-man show at the museum.

Curators from OU's Fred Jones Museum and members of the Oklahoma Arts Council also ran across his paintings at the gallery, as did curators from the National Cowboy and Western Heritage Museum. Those encounters led, among other opportunities, to an exhibition in Japan and to his being included in the Winter Camp shows and then *Small Wonders*. In 2004, the Arts Council in Oklahoma City announced their desire to do a retrospective show for Merlin at the state capitol. Although none of the work would be for sale and there was no commission to be made on her part, Doris did all the footwork for it. She called collectors, asking them to loan paintings for the show and publicized it to everyone who walked through her gallery door. When she heard there would be no refreshments due to "budgetary constraints," she rolled her eyes and went out to buy sandwiches, cookies, and punch for the event.

The skills Merlin developed painting for OIAG also helped him achieve a longstanding goal: he applied and was accepted into Santa Fe Indian Market in 2003. The following year, he was invited to put paintings in a gallery on Canyon Road simultaneously with his booth show at Indian Market. He worked hard to produce two extra paintings for the gallery and delivered them a day before their Thursday night opening. The paintings were never hung. The woman who managed the gallery, in contrast to her partner who had invited him to display, was angry that the paintings hadn't arrived earlier. Rather than sending word for us to retrieve them during Market, she called Doris at Oklahoma Indian Art gallery and asked for Merlin's address so she could ship them to him COD. Doris was furious. "Ship them to me COD," she snapped. "I'll sell them as soon as I get them," And she did.

"The last two painters I took in were Merlin Little Thunder and Robert Taylor. It's like it opened a brand new gallery for me because they were nontraditional. Some collectors said, 'Why don't you have more traditional painters?' I didn't want to hold the artist to a certain style, so neither should a collector."
—Doris Littrell

"I grew up in Doris's gallery, artistically, spiritually, emotionally. Her gallery was the hallmark of Indian art. You had to do your best. Some of these galleries [would] say, 'One of our patrons saw a painting at Doris's gallery. Can you bring it over here?' And we'd say, 'No. We can do you one similar, but we're not going to go to Doris's and get that painting so your patron can buy it.'"
—Merlin Little Thunder

"Someone said to me, maybe in '93, '94, there was a recession in galleries. I didn't even know it—I was so busy working."
—Doris Littrell

Chapter 24
More Artist Stories: Robert Taylor

ROBERT TAYLOR FIRST met Doris Littrell at a Native art gallery in Tulsa in 1983. He had been complaining to his friend, Gerald Stone, about the slowness of the show when Doris and Bob walked in after a day trip to Tulsa on business. Stone elbowed him. "That's who you want to represent you," he said. Taylor introduced himself to the couple and shook hands, but gallery etiquette forbade any conversation at the time. After that, however, he was "on a mission to get accepted into Oklahoma Indian Art Gallery."

Before that could happen, he hooked up with Gene Bonham, a psychiatrist and Native art collector. Bonham had started a new sideline business: being an agent for Native artists. He approached Taylor, Barthell Little Chief (Kiowa/Comanche), and Tillier Wesley (Mvskoke Creek), offering to put them on contract. The contract stated, among other provisions, that he would print and promote their work nationally and internationally. In exchange, he would have exclusive rights to their originals, and receive a 50 percent commission from all their sales.

Bonham did go on to publish a brochure and pull limited prints for the artists, advertising their paintings in *Southwest Art* and at least one international art publication. What he didn't do was deliver the

global audience he had promised, and some of his marketing ideas, like arranging a sales show in London in conjunction with a Jane Goodall lecture, which never made sense and so, not surprisingly, failed to come off. What really upset Taylor, though, was selling two paintings through the agent only to find out that he would not be paid for them. He had neglected to read the fine print explaining that before the artists earned any commission, their profits would go to cover their share of printing and advertising expenses. The painter soon realized he was in a "company store" situation and confronted Bonham, who agreed to release him from the contract in exchange for paintings and cash.

The two managed to remain friends, and in 1990, they met at the National Cowboy and Western Heritage Museum in Oklahoma City to view the T. C. Cannon retrospective. Afterwards, Taylor told Bonham he was headed to Oklahoma Indian Art Gallery to schedule an appointment with Doris Littrell. He was too methodical to drop in with paintings unannounced: he wanted to set a date in advance. Even that prospect made him nervous, so he invited his ex-agent to ride along.

Doris remembered Taylor. She also remembered Bonham from a previous visit he had made to OIAG. He'd had a woman with him then, and after walking through the space, declared loudly, "Well, there's nothing here that I want." She hadn't taken offense, attributing his comment to his desire to impress his date, but while she and Taylor were talking, she noticed Bonham sitting at an odd angle, that allowed him to pretend to be looking at art, when, in fact, he was watching her. "It was his psychiatric training, I guess, to try to figure out the kind of person I was," she said, with a laugh.

After she and the artist agreed on an appointment date, the men left. She later learned Bonham told Taylor afterwards that he thought the gallery might be a good venue for him.

When he returned a few weeks later, Taylor brought several eight-by-eleven acrylics, executed on watercolor paper. He described them as "idea sketches" for a series he was working on about turn-of-the-century federal Indian policy. One depicted a man with two mouths, one on each side of his face, a literal portrayal of hypocritical speech. The other images were equally compelling, but he insisted to Doris they were just studies, guideposts for "real" paintings he planned to do later.

She was puzzled. "These are almost finished paintings," she insisted. "If you tighten them up, I can sell them."

This straightforward response turned out to be exactly what Taylor needed to have his own artistic breakthrough. He had long admired Paul Pletka's work and his use of symbolic distortion. He was also strongly drawn to John Biggers's paintings of African Americans. But each time he tried to balance his hyper-realistic subjects against a detailed background, crammed with symbolic references and cultural objects, he ended up being stuck. When Doris urged him to finish his sketches, sketches which by their very definition are loose and spontaneous, he was able to resolve his compositional block: to keep his backgrounds suggestive and reduce the overall number of objects in his paintings to better focus the viewer on his Native subjects.

When next he returned to the gallery, having turned his sketches into matted and framed paintings, the gallery owner was pleased. Then he quoted her a retail price: sixty dollars a painting. "She started asking me, 'How much did I pay for the glass? How much for the frame and the mat? What about the gallery's thirty-five percent? Did I really think I could make money that way?'" In the end, they settled on a retail price of a hundred dollars a painting. She bought some; he consigned some, and she promised to get back with him.

Despite her confidence about what constituted an appropriate price for his work, Doris wasn't sure she could move it. Taylor's philosophical musings in paint were unlike anything else she carried. His mostly male subjects were not romanticized figures from an ancient, Edenic past. They were wizened cosmic travelers, familiar with displacement and upheaval. Many of the initial comments she heard were negative. "My older collectors asked me, 'Why did you bring those paintings with those ugly Indians in here?'" One of her gifts, however, was her ability to recognize significant art, even when it went beyond her personal comfort zone. "I figured they could either come along or shut up."

It took his work about a year and a half to start selling in her gallery, after which it accounted for as a much as a third of her business each year. Taylor's pleasant manner and his ability to laugh at his own foibles soon made him a favorite among collectors. It also broke down

Doris's usual reserve, and the two became fast friends. He says conversations with her often generated ideas and insights that ended up in his paintings. Sometimes she would point out images that her collectors particularly liked, which might prompt him to deeper explorations of the theme. She also encouraged his risk-taking. "Whenever I wanted to try something people didn't expect, she'd tell me, 'Bring it in. Let's test the waters.'"

Their friendship was an emotional refuge for Taylor when he and his wife, Susan, went through a divorce in 2003. After they sold their house in Tulsa, Susan moved to Florida with their daughter, and although they still remained close, he lost his bearings for a while. Doris worked especially hard to sell paintings for him so he could pay child support and other expenses. The following spring, he had a chance to return the favor when she fell ill with a lung infection and was unable to work for a year. She knew she had one of two choices: close the gallery or find someone to manage it. Under normal circumstances, she would never have dreamed of asking an artist to take on the job, but these were not normal circumstances. She had seen Taylor in action with collectors: she knew he had good people skills. He was smart, reliable, and because of his divorce, he might welcome the extra income.

When she called and proposed the idea, he said he would think about it. Then he called back, and said yes, provided he could find a place to live in Oklahoma City. Two days later, a "For Rent" sign popped up on a house across the street from the gallery. Once he verified that one of the rooms could be converted to a studio, Robert signed the lease and began reporting to work. Despite being ill, Doris made a couple of trips to the gallery to show him her books and other aspects of her operation. After that, they talked mostly by phone. "We discovered we had the same business sense, which was more common sense than anything else," Taylor observed.

When word got out Taylor was managing the gallery, the Native art gossip mill went into overdrive. "There was a bet I wouldn't last two months before I quit or Doris fired me," he said. "But we got along great, because I never made the mistake of thinking I could run the gallery better than her." He also refused to be "one of those manager/artists who takes the premier spot and gives his work priority over

everyone else." As other painters brought in work, he would ask where they wanted it displayed, and he did his best to hang it there.

He soon discovered that simply hanging the art in the spot they chose didn't guarantee its visibility, however. Visual perception is based on habit, and collectors who visited the gallery even once could subconsciously block out entire areas on their next visit without realizing it. Doris told him the best way to break that visual bias was to move the art in the gallery around on a regular basis. "She was right. When I rearranged the walls, people would notice art they hadn't noticed before and think it was just brought in."

Taylor was supposed to cover for Doris for about six months. Instead, he ended up working almost two and a half years while she slowly regained her health. During that time, Taylor saw a side of the business he would never have imagined, like people showing up at least once a day with things to peddle, most having nothing to do with Native art. Then there were the two Native American brothers, who brought in a painting to sell from the 1940s. Although Robert is no longer clear on all the details, he remembers that the painting was by a relatively obscure Indian artist that was also their relative. He called Doris to come into the gallery, and she talked to the brothers, who told her their grandmother was ill and wanted them to sell the painting. She offered to take it on consignment; no, their grandmother needed the money now, so Doris reluctantly wrote them a check.

A month later, the brothers showed up again, this time with two paintings by a better known Indian artist that their grandmother had collected. Doris came in to look. Something didn't smell right, but again, their insistence that their grandmother needed the money, persuaded her to buy again against her better judgment. Not long after that, a young Native woman came to the gallery and informed Robert the paintings sold to OIAG had been stolen by the young men, her cousins, from her grandmother's house. Doris talked with the young woman, who did not want to file a police report, and sent the unsold paintings back with her.

Despite being caught, the brothers continued their trips to the gallery, first trying to sell cultural objects and after that, random store-bought items. Each time, they were scolded by Robert and turned down

cold. The last time they showed up after hours. The door was locked but Taylor was still inside, and he saw them deposit a small cardboard box in front of the gallery. After they left, he went out to pick up the box, where he discovered dozens of plastic cowboys and Indians—brand new, not antiques—the kind that could be purchased at any discount store for a dollar.

In taking over while Doris was sick, Taylor helped keep the gallery open for all her artists. Unfortunately, his managerial duties hindered his own art production. By the time she returned to work, he had done no major paintings for the gallery and barely managed to assemble a small group of paintings for a gallery show in Santa Fe. Shortly before he left town, he received an invitational packet from one of the Oklahoma centennial committees. The state's centennial was just around the corner, and a number of public art commissions had been selected to mark the occasion. This was a call for mural proposals, depicting three historic lawmen from the state. Two subjects already had been chosen: Bass Reeves, the first African American U.S. deputy marshal in Indian Territory, and Bud Ledbetter, a white Indian Territory marshal who also served as the marshal of Muskogee. The third subject was left open. The only requirement was that the lawman be Native American.

The mural was to be installed at the state capitol in the attorney general's office, and the selected artist would receive a $100,000 commission. "I didn't know it at the time," said Taylor, "but only a few painters were invited to submit a proposal. I really had to hustle to finish it when I got back from Santa Fe." He later found out the selection committee included several museum curators, Arts Council Executive Director Betty Price, and her newly hired assistant, Karen Sharp. Sharp had arrived in Oklahoma City, via Chicago, and within a week of her hiring, Price had sent her to Doris to learn about Native art.

Each of the finalists had to execute a preliminary drawing for their proposal, a miniature study of the mural they wanted to paint. One artist submitted a group depiction of the Lighthorse Police, the famed Indian lawmen employed by the Five Tribes. Taylor, however, chose an individual, Quanah Parker, a Comanche warrior, headsman, and chief who served first as sheriff of Lawton and later, as a federal judge. "He was a great example of the transition from the pre-reservation period

to statehood," Taylor explained. "And he was visited by every sitting president of the day."

Taylor's twenty-four-by-thirty-six-inch acrylic, *Honor, Serve and Protect*, was a triptych, depicting each lawman against a background that symbolically summarized his personality, culture, and time frame. Perhaps its most striking feature was the large amount of space, almost a third of the painting, devoted to the ground on which the men stood. The subterranean layers of earth beneath them were depicted X-ray style and included objects of personal significance to each of the lawmen. This added an additional mythic element to the work, suggesting the importance of the Below World, prominent in many Native beliefs.

Taylor told no one, not even Doris, about his submission to the committee for fear he would jinx himself. December of 2005, he received a call from Attorney General Drew Edmondson, congratulating him on his winning proposal. Later he and the other artists' drawings would be returned to them, along with a small honorarium, thanks to Karen Sharp. She had learned her lessons at Doris's well, including the notion that artists should always be compensated for their time.

As the painter began to contemplate the logistics of executing his mural, his elation soon turned to anxiety. "I took a canvas that was six feet across and tried to turn it on its end to see how much clearance my studio would have for an eight-by-four-foot mural. I couldn't do it." Once again, Doris came to the rescue, offering to let him work in the gallery, in a room she used primarily to store furniture. It was appreciated, but it didn't completely solve his space problem. Even in a bigger room, it was clear Taylor would have to execute the mural in sections, breaking it down into three eight-by-four canvases that he could adhere together just before the painting was installed.

Accessing the eight-foot-high mural required some kind of scaffold, so he built one from furniture. He took a desk, placed a sheet of plywood on it, and then two end tables on top of the plywood, covered by more plywood. On top of that, he placed a chair with rollers, so he could scoot back and forth from his paint palette to the canvas, at least as much as a man of his height and size could scoot. Because the design of the mural required that all three men share the same ground line, and because he could only work on two panels at a time, he would al-

ways pair an end panel with the middle panel, to make sure the triptych was aligned. Once after he started painting, Doris entered the room and saw him scooting across the scaffold on a roller-chair. "I thought, 'My God, he's going to kill himself. And I never went in there again.'"

She did see to it that the artist got lunch every day, delivered by Bob, who often stayed to chat longer than Robert would have liked. Meanwhile, Doris served as a gatekeeper, turning away overly curious collectors who tried to drop by and see how the mural was progressing.

She had to make an exception, however, for the members of the Centennial Committee, who had told Taylor from the start that they would be checking in on him from time to time. The first visit went relatively smoothly, save for a few irritating suggestions different committee members made about the composition that he was still blocking in. On their second visit, he was informed that it was customary for the artist to find a way for the committee members to make a small hands-on contribution to the mural. Perhaps each of them could apply a brushstroke of paint somewhere? That was the last straw for Taylor. "You're not the ones signing this painting." Voices were raised, a few cuss words unleashed, and one person walked out. That was his last visit from the committee. He didn't see them again until the mural's public dedication.

During the eleven months it took to complete the project, Taylor never produced more than a few small paintings for Doris. Another gallery owner might have grown impatient, even irritated, with the loss of income, especially from one of her anchor artists. Yet even if Taylor had never done another painting for her, Doris said, she would have been content, knowing her support helped carve out a psychological, as well as physical space, for him to finish the project. Ironically, once the mural was ready for installation at the capitol, the inset space created by the workmen turned out to be too small. The official dedication had to be postponed. When it did take place, Doris still wasn't physically strong enough to attend, but she did visit the mural afterwards on her own.

Throughout his career at OIAG, Taylor continued to show in out-of-state galleries. Doris promoted those shows to her collectors, too. But what really surprised him was discovering that she periodically kept in touch with his Santa Fe galleries. Those were contacts he'd made on

his own, independently of her. "About once a year, she'd call to update them on something I'd done that I hadn't told them about," he said, with a chuckle. "It was like she wanted to remind them of the historical importance of the work they were handling, not just mine but that of other Oklahoma Native artists."

"Doris Littrell shared the feeling that Native art was central to Oklahoma's heritage, and she wanted to see the artists supported."
—David Boren, president,
University of Oklahoma, and
former Governor of the State of Oklahoma and U.S. senator

Chapter 25
Collector Stories

THE PUBLIC HAS COME to expect eccentricity from artists, but in my husband Merlin's experience and mine, it was collectors who were eccentric. Not all collectors, mostly those who were driven to acquire paintings on a grand scale, including the renowned Art Silberman.

Silberman was born in German-speaking Belgium and raised in New York City, where he earned degrees in history and economics. He enlisted to fight the Nazis during World War II, moving to Oklahoma City a few years after V-E Day. There he met his wife, Shifra, and co-founded Silberman Oil with his brother in 1952. Not long after, he discovered Native art and his grand collecting project: acquiring examples of all the major Native art movements from the mid-nineteenth through twentieth centuries. When he finished, he had amassed more than 2,500 artworks by more than 190 artists from an even larger number of tribal backgrounds.

His acquisitions were not confined to artwork, either. The photographs, slides, books, and miscellaneous written materials he collected eventually became part of his Native American Painting Reference Library. He joined the faculty at Oklahoma City University where he

taught the History and Philosophy of Native American Art. Among other accomplishments, he curated *A Hundred Years of Native American Painting*, an exhibit of his collection at the Oklahoma Art Museum, and wrote the catalogue for it.

He and Doris first met around 1968 when he spotted one of her ads in the Oklahoma City paper. He called to make an appointment to view paintings at her home. "I don't know what he expected, but he didn't expect an art dealer," she said. After inquiring about different pieces and hearing prices he considered too expensive, he accused her of "prostituting" Indian art. She was shocked. Doing her best to control herself, she replied, "Mr. Silberman, you are a guest in my home. Now will you please leave."

This was just the first volley in a series of skirmishes, some of which weren't even conducted face-to-face. Silberman once showed up at an estate sale in Bethany, where unbeknownst to him, the art dealer had consigned several paintings for a woman friend. Silberman saw a piece he was interested in, and as usual, offered substantially less than the marked price. The seller told him that she didn't own it, but he could talk to the owner if he wished. He followed her inside. When he heard her ask for Doris on the phone, he took the receiver and quipped, "Mrs. McCabe, are you everywhere?" His attempt at humor didn't help. Doris refused to budge on the price and he refused to pay more. He left without the painting.

In 1969, during the period that Doris was consigning work to Imogene Mugg, Silberman appeared at the Sales and Rental Gallery. After looking at the Indian art there, which he assumed belonged to Mugg, he told her it was priced too high and not at its true value. No sooner had he left, than the store owner got on the phone to Doris.

"'Do you know what you're doing?' she asked. I assured her that I did, and I asked her to describe the man who came in. When she did, I knew it was Silberman," said Doris.

Artists also took exception to Silberman's price wrangling. Mvskoke Creek artist Jimmie Carol Fife, one of the early women to win First Place Painting at the Philbrook Annual, reports he once offered her twenty-five dollars for a forty-five dollar painting at a booth show in the sixties. She declined his offer. An hour later, he returned to repeat

it. "I took it home and gave it to my dad," said Fife, with a smile. "I ran into [Silberman] a few times after that, and every time he saw me, he would come over and say, 'I wish I'd bought that painting.'"

The philosophical differences between Littrell and Silberman became even more pronounced after she opened her gallery. Occasionally, the collector and his wife would slip inside for one of her receptions, but even then, they kept to themselves, barely greeting Doris and only rarely talking to the artists. Then one day in 1988, the two rivals found themselves at the Fred Jones Museum, where unbeknownst to each other, they had both been asked to appraise the same art collection. Doris was leafing silently through various works on paper and each time she would pause, she noticed he did, too. "We had the same non-verbal reaction. I finally looked up and said, 'Mr. Silberman, we both have the same passion for Native art. Why can't we just get along?'"

They never quarreled again. Each time they ran into each other, he seemed genuinely glad to see her, and he started addressing her by her first name, rather than her surname. He and Shifra came to the gallery more often, and he even brought art to her to frame on occasion. Eventually, he purchased two Ernest Spybuck paintings from her, despite their substantial price. "He paid it because he knew he couldn't get them anyplace else," said Doris.

Then their contact grew more sporadic, and Doris was caught off guard when he called one day to say that Shifra had passed away. "He had just called his sons and then he had called me," she mused. "That's when I knew he probably didn't have many close friends."

When the time came for Silberman to have his own collection appraised, he asked Doris if she would take on the task. He had decided to donate it to Oklahoma City's National Cowboy and Western Heritage Museum, which had a relatively small number of Native art holdings at that time. "I told him I needed to look at it first," she recalled. "I knew some of his art came from outside the U.S., from Canada and South America, and I wanted to be sure I was qualified to appraise it."

That meant a trip to Silberman's house. Prior to her visit, a mutual friend had been to the collector's home and reported that he kept his artwork covered with sheets and towels, either to protect it from the sun or to keep visitors from seeing what he had—she wasn't exactly

sure which. When Littrell visited, however, every piece was uncovered and ready for her to examine; in the end, she concluded that she could appraise all the paintings save for one. It took her a number of weeks to finish the job, and after that, their communication fell off again. A couple of years later, she was both surprised and saddened to receive a phone call from one of the collector's sons, informing her of Silberman's death. "I'm not sure how he got my number or even knew to call me, except Art must have mentioned me to his children," she said.

At the opposite end of the spectrum were collectors whose eccentricities endeared them to Doris and her artists alike. That was certainly the case with Doctor Mansfield, a forensic pathologist, who grew up on a wheat farm in western Oklahoma and attended medical school at the University of Oklahoma. After completing an internship in his specialty, he set up his own practice in Manitowoc, Wisconsin. There he was often consulted on high-profile murder cases, particularly those involving serial killers. Not all of his work was confined to the United States. He was part of an international team that traveled to Bosnia in 1995 to help identify the remains of genocide victims and pave the way for war-crimes charges.

Although motivated by a desire to help victims' families, Mansfield couldn't help but be depressed by his occupation at times. Art soothed him and provided psychological relief, reminding him of the better side of human nature. He once told Doris that he had filled his laboratory with landscape paintings so he could have "a place to escape to mentally while he was working."

Mansfield had collected Native pottery for years, primarily from the famed San Idlefonso potter Maria Martinez. He hadn't paid much attention to Native painting, however, until he saw one of Robert Redbird's images in an ad. The ad was for Redbird's newly opened store and studio, one door down from OIAG. Ironically, it was again Doris who paid for the ad, placing it below her own gallery advertisement. Doris was also the one who had told Redbird the space was available, and McCabe helped him with move-in costs.

Once he opened, the Kiowa painter came up with his own PR strategies, one of which was painting in the front window of the store. He would set his easel and chair up high where they could be seen by

the passing traffic, go into the back room and pop a tape in the tape player, and then set to work. He liked all kinds of music, but being an ordained minister on the side, he thought gospel was the most appropriate music to play for potential customers. Once Merlin and his uncle popped in when the place was empty and were greeted by a raucous James Brown song. Suddenly, the tape switched to gospel because Redbird had heard the shop bell ring as they entered. "We had a good laugh over that," said Merlin. "We told him, 'It's just us. We heard you playing James Brown. Put your tape back in.'"

The biggest problem Redbird encountered as a store owner was keeping the hours listed on his ad. As fate would have it, when Mansfield pulled into the parking lot that Sunday, his studio was closed, but Doris's, right next door, was open. The pathologist strolled inside. Perhaps because he initially had planned to look at Redbird's paintings, he ignored all the paintings inside OIAG. Instead, he zoomed in on three-dimensional work, buying four sculptures by Ted Creepingbear and writing Doris a check on the spot. He explained that he was on his way to visit his parents in Enid and once he got back to Wisconsin, he would call her and let her know when and where to ship the sculptures. In the meantime, he would like photographs of the sculptures mailed to his office as soon as possible.

She did as he asked. A week later, he phoned. "I'm ready for my sculptures," he said, "but I see in these photographs, there are paintings in back of these sculptures and they're not very clear. What can you tell me about them?" She explained the paintings were part of a solo show by the sculptor's brother, Mirac, and prices ranged from $4,500 to $6,500. Then she went on to describe the subject matter and palette of the paintings in detail. "I'll buy everything on the wall," he said. "I'll mail you a check now, but keep them in the gallery until I tell you where to send them."

Over the next few visits and phone calls, the reason for Doctor Mansfield's buying patterns became clear. His wife, Ernestine, also from Oklahoma, shared his love of three-dimensional art, so Native American sculptures and pots could be shipped to their house openly. The only paintings she liked, however, were English watercolors, so any Native paintings he wanted had to be acquired in secret.

Doris sent Mansfield invitations to all her shows, and his inability to be there in person was no obstacle to his collecting. He would call her from his office ten minutes before she opened her doors to the public, so she could describe the work various artists had brought. Based on her descriptions, he would tell her what he wanted. Then he would ask her to hand the phone to the artists so he could wish them good luck on the show. Unlike Silberman, who aimed to cover as large a spectrum and timeline of Native art as possible, Mansfield's goal was to select a few exceptional artists and accumulate their work in depth. He knew exactly what his collection included, based upon the photographs Doris sent him, and he knew what the gaps were. If he had a lot of serious pieces by a certain artist, he might ask for something with humor. If he had lots of acrylics paintings by a particular painter, he might ask for a mixed media or graphic piece.

During one Red Earth show that he attended with his wife, Mansfield was so smitten by a particular painting that he tried to buy it without her noticing. Robert Taylor was helping on the sales floor when a man's hand reached around the corner upstairs and started tapping vigorously on the wall, as if in Morse code. Puzzled, the artist went upstairs to investigate, but by that time, Mansfield, on the verge of being discovered, had withdrawn his hand. He was standing demurely next to Ernestine and both were talking to Doris. "They didn't look at me at all, so I knew not to ask questions," said Taylor.

The minute the couple moved on, Doris cornered the artist, demanding to know which piece Mansfield had pointed to. "That whole wall was full of paintings," he said. "There was no way to tell from his tapping which one he was interested in." Fortunately, before they left, the pathologist managed to duck out on his wife long enough to let Doris know which painting had him so excited.

Mansfield kept an open account with Doris and mailed her a set sum of money toward his balance each month. A number of his paintings were stored at the gallery, but others were put into salt mine storage in Hutchinson, Kansas, at his request. He would give Doris his storage access information, and McCabe would deliver the artwork there for him. Salt mine storage is reputedly among the best for artwork because the salt keeps everything insect and moisture-free.

Given the extent of his purchases, it was always hard to believe Ernestine didn't know about some of them, as indeed turned out to be the case. For several years, when the Mansfields went to Santa Fe during Indian Market they would make a point of meeting Robert Taylor for dinner after his gallery show. On one of those occasions, Ernestine excused herself to go the restroom. Then Mansfield went to track down the waiter for more drinks. He still had not returned when Ernestine came back, sat down across from the artist, and said casually, "I suppose he's bought a painting from you already. He's always doing that when I'm gone."

In 2000, when Mansfield retired from his practice, he began consulting with Doris about possible places to donate his collection. She encouraged him to consider splitting it between the Fred Jones Museum at his alma mater, the University of Oklahoma, and the National Museum of the American Indian, which had not yet moved to the National Mall. In this instance, Doris could not appraise the art because she was the one who had sold it to Mansfield, and when he arrived to pick up the work she had stored for him, even she had forgotten what was there. "I opened the door and there were eighty-three Merlin Little Thunders. And that was just the top of the pile," she said.

Chapter 26
The Mystery Collector

ONE OF THE STRANGEST collector episodes at Oklahoma Indian Art Gallery unfolded over half a week with only three witnesses: the professor clerk who worked in the gallery until he was fired, Merlin, and Doris herself. It was a Tuesday afternoon in October; the professor was alone in the gallery because Doris had taken the day off. Merlin had just delivered two paintings and driven off when a Cadillac pulled into the OIAG parking lot. A short, stocky man with dark hair got out and came in. He introduced himself to the professor as Ron X from Florida, although he was clearly not from Florida originally. He spoke with a pronounced New Jersey accent. He said he was a motivational facilitator, who helped corporate executives and middle managers improve their communication skills, and he also mentioned this was his first exposure to Native art.

He clearly liked what he saw, for as he walked through the gallery, he started picking out various pieces that caught his eye. Within an hour, he had selected several sculptures and a number of paintings, including both the miniatures Merlin had just delivered. His purchases with tax came to just under ten grand, and when the professor gave him the total, he pulled out his wallet and paid for them in cash. Then

he explained that he had to leave the art a few days—he had some business to take care of—and he would return to pick up his purchases Saturday on his way back to Florida. He expressed disappointment that the gallery didn't have more of Merlin's miniatures, as he would have liked to purchase one more.

As soon as he left, the professor, overwrought with excitement, telephoned Doris to tell her about the new patron and what he had bought. While she was happy for the volume of sales, she also found herself in a bind. She had promised to call a particular couple about the miniatures Merlin had delivered, and now they were gone before her regular patrons had even had a chance to look at them. Always proactive, she told the professor to call Merlin before he left the gallery and tell him that his paintings had sold, and she needed more as soon as he could manage. He did, adding that if Merlin could bring the new work on Saturday, the same day the collector was to come back through, he would undoubtedly enjoy meeting him.

Merlin had several paintings in progress, and he worked hard to finish them over the next few days. He left for Oklahoma City on Saturday with three paintings, but arrived later than he planned, about half past six. Usually if he arrived after hours, he went straight to Doris's house, but he saw that the gallery was open, the lights were on, and a Cadillac was parked in front, along with Bob's van. When he walked in, he saw the professor sitting at the big desk upstairs and Doris at a smaller desk in the Pink Room. She gestured for him to approach and said in a semi-whisper, "The patron who shopped with us on Tuesday is here. As soon as I take care of our business, I'll introduce you."

It was clear she didn't want Mr. X to know about the new paintings. As soon as Merlin showed her one, she jotted down the title and price and put it, image side facing in, against one side of the desk. But just as he brought out the third painting who should wander in but the new collector, accompanied by the professor. At that point, Doris had no choice but to introduce the two, and Mr. X naturally expressed a desire to see this new painting.

Mr. X then asked Doris to add it to his purchases, and because he had picked out another large grouping of art, she assented, grateful that he hadn't noticed the other Little Thunder paintings leaning against

her desk. Once again, he paid in cash, with the total coming in again just under ten thousand dollars, the amount that banks are required to report to the IRS. As the professor began to wrap and package the artwork, he asked the three of them if they would join him for dinner at Cattleman's Restaurant: his treat.

Doris declined and offered Bob, who had come in to do some framing. He refused too, but said he'd finish the packaging for the collector. The professor and Merlin rode to the restaurant together to reserve their table, and the collector joined them about forty minutes later. He told them to order whatever they wanted, that he'd be insulted if they held back. No plastic was used to pay for dinner, either. At the end of the evening, the men shook hands and said good-bye. The collector, who had managed to conduct all his business without offering so much as an address, assured Merlin that he would be in touch with him about upcoming shows.

Six months later, the professor ran across a story in *The Oklahoman* that he rushed to share with Doris and Merlin. According to the article, the FBI was investigating a new form of money laundering by the Mob, which had begun purchasing large quantities of original art in Louisiana and along the East Coast to hide the profits from its many businesses. Oklahoma didn't fit that geographic profile, but the article raised a red flag for Doris. To her great relief, and to Merlin and the professor's relief as well, Mr. X never called or visited the gallery again.

> *"Doris taught me and guided me without realizing it.*
> *When my collection first opened to the public, I sent Doris*
> *photographs of the launch. I told her, 'It's your collection,*
> *too, because you're the one who directed it."*
> —Bill Wiggins, collector

> *"A lot of times when you walk in, you get the feeling that the art is a*
> *product, and you're a number walking through the door.*
> *Doris took an interest in you as an individual."*
> —Monroe Cameron, artist

Chapter 27
Shows & Receptions

D ORIS LITTRELL MUST have hosted well over a hundred shows in the course of her career, and 99 percent of them were focused on Oklahoma Native artists. But her abundant Southwest inventory led her to host several shows of Navajo weavings and at least one solo show for Narciso Abeyta, also known as Ha So Deh. Littrell met Abeyta around the time that she opened the gallery; as she remembered it, his daughter was the one who brought him to the gallery. He was a slight, quiet man whose experiences in World War II had killed his desire to paint for several years. When the desire finally returned, Abeyta began to perfect a sinuous and graceful painting style with decorative flourishes that attracted a good following among Doris's collectors. Later, in the 1990s, she would take on another Diné painter Gary Yazzie whose approach was more realistic and grounded in western landscape traditions.

For each of her formal show openings, just as she had done for her grand opening, she covered the gallery windows in brown paper, removing it minutes before she opened her doors. One salesclerk recalled that people would start lining up outside the gallery an hour ahead. "Some would try to get in early, but the only ones we let in early

were artists, and sometimes, people who came in from out of town." Whenever possible, behind the scenes, Doris would give artists and their spouses a CliffsNotes version of the information she had shared with her clerks consisting of general information about collectors who followed their work, and who had telephoned to say they would be attending the show. When the brown paper came down, the visual setting of the play was revealed, and the performance would start. The artists held the spotlight, but they also became spectators as they watched the public interact with their art. "It was like PTA night at school," said Merlin, "except it wasn't your parents, it was your friends' parents coming to see what you'd accomplished."

The shows were especially exhilarating because Littrell's clientele always seemed more knowledgeable than the average collector. "You could actually go in depth talking about your work, whereas in most other places, they just want to touch the highlights, and they're ready to go on," explained Taylor. It was the kind of crowd, in Merlin's words "where you didn't have to put on airs. Although it was stressful and you had butterflies, you could still be yourself, talk about your work, and enjoy being with everybody." Shows were occasions for Doris to invite new artists to the gallery that she didn't normally handle, along with her mainstays. Both groups were expected to bring art specifically done for the opening, so her collectors could see something that was "fresh and new." Of course, there were always one or two artists who dragged in older work that had gone unsold at other galleries, hoping no one would notice. Doris always did. She might not say anything about it to the artist directly, but when she walked around deciding which pieces to buy, recycled paintings were rarely on her list. New artists who continued to bring in "dead wood" were not invited back.

As for the artists, they engaged in self-competition to produce the best work they could, but collectors had to vie with each other to get the paintings they wanted. The competition was usually friendly, but on at least one occasion, it nearly unraveled a friendship. During one of Merlin's solo shows, two women friends approached Doris at exactly the same time about the same painting. It was a Southwest scene depicting a pair of Pueblo women with ollas on their heads, standing in front of an adobe house, next to some hollyhocks. The scrap for the

hollyhocks, that is, the photographs they were based on, did not come out of a book, either. Merlin had taken pictures of the hollyhocks in Littrell's garden, and used them as the basis for his painted ones.

The women quarreled for nearly ten minutes about who had dibs on the painting, until Doris announced that she was keeping it for herself. There was no other way to end the women's standoff and preserve their friendship. After all, she reasoned, it was her hollyhocks that made the image so appealing. However, as Merlin and I knew, the painting wouldn't last long at her house, either, for despite her genuine intention of keeping it, she was rarely able to hold onto art she took home. The minute she hung something on the wall, she only increased the interest in it, for her collectors now saw it as more desirable, precisely because she had it. People would invariably drop to visit her, spot the piece in question, and casually begin asking about it. And then they would want to buy it. The only time they would take no for an answer is when she explained the painting had been a gift.

Not all collectors made up their minds as quickly about a painting as the two hollyhock rivals. Some would contemplate a painting for a long time, leave the room, return, look at the painting again, until they had nearly "rubbed the paint off with their eyeballs," in Merlin's words. If they waffled too much, however, Doris would take action on the artist's behalf and do for the collectors what they could not do for themselves. "When she got her pad and pencil to write down the painting and my name beside it, that's when I knew I was going to buy it," confided one collector. Even more interesting were the times when a collector would track her down to purchase a piece of art that everyone else had overlooked. The minute she placed a red dot on it, a crowd would gather to admire it, confirming her insight that "as soon as a piece sells, the interest in it goes up."

"I had a booth at Red Earth. It was my first year there, but I was just another face in the crowd. I was getting real discouraged and Doris happened to be walking by. When she saw what was going on, she turned to the crowd and said, 'You need to come look over here. Here's the next Doc Tate Nevaquaya!'"
—Tim Nevaquaya

Like the paintings themselves, the visual feast Doris created for each show required careful planning and organization. She already knew which painters could be grouped together and which, due to their style or palette, were best exhibited in their own separate spaces. To do her job well, however, she needed to know specifics: how many paintings to expect from each artist and their dimensions and titles, so she could be sure to have adequate wall space for them.

This always lit a fire under Merlin, who had a tendency to over-estimate how much he could finish for a given show. Doris learned to compensate for that by keeping a number of his framed prints on hand, and when he ran short, she brought them out to fill in his display. Sometimes I managed to get a few pieces to the gallery early, but most of the time we walked into a show with paintings an hour before the doors opened.

Doris was never pleased about that, but her mood invariably changed when she saw what Merlin had brought, and eventually, she accepted that our arriving late had a kind of therapeutic effect. Everyone, from Doris to her salesclerks to the artists, suffered from pre-show nerves, and having an urgent task to take care of minutes, before the doors opened, helped them get focused and centered. We would no more get out of the car, than someone would volunteer to help carry in paintings. Someone else would show Merlin his wall space and bring a hammer and nails. Another would start typing labels for his paintings with titles, medium, and price. Artists and collectors alike joined in the effort. The pre-show camaraderie didn't go away once the show started. "You didn't have the petty jealousy you encounter in some galleries with . . . other artists," noted Taylor. "Everybody was as willing to talk about somebody else's work as their own, and everybody was happy when anybody made a sale."

Besides the art on display, Littrell's receptions were also remarkable for their cultural sharings. Doc Tate often played the Native flute, and on several occasions, artists read poems they had penned. Some of the best moments came when different artists started talking about their work to one or two collectors and other people would drift over to listen. There was always one point in their explanation when they stopped and fumbled a bit, unable to fully explain how their paintings

had developed. At such moments it was clear that they, like the collectors, had been momentarily transported to an alternate reality by their own images. Those serendipitous moments were especially moving. It isn't easy to live in this world in the bodies we've been given, which is why we humans crave the experience of being moved by art. Art plucks us out of ourselves to dunk us in the beautiful, which is also the spiritual, and then replants us, ready for growth.

"You walk into a lot of places and you know there's something there probably, but you have to dig to find that treasure. You walked into Doris's and the moment you got inside, you were surrounded by treasures. You didn't know which way to go first."
—Jeanne Devlin

"The whole business of Indians, Indian history, Indian culture, is taken for granted in Oklahoma."
—Ken Bonds, co-founder,
Red Earth Festival

Among Littrell's group show receptions, perhaps the largest and most exciting were those she hosted during the Red Earth Indian Arts Festival in Oklahoma City. In many ways, the circumstances surrounding the festival's birth echoed the challenges encountered by Doris in her early art dealing days. As retired investment banker Ken Bonds tells it, he and Yvonne Kauger, then an Oklahoma supreme court justice, now chief justice, were meeting over lunch to discuss the lack of Native art venues in the state. Kauger, who was raised in Colony, Oklahoma, and opened a small gallery there, pointed to the example set by Santa Fe Indian Market.

The largest and most famous Native art market in the country, Santa Fe Indian Market focused for good historical reasons on Southwest artists. The number of booths allocated to out-of-state artists during the 1980s was especially small, and as Kauger complained, "Oklahoma artists could hardly get in." She and Bonds agreed the state's Native artists needed a homegrown, large-scale venue of their own. They had no idea their opportunity for action would come so soon.

Oklahoma City had played host to the National Finals Rodeo since 1965. Held at the state fairgrounds, the ten-day event was an economic boom, drawing thousands of contestants and visitors to the community. Then in 1984, Las Vegas lassoed it away, outbidding Oklahoma City for the event by ten million dollars. Bonds, who sat on the local Chamber of Commerce, witnessed the fallout. Where the Chamber saw defeat, however, he saw opportunity. "We've lost the cowboys, but what if we create an Indian event even better than that?" he proposed to them. Then he described his and Justice Kauger's vision of a world-class Native art show and cultural festival that people from around Oklahoma, the country, and the world would pay to attend. Naysayers immediately threw up the cliché of tribes "being unable to work together," but they became more receptive when Allie Reynolds of the Center of the American Indian stepped forward.

At the time, the center was located in the Kirkpatrick Museum, and Reynolds (Mvskoke Creek) was president of its board. A former New York Yankees pitcher and baseball hall of famer, Reynolds was charismatic, with an ability to bring people together. He offered to coordinate planning meetings with the larger Native community, as the investment banker turned his attention toward raising the funds for the festival.

For starters, Bonds secured a $5,000 donation from his bank. Then he went around, hat in hand, he said, asking other businesses to match it. In lieu of a cash donation, the Chamber of Commerce loaned a full-time employee, Christy Alcox, to help with the planning. In June of 1986, the Red Earth Indian Arts Festival opened at the Myriad Gardens in downtown Oklahoma City.

Like any new venture, the festival had to learn from its failures. The first powwow held in conjunction with festival took place indoors while the artists set up outside in an open area around the Myriad Gardens greenhouse. Instead of paying a booth fee, artists were charged a percentage of their overall sales. A central sales tent was set up to process all transactions. One rationale for the sales tent, aside from keeping track of sales, was to allow collectors to make credit card purchases from artists who didn't have credit card machines. Doris volunteered at the sales tent that first year. Her shift went smoothly, but the artists

complained that other volunteers had miscalculated their sales percentage. What really infuriated the artists was the fact that they couldn't access any of the money they had earned, including purchases made with cash, until the end of the show.

Festival organizers were also policing booths to make sure their contents all came from the artists. Merlin, who arrived there with one large painting and a single print, was told he didn't have enough inventory for a booth and was asked to leave. He remembers it also rained the day he was there, damaging some of the work in the artists' booths. The outdoor booths and centralized sales tent lasted a total of two years. After that, the festival moved inside what was then known as the Myriad Convention Center, now the Cox Center, where the artists paid a flat fee for their booths and handled their own sales.

Doris remained active with the festival, attending planning meetings and donating items to its fund-raising auction. She sent her own sales help to work the auction with festival volunteers and paid them out of her own pocket for their time. Sometimes her donations would result in a new contact for the gallery but she considered any benefits to her business as ancillary. She wanted Red Earth to succeed as a first-class art show for the artists and the people of Oklahoma, and she was willing to put her time and money behind it. She says she was the one who suggested to the board the idea of recognizing an older artist who had deeply impacted the Native community as the "Red Earth Honored One." She also initiated a competitive category for miniature paintings at Red Earth in 1994 by donating prize money for it.

At that point, she had been handling Merlin's work for eight years, and a few voices grumbled that she started the miniature category because she was certain he would win. He didn't even enter the competition the first year, however. But he did the following year and won First Place in miniatures three years in a row. After that, a decision was made to drop the category, though no one could ever tell him exactly why.

In 1990, Doris started hosting her own shows during Red Earth. The festival had grown substantially in size and visibility, and was drawing tourists from out of town and even overseas. At the time of her first Red Earth show, several of her artists including Mirac and Ted Creepingbear, Doc Tate Nevaquaya, Merlin, and Ben Harjo, either had never

done the festival or had participated a year or two, and quit. Hosting her own shows gave these artists a sales venue and a chance to take advantage of the national and international spotlight cast on Oklahoma City by the festival; by that time, Red Earth was pulling in more than a hundred thousand visitors.

For the first few years, Littrell's Red Earth receptions took place on Friday evenings because Thursday night was the artist awards ceremony and the night of Red Earth's fund-raising dinner. As more people began attending the OIAG shows, and more galleries began mounting their own Red Earth shows, Doris moved her openings to Wednesday nights. She was not merely trying to get the jump on other shows: she was accommodating a small group of overachievers, who by then, were entering the festival as well as showing with her. These included Robert Annesley, Sherman and Allie Chaddlesone, Bill Glass, Virginia Stroud, and Merlin Little Thunder, who had decided to try the festival again. It was an exciting time, despite the stress involved. "The air was full of electricity," Merlin said. "People were coming in for Red Earth, and coming to the gallery from Canada, Germany, and Japan—all kinds of places."

Gallery hours during Red Earth weekend were long, so Littrell always made sure her artists and employees had lunch in the gallery. Sometimes it was the green chili stew she had learned to make while living with Mel. Other times, it was sandwiches or pizza. Her reception food at Red Earth tended to be even more varied than at her other openings, and much of it was served on beautiful, antique china. At a time when many galleries served wine, hoping that the flow of libations would loosen their collectors' purse strings, her spread was always alcohol-free. "I knew many of my artists and collectors were in recovery, so why would I serve alcohol? That seemed rude to me," she said.

The laughter, teasing, and sense of fun that has meant survival for Native peoples through the centuries were present at every OIAG opening, and were especially noticeable at the Red Earth show when the artists' nerves were often raw with excitement. Sometimes the laughter came from a prank, such as the one organized by Ben Harjo who once asked all the artists to show up wearing something red on Doris's opening night. She didn't pay that much attention to the red

shirts on the first couple of artists who walked in, though she did stop to admire the red-beaded sneakers worn by Charlie Pratt, but when Harjo himself appeared in a red polyester leisure suit that once belonged to his father, she took note. Obviously, the color theme for the evening had been orchestrated, although the only confession she ever got from Harjo was a giggle.

For reasons no one ever fathomed, Red Earth was also when gallery furniture invariably got broken, always by accident, of course. Once Bill Glass, his wife, and Ben Harjo were sitting on an antique bench when one leg broke without warning and sent them tumbling to the ground. No one was hurt, and they stood up dusting themselves off and laughing. Then someone pointed out the bench was designed by Frank Lloyd Wright. The laughter started all over again. Only Doris was not amused.

Another year, it was a Mission-style church pew. Prior to her opening, Doris had set a Saltillo blanket on the back of the pew and placed yellow tape across its arms, so people would know not to sit there. At some point, however, perhaps to better show it to a collector, a clerk had removed the tape and never replaced it. Sunday afternoon, the last day of Doris's reception, Barthell Little Chief (Comanche/Kiowa), Robert Annesley and his wife, and another artist couple had gravitated there with generous plates of reception food. Both Annesley and Little Chief were big men, and the five-person combo was more than the bench could bear. Both legs collapsed in the same direction and everyone jumped off in unison, just as Doris, hearing the noise, came round the corner. Again, no one was hurt. Another artist, who examined the bench, said the legs had been secured with nails, instead of pegs, but assured her that it could be fixed. "I certainly hope so," she scolded. "That came out of an historic New Mexico church."

Perhaps nothing better illustrates the range of Doris's clientele or the extravagance that marked her Red Earth show than one sale she made for Merlin in 1993. He was splitting his time between the gallery and his booth at the festival, and he had just entered the door at OIAG when Littrell whisked him upstairs. She introduced him to a collector, an interior designer from Houston, and his assistant, who were both standing in front of one of his paintings. Merlin talked with them a few

minutes, but they didn't strike him as terribly interested in the piece, and they soon walked off to look at other artwork. Because of that, he was surprised when Doris came back upstairs to inform him they wanted to put a hold on it. Was he okay with that? She had told the designer the only way she could hold the piece for him was if he wrote her a check for a third of the price of the painting. She would keep the check in her drawer and once they got back to Houston, he needed to call her with a final yes or no. If he decided to release the piece, she would tear up his check. If not, she would expect the balance of his payment forthwith. Either way, she expected to hear from him before the end of the show, because if he released it, she didn't want to miss the opportunity to sell it to someone else.

Between four o'clock on Friday afternoon when Merlin left the gallery, and noon Sunday when he returned, the designer still had not called. In the meantime, two other couples had expressed a desire to buy the painting; Littrell told Merlin she was going to call the designer and tell him she was tearing up his check. He glanced downstairs just as she got off the phone with the designer, and unaware that she was being observed, whispered something to the sales clerk. The clerk looked up at Merlin, smiling and shaking her head, as though nothing more could surprise her. The designer was flying in by helicopter to pay his balance and pick up the painting. Why the man didn't offer to give her a credit card number over the phone and have the painting shipped to Houston, we still don't know. But factoring in helicopter fuel, we figure that had to be the most expensive miniature Merlin sold that year.

Besides witnessing the launch of Doris's Red Earth shows, 1990 turned out to be a critical year of change on the nation's Native art scene. In October 1990, a new version of the Indian Arts and Crafts Act was passed, increasing the criminal penalties for persons or companies misrepresenting Indian-made goods and products. First violations of the act would earn an individual "no more than a $250,000 fine" and "no more than five years in jail." Sentences for businesses and corporations were appropriately stiffer. The act defined "Indian" to include "any individual who is a member of an Indian tribe" or "is certified as an Indian artisan by an Indian tribe."

No one disagreed with the need for more protections for Native

artists. Plagiarism of works by Native individuals and communities had been occurring since the first commercial Native art markets in the 1930s. For every Indian Arts and Crafts bill passed after that, and there were several, it seemed some company or individual could find a loophole to exploit. Violations were common. Gina Gray, an Osage artist who chaired the Indian Arts and Crafts Commission in 2000, once told about walking through a store in Gallup, New Mexico, and seeing designs from her prints on imported scarves from China. No one asked her permission to use her images or paid her any royalties for them, and this was a decade after the 1990 act. She encountered many more examples of economic and artistic harms during her tenure as commission chair. Perhaps the most egregious example, according to Gray, was a Taiwanese manufacturing company that renamed itself "Zuni" so it could legally stamp "Zuni" on its mass-manufactured jewelry.

In Oklahoma, however, the act had unintended consequences for artists who claimed Indian descent but who were not enrolled with their tribes. Native American identity is complex: it has biological, cultural, and social aspects, but its most important aspect, from the viewpoint of the federal government, is Native people's political status. Native Americans enrolled with their tribes have a dual citizenship: they are both citizens of the U.S. and citizens of their respective tribal nations. As Cherokee artist Ron Mitchell explained, not being a tribal member doesn't invalidate claims of Native parentage. "It's like someone would be a citizen of France or a citizen of Germany. It doesn't mean that they're not German or French, anymore. It just means that they're not a citizen."

It did, however, mean big changes for Oklahoma's unenrolled artists, because the phrasing of the act equated "Indian" with tribal citizen. None of the unenrolled artists had claimed to be enrolled, but in many cases, the subject of their enrollment or lack thereof had never come up. Passage of the act meant they could no longer exhibit as Indian artists, and they were potentially subject to prosecution if they did. This was obviously a financial blow, but many of the unenrolled artists had practiced Native art before it became lucrative. They viewed Native subject matter as a way of exploring and affirming their heritage, and the act put into question their entire body of work.

No one active on the Native art scene disputes that some individuals claim Indian ancestry simply based upon family fantasy or hearsay. A few go even further, invoking reincarnation and insisting they were Indian "in a former life" because of dreams they had or their passion for "animals and nature." If they knew how offensive this is to Native Americans, they might not make such statements. But Native people are generally too polite to openly contradict them. The old joke "my great-great-grandmother was a Cherokee princess" may well have gotten its start at Native art shows.

At the same time, good historical reasons exist for there being individuals of Native ancestry who are not enrolled. Those encountered most often in Oklahoma include families who managed to evade removal to Indian Territory, and those who removed with their tribes but did not end up on the Dawes Rolls. It is no accident that nearly all the unenrolled artists in Oklahoma assert descent from the Cherokee, Choctaw, Chickasaw, Creek, or Seminole tribes. These Five Tribes were among the first and largest tribes forcibly removed to Indian Territory. Their collective tribal histories attest to members who eluded removal, individually or in groups, individuals who were held in slavery or who stayed voluntarily, accepting state rule and loss of their citizenship to remain in their homelands.

However, not all members of the Five Tribes who made it to Indian Territory were enrolled, either, including individuals of Native and African American descent. The allotment of Indian lands under the Dawes Commission and the enrollment process itself were far from perfect. Some of the problems were logistical, including the challenge of locating and listing all the Native individuals within each tribe's land base and doing so within a fairly narrow time frame. Others arose from conflicting values. Many groups and families opposed allotment because it violated their beliefs about using and managing land collectively. Some were suspicious of the federal government's motives for wanting to enroll them, a suspicion well-warranted since allotment in fact led to the loss of the tribes' land base. Others, it must be said, did not want to be identified as Native and embraced the opportunity statehood offered to blend into white society. While a vast majority of individuals ended up receiving allotments and being enrolled, whether

voluntarily or involuntarily, it was the white Dawes commissioners, not the tribes themselves, who oversaw the final rolls.

Partly because of this history, there was a general acceptance of unenrolled Native artists within the Oklahoma Native art scene. Few people publicly challenged their right to participate in Native art shows until the 1990 act went into effect. One of the first to tumble in status, although he was already deceased, was Willard Stone, the brilliant wood sculptor who provided the *Exodus* logo for the Cherokee Nation. Perhaps the most visible living unenrolled artist at the time was Bert Seabourn, and his very popularity with the public made him a media target at the time.

Seabourn recalled how his phone began ringing off the hook as readers around the country picked up newspapers with such headlines as "Indian Art Fraud." "I made headlines from New York to California to France," he said. "We had phone calls coming in from all over the world, wanting to talk to us about it."

Coverage outside Oklahoma was often sensationalized and failed to provide any context for the uproar. Oklahoma newspapers generally did better, but they, too, could fall short of the facts. Jeanne Rorex points to an article in the *Muskogee Phoenix*, charging that her grandparents on the Stone side didn't arrive in Indian Territory until after statehood. When she called the reporter to tell her the people named in the article were not her grandparents, and she had researched the wrong Stone family, the journalist refused to print a correction.

For a while there was talk of seeking a state exemption for Oklahoma. A hearing was scheduled for unenrolled artists and their supporters with the Oklahoma legislature. Rorex drove to Oklahoma City on the day of the hearing, accompanied by her cousin, Jason Stone, Willard Stone's son. As they got closer, she says she noticed "black Suburbans with big antennas" going up and down Interstate 40. "I thought, 'What the heck is going on?' It was the morning they attacked—Desert Storm was that day." When she and Jason arrived at the capitol, they learned the U.S. had officially entered the first Gulf War. All state business for the day was canceled, and the hearing was never rescheduled. "All the momentum we had was just forgotten about," said Rorex.

The fissures that underlay the Native art landscape quickly pushed

their way to the surface. Reactions from enrolled Native artists varied widely. "It created a lot of tension and finger-pointing," said Ben Harjo. "People . . . could finally come out and say, 'Well, they are not truly an Indian artist.'" Gina Gray noted, "It hit a lot of our artist friends hard. A lot of us stood up for them, because we knew their history. It's just they couldn't get it certified." Bill Glass, who was particularly close to Willard Stone, having spent a lot of time visiting him, observed, "It really divided our tribe. There was a lot of guys that had been doing art for twenty, thirty years that . . . weren't on the Dawes. I think some of the best artists got shunned out."

Plains artists tended to be less sympathetic toward unenrolled artists, in part, because their historical experiences were so different from the Five Tribes. Many had been confined to reservations prior to allotment and enrollment. They were also less intermarried with non-Indians than Five Tribes members. Like other Native Americans across the country, they had grown up watching mixed bloods receive preferential treatment over full bloods in education and jobs, and the same dynamic had played out in Native art. "There was money to be had" in Indian art, points out Sharron Harjo. "There were trips and show sponsorships, and the first in line weren't the tribally enrolled people."

Doris had handled only a couple of unenrolled artists during her career, but they were also dear friends, artists she had known since her dealer days. When the headlines broke, she got a call from a collector, who warned, "They're fingering you to be the first one fined because you've been in it the longest. They think they can hurt the industry by getting you." "I was so upset," she recalled. "I didn't want them to, but Bert Seabourn and his daughter, Connie, came and took their things out. I closed the gallery, wrote something on the door, and went home. I was closed for about a month, trying to figure out what to do."

Organizers of Native art shows and Native art museums found themselves in a similar bind. Some relief was supposed to be available through the language of the act that allowed tribes to "certify" artists to represent them. But unenrolled artists were correctly skeptical as to whether this would happen, because they knew any such move would be politically contentious in the tribes. Seabourn noted that he was initially promised a letter by then Cherokee Chief Wilma Mankiller, but

she later changed her mind. He did finally receive a general letter from the Cherokee Nation giving him permission to show at the Red Earth Indian Arts Festival in 1991. At that point, however, his wife did not want him to enter Indian art shows at all.

The exact way in which unenrolled artists could describe their identity and still comply with the law was tricky at best. Rorex recalled how she was entrapped by an undercover FBI agent during a Red Earth show. She was busy with customers, and as he came by, he asked what tribe she was, to which she replied, "I'm part Cherokee." She was reported for violating the act, and during her interrogation by the agent's supervisor, he informed her that all she could legally say was that she had "Cherokee ancestry" or was of "Cherokee descent." Without being enrolled, she couldn't say she was "part Cherokee" or had "Cherokee blood." "What in the (blankety-blank) do you think 'descent' means?" she retorted.

As if phrasing weren't enough of a problem, citizenship (though not full services) among the Five Tribes is based upon descendency from a tribal citizen ancestor. It is not tied to blood quantum as it is with the Plains tribes, yet another white-imposed concept, but one essential to qualify for certain federal scholarships, programs, or services. "It really irritated me," said Mel Cornshucker, showing the tip of his pinky, "There [were] some would-be Indians with this much Indian in them, but they could prove it, making a big issue of it at the shows. And there were artists that can't prove their lineage, but I know that they're Indian. The [act] knocked them out, but it let those little bitty Indians in."

Linda Greever of the Art Market was the first gallery owner to consult with a lawyer who drew up a template she could use as a disclaimer for her Tulsa gallery. The disclaimer, still posted today, reads in part that the presence of art in her gallery does "not represent or suggest either expressly or impliedly that any given artist is a registered tribal member."

When Doris reopened her gallery after a short hiatus, she adopted the same template. Ironically, it was not her, but Greever whose name was turned in to the U.S. Attorney General for a supposed violation. "I had a show after the act passed that I was careful to list as an art

show, not an Indian art show, even though only one artist wasn't a tribal member. But because someone complained, the head of the Indian Arts and Crafts Board flew in from D.C. to investigate me," said Greever. The woman looked all around and proclaimed her okay, and then called the art dealer after she got back to D.C. "She wanted to buy a painting she'd seen, but I had to turn her down because it sold after she left."

Contention over the act continues to this day. The use of disclaimers by Oklahoma galleries angers some Native artists who see it as yet another way to avoid compliance with the law. Until his death from cancer, Sherman Chaddlesone deplored the fact that shows and galleries were still profiting from unenrolled artists and tribal members weren't calling them on it. "To me, the true Indian artists don't worry about it, and they need to, because there's other people shoving them out of the way, making money where they could be doing that."

Doris did not want to alienate Chaddlesone or other artists who were tribal members, but she also felt she could not in good conscience turn her back on the few unenrolled artists she carried. "I had known them for years. They were honest people who would not have claimed to be something they weren't. They came by their identity the way most of us do. That's who they were told they were, growing up."

Because she was such a strong communicator, the Red Earth Indian Arts Festival asked her to participate in a series of meetings they held about the law for the public. As one staff member put it, "She was always good at explaining the situation of the unenrolled artists in a way that people could understand."

Chapter 28
A Season of Gifts

IF THE GALLERY WORE its Sunday best during Doris's Red Earth shows, it was jewel-bedecked and resplendent during the holidays. Long before home-decorating magazines picked up on the idea, Doris would place Christmas wreaths throughout the gallery, not just over the gallery door. She put up a Christmas tree featuring handcrafted Native ornaments in one of the rooms, along with a Southwestern crèche scene she'd had for many years. Spread over the floor and on the furniture were pots of red and white poinsettias, all adding to the holiday ambience of the place.

She worked especially hard at her holiday shows, so her artists could celebrate Christmas with gifts under the tree like everyone else. Throughout the year, even when a customer put something on layaway, she always paid artists their full percentage on the spot, reasoning that she could more easily wait for her money than the artists could. She always had a lot of layaways during Christmas, but unless it was an item of $5,000 or over, in which case she might split her payments to artists in half, she continued to pay their percentage of the sale up front.

At the close of her holiday shows, when the last collector had left, she would walk around, buying art from artists who hadn't sold during

the reception. The money she'd earned from the sales of one artist would be spent on another; she wanted everyone to be able to leave with a check. At night's end, she would gather up all the poinsettias she had purchased and send them home with the artists and their families, along with gift baskets of fruit, baked goods, and other treats.

As Robert Taylor explained, even when certain paintings didn't sell at the holiday show, they mysteriously sold afterwards. "We walked around thinking, 'I'm sure glad we made that sale! A lot of those 'sales' were put in the closet because Doris was buying them, and she didn't want to embarrass us." The gallery owner knew they would sell later during the year, but Christmas itself couldn't be postponed. She was doing as her grandmother had urged, trusting things would work out, believing in the Bounty.

I should have suspected something was up with those checks for it was rare for Doris to mail us a check with a short note that simply said, "Thank you!" or "Congratulations!" For all other sales, she included a handwritten letter, explaining how much the collectors in question enjoyed his work and relaying their comments. Those letters always seemed to come at times when Merlin was feeling burned out or struggling with some compositional problem that didn't seem to have an answer. Such positive feedback invariably would get him fired up again.

In the early years, when Merlin and I hauled scrub cedar trees home from his land for Christmas, it was difficult to indulge in anything extra. I remember being so excited one December, when after a trip to the gallery, Doris gave us a Christmas wreath along with a check. We knew that check would not only afford us a merry Christmas, it would sustain us through the sales doldrums of January. It was snowy and dark when we got in the car, but there was a traveler's moon in the sky, illuminating the road ahead that looked as though it came straight out of one of Merlin's paintings. Driving back to Tulsa that night, we felt both humbled and elated, keenly aware of how privileged we were to be earning a living with art.

"One of the artists said, 'You've retired five times.' I really lost track!
I was glad he was making a note."
—Doris Littrell

Chapter 29
Good-Bye, Dear

DORIS HAD TALKED periodically about selling the gallery, beginning in the mid-nineties. But she began to discuss it more frequently with close friends and artists around 2004, as she started to have more trouble walking. She was seventy-five by then, and the long hours and sheer physicality required to run a gallery were taking their toll. She had grieved the passing of several artist friends, and suffered through her own bouts of illness and through the emotional and social upheavals of the Oklahoma City bombing of April 19, 1995, and the September 11th terrorist attacks of 2001.

Everything around her was pointing to change. Stores in the strip mall had always opened and closed, but they did so now at a faster rate than ever. The whole neighborhood seemed to be sliding into entropy. For the first time since she opened, she felt she actually needed the iron bars the landlady had installed on the windows a decade before. Although most of her painters no longer relied on her as heavily as they did in the 1980s and 1990s, she still worried that closing the gallery would hurt them financially. As she cast about for a long-term solution, she thought about selling the business to someone who would keep working with her artists and perhaps even keep the gallery's name.

Her biggest challenge was her inventory, or so she told herself. Selective as she had been, she still owned perhaps a hundred originals, most of them acquired prior to the year 2000. There was no way to sell that much art in auctions or public sales without backtracking on the prices she had built up for her artists. She decided that if she did sell the gallery, whoever bought it would have to buy her inventory as well.

She got a few serious bites. Some came from collectors intrigued with the idea of starting a new career after they retired. One or two were former employees who, in working for her, had developed their own close relationships with her artists and patrons. On one occasion, she and a salesclerk drew up a contract together, but the deal collapsed before anything was signed. Eventually, she realized she could no more part with her business than she could with one of her daughters.

In 2005, she announced that she was closing the gallery, and she began calling artists to pick up their consignment work. Her landlady hosted a farewell party for her, attended by artists, their families, and collectors. After the party, Doris advertised a gallery sale of discounted originals, prints, and furnishings. Many of them sold, but a substantive amount remained, so she held a second sale six months later.

In the meantime, of course, she had to stay open to prepare for the sale, and whenever she was open, people would file in. Collectors would tell her how much they hated to see her go or some artist would drop in unannounced with a painting to put in the sale. She began to wonder if maybe she should think about downsizing instead of closing. If she leased a single room like the Pink Room, instead of the entire gallery, she wouldn't have to walk so much and she could still market a small, select group of artists.

She and her landlady renegotiated the lease. Then in 2006, the same year she received the Governor's Art award from the Oklahoma Arts Council for her contributions to the state's Native art scene, Bob McCabe was diagnosed with liver cancer. She moved him into her home so she could care for him with the help of hospice. After three months, he was doing so well hospice withdrew, and he insisted on moving to the gallery where he felt more comfortable. As long as Bob was there, she had no choice but to stay open. He lived at the gallery until his final hospitalization in 2007. After his death, she found stacks

of unopened prints in his inventory, more than three thousand in all. That became another reason to hang on.

She moved the art through wholesale and retail channels as best she could. By that time, her own health was suffering. She knew she needed to close, but at her own pace and in stages and in 2010, the door to Oklahoma Indian Art Gallery shut for the last time.

There is a story about how the Kiowas discovered peyote, the principal sacrament of the Native American Church. Like all traditional stories, it loses its meaning when taken out of context, but there is one moment in Robert Redbird's version that invites metaphoric comparison with Doris Littrell's life.

"This lady was dying . . . as she was laying there dying, she heard a voice. She looked up with dim eyes, and she saw a white buffalo. It was spiritual and it began to speak to her. It told her, 'Why are you dying when there is so much abundant life around you?' 'There's nothing to eat here.' [The buffalo] said, 'Get up. Follow me.' There was an herb down there. He told her what to do and he cleaned it off and he said, 'Eat that, and you will have new strength and new life.'"

Native painting was Doris Littrell's white buffalo. When she found herself in crisis and didn't know where to turn, Indian art was there to guide her to a place of beauty, solace, and renewal.

As I write this, a few Native paintings still hang on her walls in the tiny room she now calls home; they are the first and last sights that she sees every day, along with the sunrise and sunset. Although she still misses her gallery business, she also takes pride in knowing so many of the artists she handled through the years are still producing art today.

Good-bye, dear

About the Author

Julie Pearson-Little Thunder is writer, playwright, and co-founder of the Tulsa Indian Actors' Workshop, now Thunder Road Theatre. A visiting assistant professor with the Oklahoma Oral History Research Program at Oklahoma State University in Stillwater, Oklahoma, she has a doctorate in theatre studies from the University of Kansas. Of mixed blood Creek ancestry, she was reared in Denver, Colorado, and moved to Tulsa, Oklahoma, in 1981 to work with American Indian Theatre Company of Oklahoma. There she met her husband, Merlin Little Thunder and became involved in the visual arts scene, writing over a dozen articles on Native artists for *Southwest Art* and *Oklahoma Today* magazines. She makes her home in Tulsa.

Acknowledgments

The impulse for this book was truly a collective one, and in addition to the artists, my thanks go out to all the collectors and employees of Doris who shared their insights and stories with me. Among Doris's collectors, Carl and Deborah Rubenstein were the most persistent cheerleaders for this project. They hosted the first group discussion sessions for it and stayed in touch with me throughout it.

This book would not have been possible without the foresight of Sheila Johnson, dean of libraries at Oklahoma State University in Stillwater. It was Dean Johnson's idea to start an interview series with Oklahoma's Native artists. When I had the good fortune to be hired to conduct those interviews, the idea for the book had not yet been conceived, and I had no idea how invaluable that material would be and how it would prove so central to Doris's story. I hope it will continue to provide research materials for many others to come.

This manuscript would still be a work in process but for the generosity of Donna and Randy Wilson. They provided me with a second home in Stillwater for several years, so I could write after work without losing time and energy commuting home.

Finally, I wish to thank my husband, Merlin Little Thunder, whose incisive observations about Doris and whose extraordinary ability to remember other people's stories as well as his own were invaluable; and my father, the keeper of stories in our family, who taught me to love writing and the spoken word equally.

Author's Note Regarding Research

Most artists' quotes come from one of two sources: personal conversations conducted on the phone or in person, or from the Oklahoma Native Artists Project. You can visit the project here: http://www.library.okstate.edu/oralhistory/digital/oklahoma-native-artists-project/.

On those occasions when an artist, gallery owner, or collector expressed in my personal interviews a thought similar to one in the ONA collection, I chose the most clear or vividly phrased quote. Artist interviews from the ONA series include Mary Adair, Joan Brown, Allie and Sherman Chaddlesone, Mike Daniel, Mel Cornshucker, Gary and Elizabeth Ferris, Benjamin Harjo Jr., Sharron Ahtone-Harjo, Robert Henry, Joan Hill, Rance Hood, Bill Glass, Gina Gray, Linda Greever, Merlin Little Thunder, Doris Littrell, Robert Taylor, Joe McBride, Gary Montgomery, Charlie Pratt, Harvey Pratt, Robert Redbird, Jeanne Rorex, Carl and Deborah Rubenstein, and Bert Seabourne. Interviews conducted independently include Tammy Adams, Richard Aitson, Lee Bocock, Jane Osti, Rex Page and Lucy Saarni, Leslie Pate, Mimi Smith, Jimmie Carol (Fife) Stewart, Cecilia Yoder, Michael and Jody Wahlig, and Bill Wiggins.

Archives consulted include the Oklahoma Artist Files at the Donald and Elizabeth M. Dickenson Research Center, National Cowboy and Western Heritage Museum, Oklahoma City, Oklahoma; and the Mark K. Chapman Library, Philbrook Museum, Tulsa, Oklahoma. I am happy to share academic footnotes for books, newspaper, and magazine articles upon request.

Photographs & Art Section

The Kiowa Five images courtesy of the Arthur & Shifra Silberman Collection, 1996.017, Dickinson Research Center at the National Cowboy & Western Heritage Museum, Oklahoma City, Oklahoma.

The Marrying Kind by Benjamin Harjo courtesy the collection of Gary and Ann Baer.

Courtesy the collection of Bill Wiggins: *Kiowa Black-Leg Society Going to a Dance* and *Moving Day* (Sherman Chaddlesone), *Chicken Pull* and *Narrow Escape* (Narsico Abeyta), *Roadman* and *Kiowa Arapaho on July 4th* (Mirac Creepingbear), *Peyote Ceremony, Bringing of the Morning Water* (Robert Redbird), *Changing Woman* and *Hog Fry* (Virginia Stroud), *Singer* (Bill Glass), *The Shield Bearers, Warrior with Yellow Rifle,* and *Kiowa Gourd Clan Dance* (Dennis Belindo), Beaded Pin Feather Medallion (Richard Aitson).

Remaining images from Doris Littrell's letters and archives courtesy of the Arthur & Shifra Silberman Collection, 1996.017, Dickinson Research Center at the National Cowboy & Western Heritage Museum, Oklahoma City, Oklahoma.